Paul Cézanne

1839–1906

Anna Barskaya
Yevgenia Georgievskaya

Paul Cézanne

1839–1906

Grange
BOOKS

Text: Anna Barskaya, Yevgenia Georgievskaya

Published in 2004 by Grange Books
an imprint of Grange Books Plc
The Grange
Kingsnorth Industrial Estate
Hoo, nr Rochester
Kent ME3 9ND
www. Grangebooks.co.uk
ISBN 1 84013 569 7

© Confidential Concepts, worldwide, USA
© Sirrocco, London, UK, 2004 (English version)

Printed in Singapore

Contents

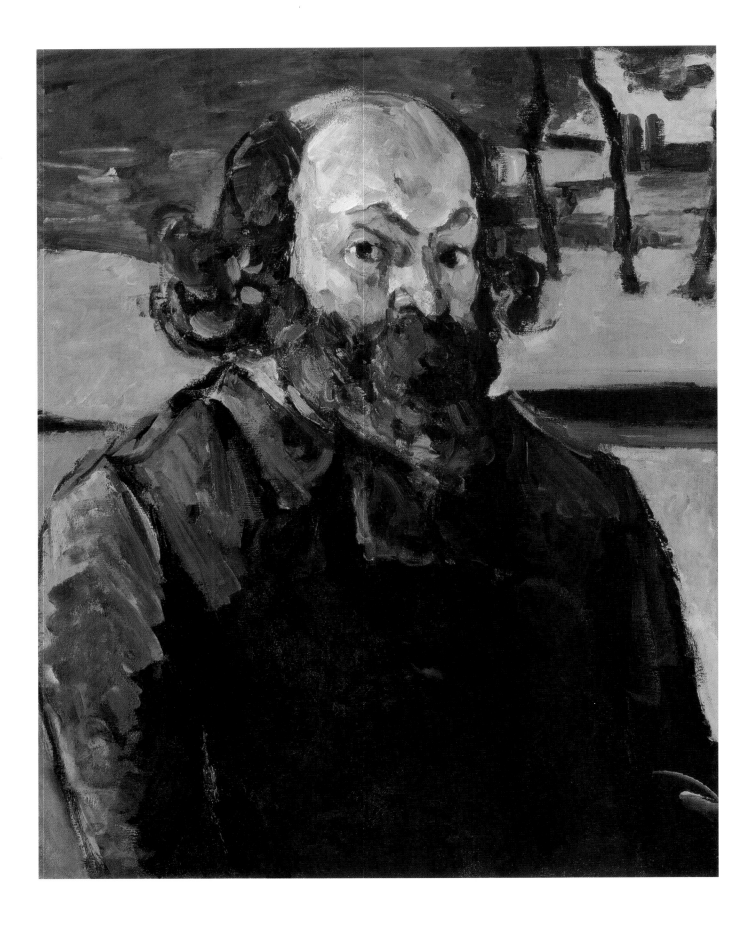

His Life

It is generally acknowledged today that the twenty-five paintings by Paul Cézanne in the possession of the Pushkin Museum of Fine Arts in Moscow and the Hermitage in St. Petersburg constitute an extremely important part of the artist's legacy. They are not only of a high standard but are superb examples of the main periods in his artistic career. Besides such recognized masterpieces as *The Banks of the Marne*, *Great Pine near Aix*, and *Mont Sainte-Victoire*, there are also some unique works, unparalleled in Cézanne's œuvre, such as *Girl at the Piano (Overture to "Tannhäuser")* (p.65) and *Pierrot and Harlequin (Mardi Gras)* (p.103).

All the paintings were acquired at the beginning of the twentieth century by two outstanding Russian collectors, Ivan Morozov and Sergei Shchukin, men of impeccable taste with a true eye for great art, which accounts for the exceptional quality of their collections. In buying Cézanne's canvases, they were also encouraged by the keen interest which the Russian artistic public evinced in the master from Provence. As early as 1904, the year of Cézanne's first personal exhibition at the Salon d'Automne in Paris, the St. Petersburg magazine *Mir Iskusstva (World of Art)* published reviews by Igor Grabar and Stepan Yaremich of Cézanne's exhibitions in Berlin and Paris. These were followed by a number of articles in the art magazines *Iskusstvo (Art)*, 1905, *Vesy (Scales)*, 1906, *Zolotoye Runo (The Golden Fleece)*, 1908, and *Apollon (Apollo)*, 1910 and 1912. It was during this period that most of Cézanne's canvases now in Russia were acquired. In 1907, after Cézanne's posthumous exhibition at the Salon d'Automne, Ivan Morozov purchased two of his paintings, *Plain by Mont Sainte-Victoire* (p.85) and *Still Life with Curtain* (p.129).

In a text of this size, it would be impossible to encompass Cézanne's entire œuvre, and, more importantly, hardly be necessary as it has been done in the fundamental works of Gerstle Mack, Lionello Venturi, John Rewald, Jack Lindsay, among others. But even in the most comprehensive of these treatises, the researcher was not able to treat the master's enormous output, comprising over 800 pictures, about 500 drawings, and 350 watercolors. Each researcher therefore made his own selection from this treasure and evaluated each piece chosen according to its merits. The author of this text analyses Cézanne's artistic development based on the works collected by Morozov and Shchukin. This is particularly interesting in view of the fact that Russian artists and critics also contributed to the collecting of Cézanne's works in their country and that several generations of Russian painters have drawn inspiration from the Cézannes in Morozov's and Shchukin's collections. Although a limited range of works cannot give a complete picture of Cézanne's artistic evolution, the author still hopes that this analysis will shed new light on it.

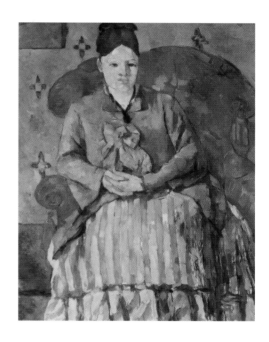

Portrait of the Artist, c. 1873–1876.
Musée d'Orsay, Paris.

Madame Cézanne in a Red Chair (Madame Cézanne in a Striped Skirt), c. 1877.
Oil on canvas.
Museum of Fine Arts, Boston.

This work which brooked no predilections, no favouring, no selective discriminations, whose least element had been weighed in the balance of an infinitely restive conscience, and which so incorruptibly reduced what is to its color content that it commenced a new existence in a dimension beyond color, unencumbered by earlier memories. It is this unrestrained objectivity, which rejected all meddling with another person's oneness, which makes people find Cézanne's portraits offensive and risible...

Rainer Maria Rilke (*Letters about Cézanne*)

Thus the great German poet Rainer Maria Rilke described the profound impression Cézanne's work had on him at the Salon d'Automne of 1907. And indeed, at the turn of the century Cézanne began to be taken more and more seriously by the avant-garde: Matisse, Picasso, Braque, Vlaminck, Derain and others, and among them young Russian painters whose new art owed much to the master from Provence. However, many of Cézanne's contemporaries, including such well-known authors as Arsene Alexandre and Camille Mauclair, did not realize his true greatness. When Paul Cézanne died in October 1906 in Aix-en-Provence, Parisian newspapers reacted by publishing a handful of rather equivocal obituaries. "Imperfect talent," "crude painting," "an artist that never was," "incapable of anything but sketches," owing to "a congenital sight defect" — such were the epithets showered on the great artist during his lifetime and repeated at his graveside.

This was not merely due to a lack of understanding on the part of individual artists and critics but above all to an objective factor: the complexity of his art, his specific artistic system which he developed throughout his career and was not embodied *in toto* in a single one of his works. Cézanne was perhaps the most complex artist of the nineteenth century. "One cannot help feeling something akin to awe in the face of Cézanne's greatness," wrote Lionello Venturi. "You seem to be entering an unfamiliar world — rich and austere with peaks so high that they seem inaccessible."[1] It is not, in fact, easy to attain those heights. One does not reach them by the old, well-trodden paths of literary subjects and familiar associations with everyday life.

Today, Cézanne's art unfolds before us with the consistency of a logical development, the first stages already containing the seeds of the final fruit, but to those who could see only separate fragments of the whole, naturally much of Cézanne's œuvre must have seemed strange and incomprehensible. This was the only way in which his contemporaries were able to see it, as fragmentary parts in private collections and at occasional exhibitions; only a few sensed the greatness of his work. Most people, however, were struck by the odd diversity of styles and the differing stages of completion of his paintings. In some paintings, one saw a fury of emotion, which bursts through in vigorous, tumultuous forms and in brutally powerful volumes apparently sculpted in colored clay; in others, there was rational, carefully conceived composition and an incredible variety of color modulations. Some works resembled rough sketches in which a few transparent brushstrokes produced a sense of depth, while in others powerfully modeled figures entered into complex, interdependent spatial relationships, which Russian artist Alexei *Nürenberg* has aptly called "the tying together of space."[2] Even one of Cézanne's devoted admirers, Émile Bernard, ascribed the unfinished character of these works to the painter's awkwardness, oddities, and naivety, which at times verged on crudity, and proposed that they be distinguished from "those that are really beautiful."[3] Cézanne himself, with his constant laments about the impossibility of conveying his own

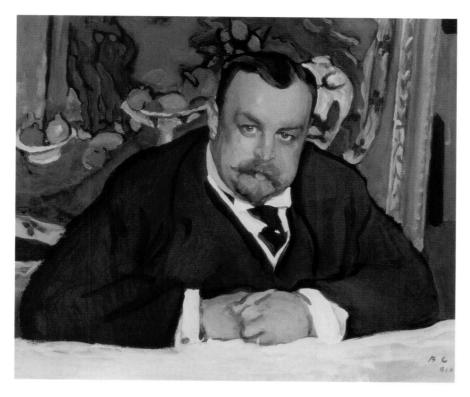

sensations, prompted critics to speak of the fragmentary character of his work. He saw each of his paintings as nothing but an incomplete part of the whole. He always felt that just one more effort was required, just a little more exertion of willpower, and the goal would be reached. But it sometimes happened that the entirety of the world seen by the artist in each bit of nature eluded his brush. Often, after dozens of interminable sessions, Cézanne would abandon the picture he had started, hoping to return to it later. In each succeeding work, he would try to overcome the imperfection of the previous one, to make it more finished than before. "I am long on hair and beard but short on talent."[4]

Of a rejected painting he had submitted for the 1878 Salon, he wrote: "I can quite see that they could not accept it because of my starting point, which is too far removed from the aim to be attained, that is to say, the reproduction of nature."[5] The final aim would at times hover vaguely before him in the misty future, while at others it would be lost in the immensity of the specific tasks he set himself. "I am working obstinately, for I am beginning to see the promised land. Will I be like the great Hebrew leader or will I be able to enter?... I have made some progress. Why so late and with such difficulty?"[6] "My age and my health will never allow me to realize the dream that all my life I have longed to achieve."[7] Exactly a month before his death, Cézanne wrote to Émile Bernard: "Shall I attain the aim so ardently desired and so long pursued? I want to, but as long as the goal is not reached, I shall feel a vague malaise until I reach the haven, that is, until I achieve a greater perfection than before and thus prove the rightness of my theories."[8]

Such thoughts, shot through with bitterness, are a tragic theme recurring in Cézanne's correspondence and conversations with his friends. They are the tragedy of his whole life — a tragedy of constant doubting, dissatisfaction, and lack of confidence in his own ability. But here, too, was the mainspring of his art, which developed as a tree grows or as a rock forms — by the slow accumulation of more and more layers on a given foundation. Throughout history there have been many artists who were dissatisfied with their work. At the end of the fifteenth

Portrait of Ivan Morozov.

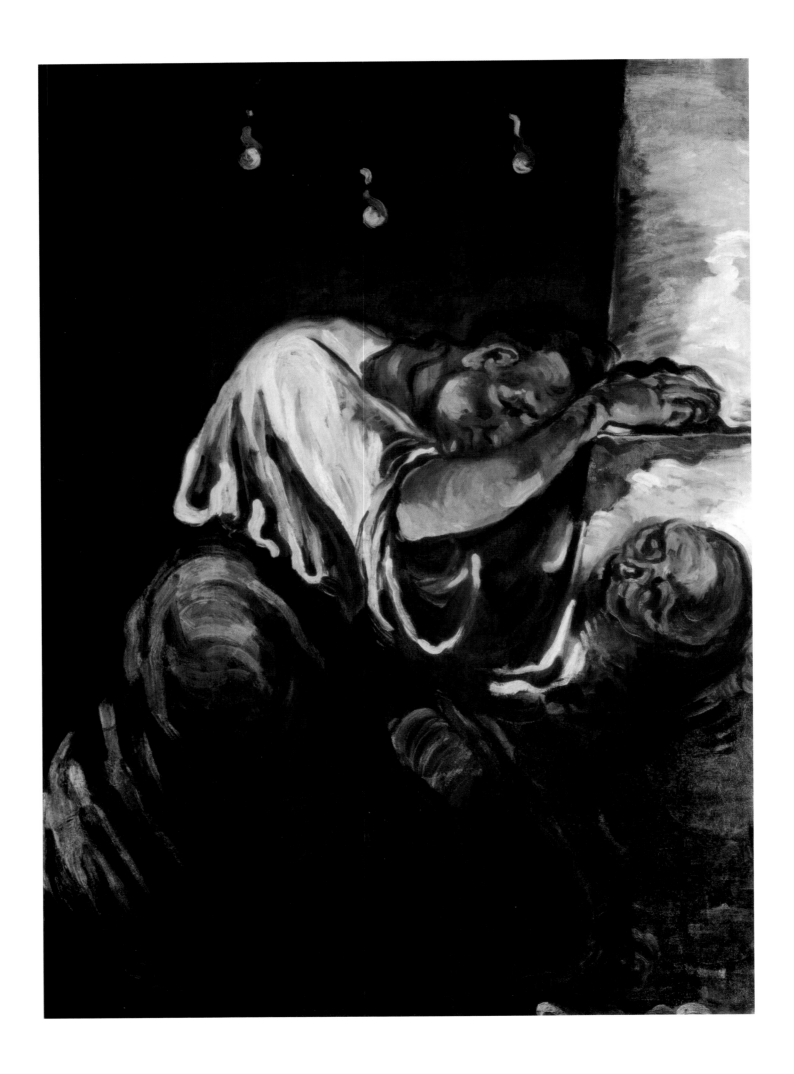

century, Botticelli burnt his own works, considering them iniquitous. Michelangelo smashed with a hammer those of his sculptures which seemed to deviate from his artistic goal. Many of Cézanne's talented contemporaries, knocked off balance by the onslaughts of the critics, left the narrow path of innovation for the well-trodden road of tradition. Cézanne's doubts were of a fundamentally different order. For him it had to be all or nothing. He saw each of his pictures as nothing but a stage, a springboard from which he hoped to attain new heights. "He was always convinced that all that he had done was only a beginning,"[9] Émile Bernard recalled.

Often Cézanne would take a knife and scrape off all he had managed to paint during a day of hard work, or throw it out of the window in a fit of exasperation. He was also prone, when moving from one studio to another, to forget to take with him dozens of paintings he considered unfinished. He hoped eventually to render his entire vision of the world in one great, complete work of art as did the geniuses of classical painting and having "redone Nature according to Poussin," to emulate Poussin.[10] But to a person living at the end of the nineteenth century, the surrounding reality seemed far more complex and unstable than that of someone living in Poussin's time. Its dynamic character could not be compressed within static forms of a painting: Its diverse facets and aspects could not be reduced to a universal principle capable of being expressed in a single plastic formula but had to be rendered by other means. Cézanne devoted many years to the search for such means, hoping eventually to bring them all together. His ultimate aim was to paint a masterpiece, and he did create many works that we now consider to be masterpieces. But apart from that, he evolved a new creative method and a new artistic system, which he adhered to consistently throughout his life. In creating this system, he contributed to the birth of twentieth-century art.

It would be useless to look for the essence and meaning of Cézanne's new artistic system in his own pronouncements. Few of his generation showed so little regard for all manner of philosophical speculation about art. Paul Gauguin, for instance, provided the theoretical basis for the new principles he followed in his work, and in Van Gogh's correspondence we find philosophical, social, aesthetic, and even theological essays on painting. Seurat attempted to apply the laws of physics, mathematics, and optics to painting. Cézanne had no use for thoughts on art expressed by any other means except "with brush in hand." "Indeed, one can say more and perhaps better things about painting when facing the motif than when discussing purely speculative theories in which more often than not one loses one's bearings."[11] He spoke only of nature, of the motif, and of how best to get it onto canvas. His pronouncements bear the stamp not so much of theoretical postulates as of practical advice to fellow artists, reflecting his preoccupation with one creative task or another. Therefore the attempts to formulate a comprehensive concept of Cézanne's artistic idiom on their basis have confounded many an art historian, and efforts made by certain of Cézanne's followers to put some of his "theories" into practice produced results that more often than not evoked the painter's fury.

Cézanne's œuvre is to this day a complex problem which has not yet been completely resolved by art historians. With the passage of time, however, his place in the mainstream of Western artistic culture and the character of his tremendous influence on twentieth-century art have been assessed in a new light. It is not, therefore, to the artist's theoretical

The Madeleine or Sorrow, c. 1868–1869.
Oil on canvas, 165 x 125.5 cm.
Musée d'Orsay, Paris.

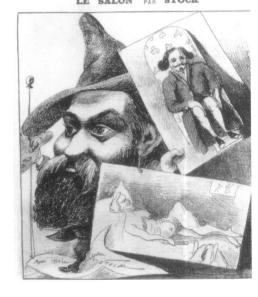

Portrait of Émile Zola, 1861–1862.

Stock's caricature of Paul Cézanne with two of his canvases rejected by the jury of the Salon in 1870.

statements but to his works that we must look for an explanation of how his creative method gradually came into its own, how the links were forged of the whole chain which today we justly call "Cézanne's artistic system."

In April 1861, the 22-year-old Paul Cézanne, son of a wealthy banker in Aix-en-Provence, arrived in Paris. His aim, his passion, his most fervent wish was to devote himself, body and soul, to art. Behind him was a solid classical education received from the college of Aix, rather modest successes (according to his teachers) at the local school of drawing, but, above all, years of rapturous absorption in the unrestrained romanticism of Victor Hugo, Alfred de Musset, and Charles Baudelaire and of youthful dreaming together with Émile Zola of the lofty calling of the artist and of their future collaboration in the field of art.

However, Cézanne's ideas on the subject were then, like those of Zola, rather hazy. The first thing that struck him in Paris was an exhibition held at the official Salon. On June 4, 1861, he expressed his opinion of it in verse in a letter to his friend Joseph Huot:

> J'ai vu d'Yvon la bataille éclatante;
> Pils dont le chic crayon d'une scène émouvante
> Trace le souvenir dans son tableau vivant,
> Et les portraits de ceux qui nous mènent en laisse;
> Grands, petits. moyens, courts, beaux ou de pire espèce.
> Ici, c'est un ruisseau; là, le soleil brûlant,
> Le lever de Phébus, le coucher de la lune;
> Un jour étincelant, une profonde brune,
> Le climat de Russie ou le del africain;
> Ici, d'un Turc brutal la figure abrutie,
> Là, par contre, je vois un sourire enfantin:
> Sur des coussins de pourpre une fille jolie
> Étale de ses seins l'éclat et la fraîcheur.
> De frais petits amours voltigent dans l'espace;
> Coquette au frais minois se mire dans la glace.
> Gérôme avec Hamon, Glaise avec Cabanel,
> Müller, Courbet, Gudin, se disputent l'honneur
> De la victoire…

And turning to prose, Cézanne mentioned several "magnificent Meissoniers" and referred to the exhibition as "a grand show."[12] In these verses, not devoid of humor, Cézanne draws a fairly accurate picture of Salon art in the 1860s, an art against which protest was already growing among the younger generation of artists who in the early 1870s formed a *société anonyme* and were later called the Impressionists. But during his first year in Paris, Cézanne evidently still held a certain respect for the acknowledged masters and was willing to join them. During this short period he was at a crossroads; not being fully aware of his talent, he was trying in vain to find himself and finally returned to Aix, acceding to his father's wish to continue the family business. In the bank, he sat despondently contemplating columns of figures, while spending all his spare time roaming the picturesque countryside around Aix. One day he wrote on a page in a ledger:

> Mon père le banquier ne voit pas sans frémir,
> Au fond de son comptoir naître un peintre à venir…

Ultimately, Cézanne the banker was obliged to abandon his hopes of making his son a worthy successor to himself in business; granting him a very modest allowance of 250 francs a month, he let Paul go to Paris to devote himself to his consuming passion. There, Cézanne took up art in

earnest. Anxious to obtain a fundamental artistic training, he was preparing to enter the École des Beaux-Arts and worked hard at the Académie Suisse desiring to improve his technique. He failed the entrance examination for the École des Beaux-Arts but at the same time found new friends, above all Camille Pissarro, who was to exert a substantial influence on his artistic development.

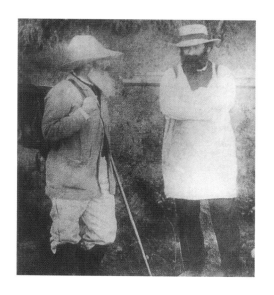

That was how Cézanne started out as an artist. He emerged in the art world of Paris in the early sixties, a period that saw a breakthrough in the history of French art. By the time of Cézanne's studies at the Académie Suisse, the group of young artists who brought about that breakthrough had already been formed. They were Claude Monet, Pierre-Auguste Renoir, Alfred Sisley, and Frédéric Bazille. None was yet aware of his own potential, yet all were united by their common opposition to the conventions of the official school and a desire to rely unreservedly on the visual perception of reality. To some extent, this was the result of new discoveries associated with the invention of the "mechanical eye" — photography — which was then enjoying immense success. It was then that the difference between the image recorded by the immobile camera lens and the perception of the living human eye was revealed in all its clarity. However, photography opened the way for understanding the unlimited potentials of representing space in which the logical or emotional center lost its absolute truth for the artist.

Truth to tell, these young painters still had only a vague idea of how to make a new start. For the time being, they only saw one possibility of advancing — to go outdoors and begin work anew, from nature. Thus there emerged a new trend in French art — Impressionism — that was to travel a long road of accumulating discoveries and techniques obtained by the keen observation of light and air effects in nature. This brought about a new approach to the picture; the portrayal was governed not so much by an idea worked out over a prolonged period as by direct visual perception. One cannot say that the Impressionists utterly rejected the idea of showing an object; however, space in their paintings was no longer subordinate to the depiction of objects but to the unstable movement of warm and cold tones of color that created the impression of a life surface where depth and flat planes were constantly changing places. Consequently, the Renaissance system of constructing a painting, one that had endured for four centuries, was severely shaken. For the sake of this new art, the Impressionists, of course had, to face some difficult ordeals, and Cézanne took a most enthusiastic part in their struggles. Like other artists involved in the movement, he thirsted for a change in the traditional system of painting but persistently sought his own way out of the critical condition in which art found itself. During the first decade of his artistic career, that way diverged markedly from the road chosen by other avant-garde painters.

During that first decade, generally counted from 1859 to 1870, Cézanne's work was marked by a wealth of themes and experiments. Among the few surviving works of his youth are genre scenes, compositions on religious and mythological subjects, and decorative allegorical panels, with which he adorned the walls of the Jas de Bouffan, his parents' estate. Sometimes these are copies of prints or of pictures from his mother's and sister's fashion magazines. At first glance, it may seem that Cézanne applied himself at random to an extremely wide range of themes and images in his essays at painting. To judge from the early extant paintings, however, Cézanne displayed a leaning towards definite subjects from the very outset.

Photograph of Camille Pissaro and Paul Cézanne, 1872–1876.

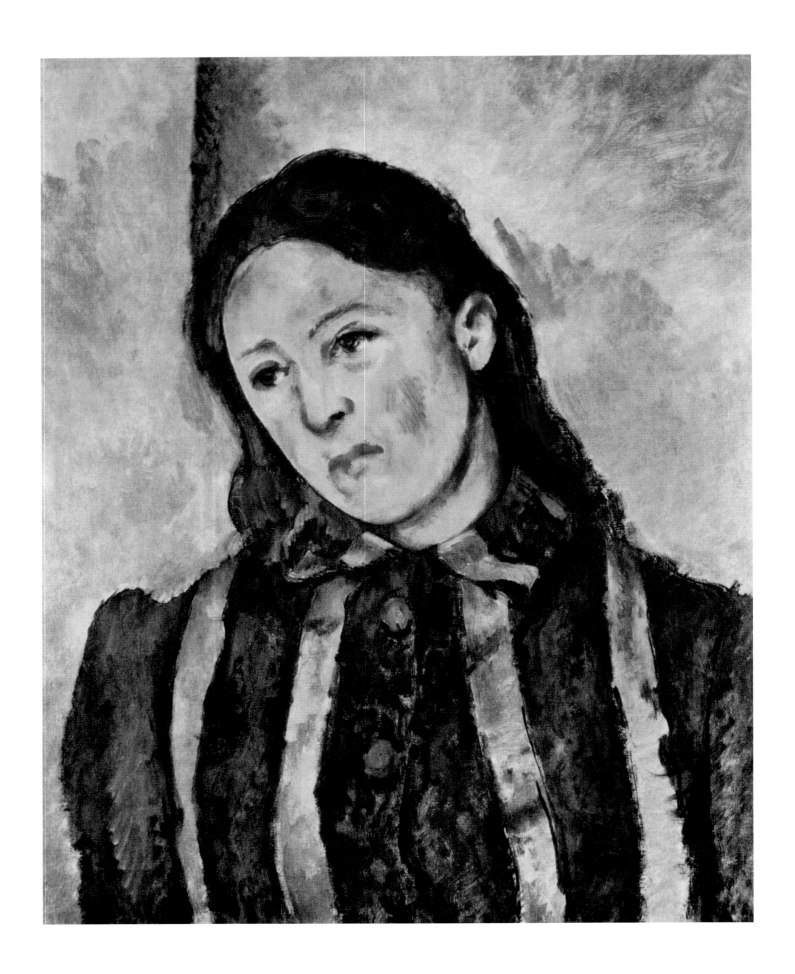

The fact that he chose to copy B. Roget's print *Eat, Little One, Eat*, which was in turn a reproduction of Prud'hon's painting *Children with Rabbit*, shows that Cézanne was attracted to this print by recollections of his childhood and of walks on the outskirts of Aix, where people bred rabbits. He was fascinated with the theme of *The Judgment of Paris* (c. 1860) and was to repeat it later; it was also to be linked with his *Temptation of St. Anthony* (1873–1877) (p.19) and his paintings of bathing women. These early works already bear the stamp of the artist's individuality. They reveal his love for powerful, massive forms and simplified light-and-shade relations, which points to his familiarity with primitive, or non-professional art. Perhaps Cézanne was also influenced by the decorative baroque sculpture to be seen in such profusion in Aix. In fact, these early pictures already manifest his idiosyncratic approach and total indifference to academic taste.

During his second spell in Paris and in the following years, Cézanne's tastes and inclinations were clearly defined. He was in no hurry to follow the Impressionists out of the museum halls and the studio's atmosphere of concentration in order to paint in the open air. He was immersed in an imaginary fantasy world, consumed by the desire to express an irresistible flood of human passion. Then, as before, he was attracted, above all, by the art of strong emotions. For an artist with Cézanne's keen sense of the dramatic complexity of the world, a simple representation of the visible was insufficient. He would constantly modify and deform figures, emphasizing in them what he thought to be most important and creating compositions with unstable equilibrium. He felt an affinity with the art of Delacroix, Daumier, and Courbet. In his hostility to academic and Salon art, he took up the struggle, these painters had started (which was already losing momentum in the 1860s) and gave it a new urgency. Cézanne's creative work began on a romantic note, which intensified and reached a peak by the end of the sixties.

There are scarcely any examples of Cézanne's early work in the Moscow and St. Petersburg collections. The reason for this is that Ivan Morozov, who was especially fond of Cézanne's paintings, was indifferent to the Provencal master's extremes of romanticism, while the critics and artists of the day thought most highly of his mature and later periods. *Two Women and Child in an Interior (Scène d'intérieur)* (Pushkin Museum of Fine Arts; p.63), the earliest of Cézanne's pictures in Russian museums, was executed in the 1860s. It should be pointed out that romantic features are expressed here, but in a very restrained way.

Although the source of this painting has not yet been discovered, it seems likely that it was one or several illustrations in a fashion magazine. At any rate, in such publications one finds pictures similar in type and composition. Here we can justly speak of Cézanne's rich imagination: having a second-rate illustration as a point of departure, he produced a profoundly individual image.

Cézanne achieves an effect of depth by the use of a few, skillfully arranged objects: a curtain, a small table, and an armchair. The figures of two women and a girl are grouped around a goldfish bowl. Their poses are thematically undefined, their movements slow, they are absorbed in themselves as if spellbound by the measured movements of the three goldfish in the water. The same dull, dark tone is used for the background, the deep shadows on the objects, and the water in the goldfish bowl (the water is not pictorially designated at all — through the transparent glass of the bowl one simply sees a fragment of the dark background), thus creating

Portrait of Madame Cézanne, 1883–1885.
Oil on canvas, 62 x 51 cm.
Private Collection, Philadelphia.

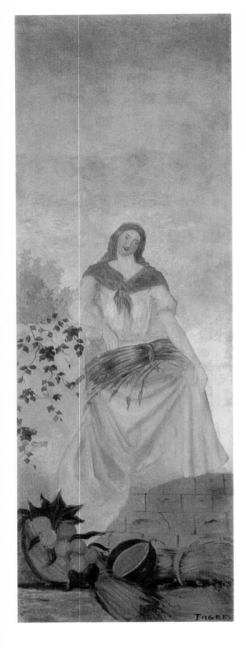

a sense of one environment that encloses human beings, fish and objects alike. Cézanne employs the same thick, dark contour to designate the boundaries of forms within the color planes, so that both people and objects are firmly linked to the background and become one with the gloomy medium from which they emerge like transparent bodies and into which they are about to dissolve as medieval stained-glass panels dissolve and vanish in the gloom of a Gothic cathedral. A hypnotizing atmosphere of inner concentration pervades the scene, mutes the sonority of the colors, and slows down the characters' movements, transforming what is in essence an ordinary genre scene into a kind of fantastic dream.

People and objects are almost completely devoid of the dynamic interrelationship of a genre painting: the movement of the goldfish in their bowl has been halted, as have the movements of the people. These people do not live in real, everyday surroundings but in a certain conventional medium, that of the artist's own spiritual and emotional mood superimposed on his characters. In his treatment of objects, Cézanne does not so much aim to convey their material qualities as to bring out the logic of the construction of their forms, simplifying and, at times, distorting them. Thus the neckline of the dress of the woman on the left encircles her bosom like a hoop, descends like a cone to her waist, and from there spreads out in a torrent of luxuriant folds and flounces. Contrasts of red, green, orange, and gray merge into a resounding and effective color chord. But for Cézanne, color is also an important factor in creating the emotional and psychological mood of the picture. In this subordination of the image to the artist's inner state lies Cézanne's special brand of romanticism, his highly individual artistic temperament. "Our generation is shot through with the spirit of romanticism,"[13] says one of Zola's characters in his novel *L'Œuvre*. Toward the end of the 1860s, romantic tendencies strengthened in the artist's work. The inner tension, still bound by static forms in *Two Women and Child in an Interior* (p.63), is released with tremendous explosive force in other paintings, accompanied by a buildup of color contrasts. Traditional subjects like *Pastoral* (p.32), *Déjeuner sur l'herbe* (p.20), *Fishing*, and others are set in unreal, fantastic surroundings reminiscent of strange, dreamlike visions.

The painting *Murder* (1867–1870, Walker Art Gallery, Liverpool; p.21) seems to be seen through the eyes of a man stunned by the sight of the murderer's hand raised over his victim. Forms here are generalized in the extreme and are subordinated to a whirlwind of movement: the man's clothes rise in a corkscrew fashion following the thrust of the hand clutching the knife; on the right there emerges a sinister female figure from the depth, a kind of chimera, the whole weight of her boulder-like body falling upon the victim; the sharply designated diagonal of the landscape plane recedes into the depths of the painting, and a swirling storm-cloud hangs low over the scene. Cézanne put a lot of effort into this composition,

The Four Seasons, 1859–1860.
Musée du Petit Palais, Paris.

as is evidenced by the large number of preparatory drawings. Yet it still looks as if it were painted in a fit of frenzy — the artist applied thick dabs of paint with a palette knife and modeled form with pools of color, striving to truthfully express his own powerful sensations.

Cézanne was not the only artist to choose such subjects. The manifestation of savage, brutal instincts was described by Zola in his novels at about the same time when this picture was painted. As John Rewald has pointed out in his *History of Impressionism*, Cézanne presented Zola with one such scene of violence.[14] The theme of *The Temptation of St. Anthony* (p.19), to which Cézanne turned again and again during those years, was also handled by Gustave Flaubert. Nonetheless, these works of Cézanne's do not evoke any literary associations, nor do they bear the character of a narrative or story, which hallmarked the most dramatic canvases of the romantics in the 1830s. They impress the onlooker by their expressive images, their generalized and laconic treatment of action, and their intense passion of feeling, producing the effect of a sudden, fleeting vision. They were born in the heated imagination of a painter living in provincial bourgeois surroundings, where everything was in opposition to his strivings and hostile to the urgings of his rather prolonged youth. (In the period described, Cézanne was approaching thirty. He took up with Hortense Fiquet, a girl out of his class, but for many years, until 1886, when he turned forty, was obliged to conceal the liaison and the birth of his son from his father and to live and keep his family on an irregular pittance. What is more, from time to time the despotic banker threatened to withdraw his allowance altogether.) Cézanne's *Orgy* (1864–1868, private collection, Paris), *Pastoral* (c. 1870, ex-collection of J. Pellerin, Paris; p.32), *Déjeuner sur l'herbe* (1869–1870, private collection, Paris; p.20), and many other works painted in the late sixties and early seventies are permeated with an atmosphere of unreality. The titles of these pictures are so out of keeping with the traditional idea of the genre that the painter must have chosen them with tongue in cheek. Their overall dark coloring is enlivened by bright splashes of boulder-like figures and of objects resembling deformed human bodies. And all of them seem to be blobs of flesh that have materialized from the substance, devoid of air and real light, which fills the spaces in between.

It can be said with certainty that despite the many influences apparent in these paintings, they are unique in French mid-nineteenth-century art, being the product of the artist's powerful individual vision of the world. Perhaps only the paintings of Honoré Daumier, then little known not only to the general public but also in artistic circles, could to some degree be considered a stylistic parallel to Cézanne's early canvases.

Although many years later Cézanne referred to van Gogh's works as "the paintings of a madman," his own early pictures were marked by

uncurbed passion and frenzy. Cézanne could also be reproached for "making a parade of his feelings before the public," something for which he blamed Gauguin. The fact is that Cézanne's richly endowed nature encompassed two seemingly irreconcilable traits — an emotional intensity and a strict rationalism, which all the while urged him to seek behind the external chaos of sensitively perceived phenomena some hidden order and to direct the motley kaleidoscope of visual impressions and emotions into the channel of a logically thought-out system. What irritated him in van Gogh's painting was something that formed part of his own makeup, something he was agonizingly trying to overcome.

The majority of Cézanne's early works bear the romantic imprint of powerful emotional perception (this is why his early period is usually called the romantic period), but this is only one aspect of his art. He constantly turns from the world of ghostly visions to that of reality. A different sphere of images and themes of his early stage is associated with his guest for ways of expressing the material structure of objects. In many of the portraits, still lifes, and landscapes of those years, he follows in the footsteps of Courbet, mastering, revealing, and emphasizing material solidity, volume, and weight of the object outlines.

The painting *Uncle Dominic as a Monk* (c. 1865, Ira Haupt collection, New York; p.34) is one in the *Uncle Dominic* series in which the subject is portrayed in one case as a lawyer, in another wearing ordinary indoor clothes, and in others in a cap or fantastic headgear. From the frontal pose in each of these works one can infer that the artist attempted to build up a strongly pronounced relief on the canvas's surface. By piling dabs of paint, one upon the other, he created an almost sculptural effect. In *Uncle Dominic as a Monk*, Cézanne uses this technique without resorting to light-and-shade modeling. Furthermore, he sets off the warm colors of the clothes and the body — from yellows to reds — against the cold mauvish-gray background, making the figure stand out against the flat surface, bringing it nearer to the onlooker and emphasizing its heavy volume. But while enabling the spectator to see all the movements and directions of the dabs of paint, in other words exposing the painting technique to view, Cézanne at the same time simplifies forms, omits details, and thus creates an image designed to be viewed at a distance. In all probability, the artist was attracted by this model because of his rough, large facial features.

Obviously from the very beginning, Cézanne developed a taste for strongly expressed volume, and his painting *Dish of Peaches* (1860–1864), a copy of part of a composition by a seventeenth-century Dutch still life artist, displayed in the Aix municipal museum, may serve as an example. Cézanne selected that part of the composition which allowed him to single out the rounded volume of the fruit. In addition, he cut off the left edge of the dish, and thus intensified the sensation of unstable equilibrium: the peaches are on the verge of falling from the dish, they are about to go into movement and yet preserve their stability. This picture already contains the core of Cézanne's future approach to still life. This interest in the interaction of immobility and movement is also evident in the *Portrait of the Artist's Father* (1866–1867, private collection, Paris; p.27). By slightly moving the figure in relation to the armchair, and the armchair in relation to the wall, the painter has brought all the elements of the picture into a state of instability which, however, is compensated for by the frontal pose of the figure and the implanting of a large newspaper in the hands of Auguste Cézanne. It was the very same newspaper that carried Zola's articles

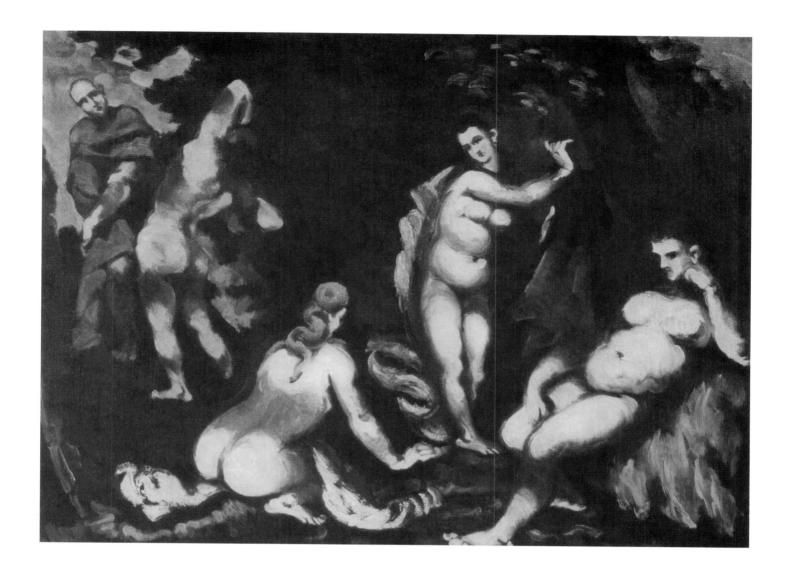

defending the future Impressionists. Cézanne deliberately included the
name of the newspaper in the composition, *L'Événement*. Another important
factor in revealing the conception of this picture was the choice of model
— his own father, head of the family — for in this way the painter showed
his commitment to developments in the contemporary art world. In
another, more complex work, *Overture to "Tannhäuser"* (1866), so called in
tribute to Richard Wagner, Cézanne kept to the same approach of fusing the
family theme with that of contemporary avant-garde art.

The first two versions of this painting have not come down to us,
having evidently been destroyed by the artist. But in the Hermitage
collection there is a generally recognized masterpiece, *Girl at the Piano*
(1868–1869; p.65), which, as Alfred Barr[15] points out, is the third and only
surviving version of *Overture to "Tannhäuser."* Both the title of the work and
the significant role assigned to the artist's sister and mother — the pianist
and the listener — indicate that Cézanne attached great importance to the
inner, conceptual aspect of the image. The idea of fusing the everyday world
with a more elevated one is embodied in the monumental immobility of the
figures, the solemn, concentrated calm of their poses, and the measured
rhythm of the ornamental pattern calling to mind a musical note or a bass
clef as it slowly drifts across the wall and recedes toward the right-hand edge
of the composition. There is the same calm rhythm in the alternation of
white, black, brown, and green. In contrast to the earlier picture *Two Women
and Child in an Interior* (p.63), there is no hint of unreality in *Overture to
"Tannhäuser,"* which shows spontaneously and directly the surrounding world

The Temptation of Saint Anthony,
1873–1877.
Former J. V. Pellerin Collection, Paris.

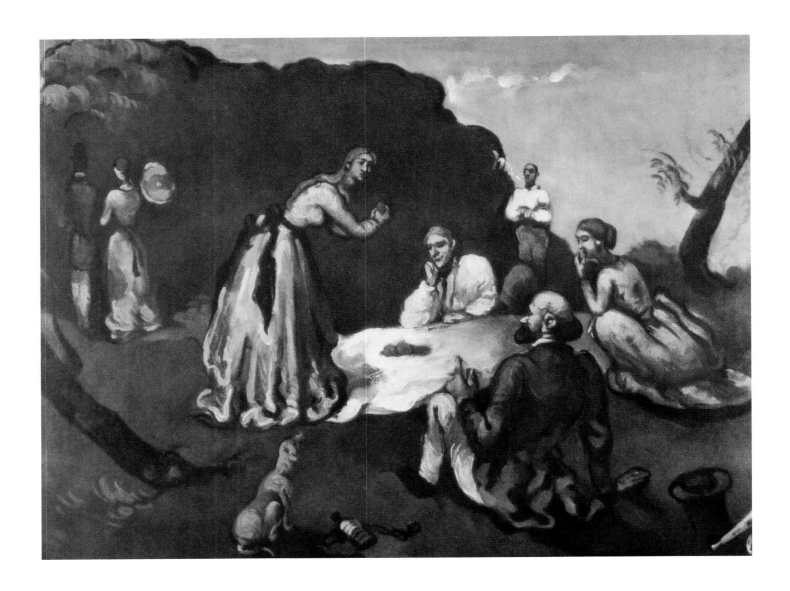

Le Déjeuner sur l'herbe, 1869–1870.
Private Collection, Paris.

and at the same time expresses something greater than everyday life. Here Cézanne has arrived at a very bold and clever solution for the interior composition. Apparently he did not want to lead the viewer into the depths of the room and show anything that might distract attention from the main theme. Therefore he chose a frieze-like format and a frontally constructed scene, arranging all the elements of the composition by way of alternating parallel surfaces. The figures had to be flattened, and the piano, placed at right angles to the surface of the painting, had to be shown in inverse perspective, with the lines of the keyboard and the piano lid converging upon the viewer. In this way, Cézanne singled out the figure of the girl at the piano by adding blue tones to the coloring of the panel, against which her light form stands out in relief, while the dark figure of the mother against the red-brown background recedes into the distance. This impression is enhanced by Cézanne's violation of dimensional proportions: the girl is almost twice as tall as the mother sitting behind her.

The compositional scheme worked out by the artist lends the scene a special austerity, uniting all the elements and introducing a note of solemnity comparable to that found in medieval icons. The actual space of the interior proves too small to accommodate everything the artist wants to put into it. Cézanne breaks down this space and constructs a new one in which we see not only the physical, but also the spiritual life of its occupants, who seem to be living in the fourth dimension — in an endless

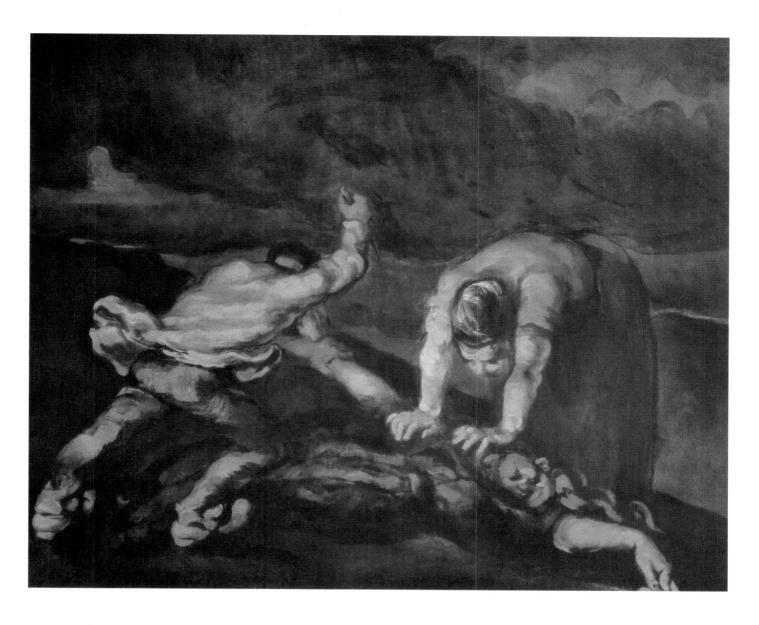

moment of inner contemplation. From the standpoint of ordinary human interrelations, the space shown in this scene strikes us with its extraordinary incongruity; but viewed as the repository of the inner life of the subjects, it acquires a convincing artistic reality.

Looking at this canvas, one is aware of Cézanne's immense influence on twentieth-century artists. We do not know whether Matisse ever saw this work and can only presume that in his treatment of interior scenes he followed in Cézanne's footsteps. For the free reconstruction of traditional spatial forms, the violation of established scales, and a synthesized, simplified drawing, at which Cézanne arrived by dint of strenuous and intensive experimentation, have become a matter of course in twentieth-century art. It should not be forgotten that *Girl at the Piano (Overture to "Tannhäuser")*(p.65) was painted in the 1860s, before Gauguin, van Gogh, and other turn-of-the-century artists had begun their careers. There is no doubt that Cézanne based his composition on a definite picture, and this was probably Édouard Manet's *Madame Manet at the Piano* (Musée d'Orsay, Paris), executed in about 1867, just around the time when, according to his contemporaries, Cézanne visited Manet's studio. Compositional points of similarity consist in the planar cross-section of the interior, the profile turn of the figure, and the relationships of verticals and horizontals in the background. But they are far outweighed by the points of difference. Manet's painting is full of air, and color relations are built up with close

Murder, 1867–1870.
Walker Art Gallery, Liverpool.

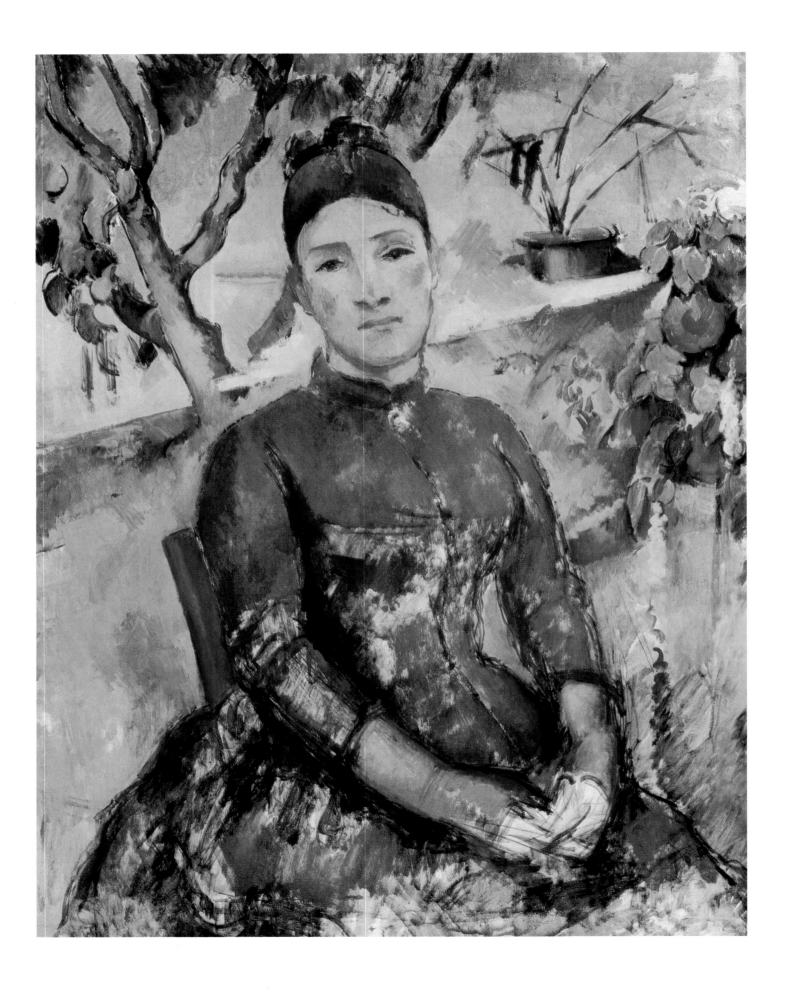

regard for the light-and-air medium. In Cézanne's interior there is no such medium whatsoever. All elements of the composition are harshly defined. This and a number of other features give Cézanne's work its originality, make it unlike anything done before him. But Cézanne fully realized the need of mastering the light-and-air medium and to this end was prepared to forego some of his discoveries. That was one of the reasons why he came close to the Impressionists in the 1870s. His anarchistic revolt against the traditional forms and themes of the art of his time had been carried through, and there began a prolonged period during which he gradually gained mastery over reality and had to forfeit much of his former spontaneous and stormy style of painting.

But this was done deliberately. His latent, inherent sense of the cosmic forces of the world, which broke through in the form of wild, bacchanalian images, had to find "realization," as he said, in systematic and persistent observation of natural phenomena. However, he had not left his old artistic world definitely and forever. That world receded into the deep and hidden recesses of Cézanne's spiritual life to find its supreme manifestation later on.

In 1866, Cézanne wrote to Zola: "But, you know, none of the pictures painted indoors, in the studio, will ever be as good as things done outdoors... I shall have to make up my mind only to do things *en plein air*."[16] Among his early works, however, there are hardly any painted outside his studio. Evidence of his first *sorties* into the outside world is to be seen in his landscapes of the 1860s. Only in 1872 did he set out to work regularly in the open air.

By the beginning of the 1870s, the Impressionists had worked out the main principles of their method of conveying the light-and-air medium, together with a number of technical devices suggested by practical experience of painting *en plein air*. In the unpublished notes of the artist Louis Le Bail, an extract of which is cited by John Rewald in his *History of Impressionism*, there is an account of Pissarro giving advice to young artists in an attempt to lead them along the road of a new art: "Look for the kind of nature that suits your temperament. The motif should be observed more for shape and color than for drawing... In a mass, the greatest difficulty is not to give the contour in detail, but to paint what is within... When painting, make a choice of subject, see what is lying at the right and at the left, and work on everything simultaneously... Use small brushstrokes and try to put down your perceptions immediately. The eye should not be fixed on one point, but should take in everything, while observing the reflections which the colors produce on their surroundings... Observe the aerial perspective well, from the foreground to the horizon, the reflections of the sky, of foliage... Don't proceed according to rules and principles, but paint what you observe and feel..."[17]

It may be assumed that one of those to whom Pissarro gave such advice was Cézanne, when he settled in Pontoise in 1872 and when a close creative association came into being between the two painters, which continued with minor breaks until 1877. This was the only period of tutelage in Cézanne's life, a period in which he was directly affected by an outside influence, and Pissarro was the only painter of that time who exercised such an influence upon him. They worked side by side on the same motifs, and some of their pictures of those years bear traces of mutual influence. Later Pissarro wrote: "At the Cézanne exhibition at the Vollard Gallery there is a striking similarity with my works in certain of the landscapes of Auvers and

Madame Cézanne in the Greenhouse,
1891–1892.
Oil on canvas, 92 x 73 cm.
The Metropolitan Museum of Art,
New York.

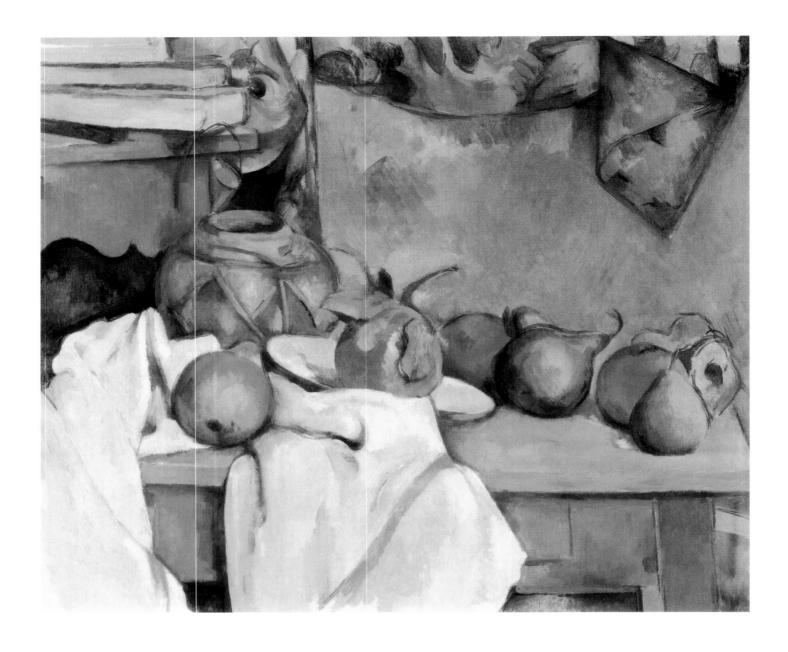

Still Life with a Ginger Pot, 1890–1893.
Oil on canvas, 46 x 55 cm.
Philips Collection, Washington DC.

Pontoise. Of course, we were always together; but it is also true that each of us preserved one valuable thing — his own sensation."[18]

The first result of this association was a lightening of Cézanne's palette. In his canvas *The House of the Hanged Man at Auvers* (1873, Musée d'Orsay, Paris; p.26), the only trace of romanticism was the name, which, however, had no direct connection with its subject matter. While using light Impressionist tones, Cézanne nevertheless applied the paint thickly, making the viewer aware of the roughness of the illuminated wall, the dryness of the sun-scorched earth, and the brittleness of the dead, bare trees. The light interacts with objects without any intermediary of an aerial medium, and in this rarefied atmosphere, which freely allows the passage of the sun's rays, the material, structural basis of the landscape stands out clearly and unfailingly: the cubes of the houses, the hard clods of soil, and the curving surfaces of the spatial planes.

His contact with Pissarro, and through him with the Impressionists, at a time when this trend reached its zenith, was a turning point in Cézanne's work. Pissarro gave him a method whose absence Cézanne acutely felt in his early period. But under Cézanne's brush, this method produced unexpected results, for the strivings of Cézanne and those of Pissarro were in many ways dissimilar.

Pissarro was fascinated by the idea of presenting the colorful picture of the world unfolding before him by the play of sunlight. Like all the Impressionists, he was interested in the possibility of expressing the inimitable and unstable combinations of color reflections created by the chance play of light. The Impressionists developed a special technique of light, swift brushstrokes and trained their eyes to catch momentary color chords. This gave a special freshness to their landscape studies, which they strove, in the 1870s, to complete in a single sitting, without resorting to further touching up in the studio. Cézanne, of course, understood the possibilities latent in this approach to a painting. It accustomed the artist to subtle analytical observation of atmospheric phenomena, to minute study of color relations, to the working out of bright chromatic harmonies and, most importantly, it sharpened and disciplined the eye.

Cézanne willingly listened to Pissarro's advice, especially as this mild and patient man had an exceptional gift as a teacher. But at the beginning of his Auvers period, Cézanne was not equipped to react so speedily to what he perceived. He was accustomed to pondering over a painting. His thick, heavy brushstrokes were not suitable for expressing fleeting atmospheric nuances. In addition, he was not satisfied with such unconditional dependence on the chromatic range provided by nature. He wanted to find a synthetic solution to all of the harmonies offered by nature, and he strove for constructively well-thought-out space in a painting. The following dilemma confronted Cézanne: he had either to accept Impressionism with all its wild play of interacting color reflections and shimmering mist of the light-and-air medium, or he must reject it and, together with it, his new perception of the world, a perception that was, partly under the influence of Impressionism, becoming wider, more profound and more acute. Cézanne wavered: at times he even copied Pissarro's landscapes or attempted, without much success, to follow in Claude Monet's footsteps or to resort to the methods of his early period, enriching them with new coloristic innovations (*A Modern Olympia*, 1872–73, Musée d'Orsay, Paris, p.29; *Afternoon in Naples*, 1872–75, Pellerin collection, Paris, p.155, and others). But even in his most impressionistic works, he could never accept entirely the system of painting in tiny, divided brushstrokes, which enabled Monet and Pissarro to achieve a sense of the continual changes of air and light.

Road at Pontoise (1875–1877, Pushkin Museum of Fine Arts; p.71) is an example of Cézanne's version of Impressionism. Following Pissarro's advice, he regards the motif first of all "from the point of view of form and color," he "does not fix his eye on one point," does not stress the thematically focal point of a composition — all the elements of a landscape are of equal value in his eyes, and he paints them simultaneously, observing at the same time the reflections of colors on everything that surrounds them. He observes that sunshine coming into contact with green treetops and grass, brings forth a wide variety of bluish tinges (from light blue to intense blue), that orange hues appear on the brownish tree trunks, and, pink and mauve reflections on the clay road, etc. However, while in Impressionist paintings these reflections create shifting surfaces and produce the effect of a fleeting glance, which takes in a totality of forms by peripheral vision, for Cézanne, they are one of the form-shaping elements of an object — they interact within the basic local color (the houses, hills, and trees on the left and right), merge into great masses so that under the weight of their material volumes the surface of the ground seems to bend and sag, forming the wavy lines of the spatial planes of the landscape.

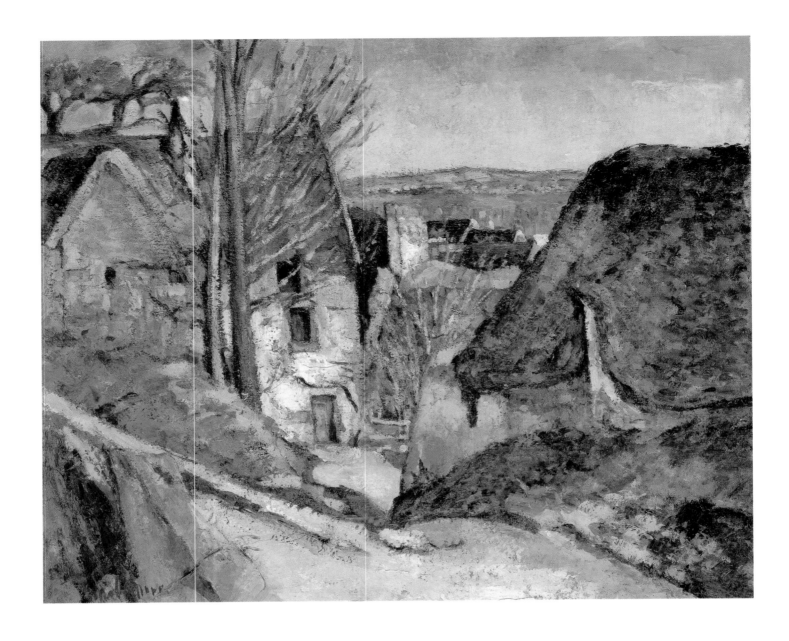

The House of the Hanged Man at Auvers,
1873.
Musée d'Orsay, Paris.

The main problem which Cézanne tackled during this period, whether in landscape, portrait, or still life, was how to achieve the wealth of color reflections revealed by light, while preserving a sense of the material mass and form of objects. Two of his paintings in the Hermitage demonstrate his searchings along these lines, notably *Flowers in a Blue Vase* (p.67) and *Self-Portrait in a Casquette* (p.69) (both done between 1873 and 1875). In his *Flowers in a Blue Vase*, Cézanne brings out the form of the objects by his control of the brush. The brushstrokes curve gently to model dahlia petals; sharp and abrupt, they vibrate and bristle in the leaves; hardly distinguishable one from another on the shadowed parts of the glazed pot, they are applied in a whitish tangle onto the illuminated areas, producing the effect of the convex surface of the vase. And all this together merges into a single pictorial volume.

For Cézanne the bouquet is a combination of separate flowers, stems, and leaves. It is first of all a pictorial form, as strict and definite as the very vessel in which it is held. In *Self-Portrait in a Casquette*, the face, the clothes, and the cap are treated as a solid color mass of the same texture throughout. Brushstrokes that are close in tone fuse together to form a single reddish-brown surface on which the green reflections (graduating to bluish violet and blue) create the sensation of natural hollows and recesses filled in with shadow. Cézanne utilizes light reflections to model the mass of color, unlike

the Impressionists, who brought out the interaction between the surface of the object and the light-and-air medium. The difference between Cézanne's and Pissarro's methods was inelegantly but precisely defined by a peasant who watched both artists at work: "Monsieur Pissarro, when he is working, pokes, Monsieur Cézanne dabs."

In his *Road at Pontoise* (p.71) and *Self-Portrait in a Casquette* (p.69), Cézanne was evidently a long way from implementing all that he sensed with his eyes. Space here is not yet pervaded with the elements of air and light that imparted so lively a palpitation to the landscapes of the Impressionists. On the other hand, though, one senses in these canvases an urge to comprehend the material structure of the visible world, to reveal not so much its outward form as its solid mass and volume.

The period of Cézanne's closest links with the Impressionists is in the 1870s; he exhibited with them in 1874 and in 1877. However, by the end of the decade, the artist began to feel sharply the incompatibility of his understanding of a painting with some aspects of the Impressionist method. "I keep on working, but with little success, and it's all too far removed from the general trend…"[19] (i.e. from Impressionism), he wrote in 1878. Cézanne gradually moves away from Impressionism, though continuing to be on friendly terms with Monet and Pissarro, even going so far as to work together with Renoir in the 1880s, but this time on a new basis.

Thus, at the end of the 1870s, now almost forty, Cézanne once again finds himself at a crossroads. The Impressionist method he assimilated comes into conflict with his fundamental world view. To achieve an equilibrium between surface and volume, form and mass and structure, the inner and the outer, the physical and the spiritual, and, in the final analysis, between the semblance and the essence of the motif depicted, another, new method was called for, though many years of strenuous toil were needed to create one. And the painter sets out on a new quest. Strictly speaking, Cézanne's work falls into two main stages: before 1873 and afterwards, when the artist started to paint from life and began to master reality, a process which went on day by day until his death. This is why there is no distinct border dividing his Impressionist period from the next one (just as there is no border between his later periods). At the time when Cézanne was coming close to Impressionism many of the features subsequently observed in his œuvre were in the process of formation. On the other hand, Cézanne made use of the achievements of Impressionism, although transforming them into something quite different. The keen interest he developed in nature under the influence of this trend became the basis upon which he built the new strata of his artistic system that he attempted to reinforce not only by practical work but by his theory.

Cézanne himself formulated his understanding of theory as "*tout est en art surtout théorie, développée et appliquée au contact de la nature.*"[20] In other words, for him theory was what Émile Bernard called "thinking with brush in hand" about methods of recreating reality. For us, Cézanne's theory can be revealed only by contact with the practical application of such thinking, that is, with the totality of his work.

Cézanne's theory arises above all from his constant efforts to get closer to nature, which for him was a far cry from the slavish copying of an object. However, a specific feature underlying his theory was that it absolutely ruled out a banal assertion of the artist's right to a free interpretation of nature. In his letters to friends and acquaintances, he often repeated the thought "that painting is a means of expressing one's sensations."[21] One of his

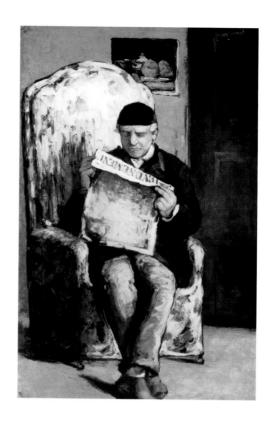

Portrait of the Artist's Father, 1866–1867. Museum of Art, Saint-Louis.

statements, which has come to us in the rendering of Joachim Gasquet, gives an approximate idea of what he meant by the words "my sensations": "I want to embrace it [reality] as a whole. Otherwise I would have done in my own way what I reproach the fine arts for: I would have kept my preconceived type in mind and reproduced truth from it, whereas I want to reproduce truth from reality."[22] Cézanne's theory thus took shape in the process of a careful study of nature, the interaction of color reflections, the formation of volumes, the way spatial planes recede into the distance or come nearer, etc. And behind these visual observations was intense work of the mind, constant thought about the logical laws of existence, the perception of nature as a single, virtually living organism in which everything is interlinked, exercising a mutual influence, where in each fragment of reality there is affinity with the whole. Cézanne did not agree with anything less than portraying nature in accordance with truth and "embracing it as a whole." And if perhaps he too often recognized the impossibility of attaining the unattainable, he did not want to reconcile himself to that and could not bring himself to do so.

Such a superhuman task was by no means the eccentricity of genius and was not merely Cézanne's personal reaction to the crisis in contemporary art when the Renaissance conceptions of pictorial space as

The Eternal Female, c. 1877.
Oil on canvas, 43 x 53 cm.
Private Collection, New York.

28

the system devised for the construction of depth were being severely shaken. Thanks to visual perspective, the viewer sees the picture as an extension of his own reality, as a window into the world and himself as the point of reference of this spatial and temporal continuity. Such a principle of constructing space could only arise in a period when the contradictions between what people saw and what actually existed had not yet entered their catastrophic phase. Being based on the conviction that the reality of art and the reality of life amounted to the same thing, this principle prevailed until the middle of the nineteenth century. It was this confined space, this space of a scenic box, that the romantics were trying to break away from. They made a number of valuable discoveries in this sphere, above all Daumier and Delacroix, but were unable to reorganize space partly because the romantic rebellion went no further than regret for the Golden Age of art and partly because a revolution in spatial concepts required the efforts of several generations of painters. A very important role in resolving this problem was played by Impressionism, which emerged during the flowering of positivist thinking. Relying on the idea of simply and directly reflecting what was taking place in nature before the artist's eyes, the Impressionists arrived at a new understanding of space as being filled with myriads of particles of color which unfold the visible world not only in depth but also

A Modern Olympia, c. 1873.
Musée d'Orsay, Paris.

29

upward, downward, and sideways. These color particles evoke color reflections, create complex color combinations, draw into their orbit the whole visible world, and give it an unusual brilliance. The Impressionists presented an open space, not limited by any screen or theatrical framework, to intensify the illusion of depth. They also showed that the artist's eye is not the ordinary eye which serves man in his practical life. However, being too strongly attached to the object portrayed, they did not visualize the world they were painting as an integral, all-embracing phenomenon. Here the acceptance of positivist thought had its effect. This limitation of the Impressionists was felt by the artists who came after them. Van Gogh, like Gauguin and other painters of the end of the century, succeeded in breaking out of this dependence on objects. They refused to paint outdoors and constructed their compositions on the basis of their own ideas of synthetic art. In contrast, Cézanne never rejected the "motif," as he used to say, and to the very end continued to paint *en plein air*. But as he worked amidst nature, he "thought with brush in hand." In agonizing doubt, prompted by an inner demand for that synthesis he saw in nature, he was to construct and reconstruct his canvases in the attempt to show an overall picture of creation, to reveal its essence, its objective existence, independently of man's perception.

At a certain stage, Cézanne's idea of embracing reality as a whole confronted him with the need to tackle the practical task of maintaining the achievements of the Impressionists, above all in the spatial treatment of light and air, without losing the wealth of objects and colors of reality. Although in the late 1870s, Cézanne and the Impressionists parted company, this did not imply an ideological rupture: their aims and tasks continued to coincide in more than one respect.

Like the Impressionists, Cézanne made an increasingly keen study of nature, yet the process of working on a painting became increasingly prolonged and agonizing for him, since he was trying not only to bring his own sensations and instincts to life by contact with nature, but to correct constantly his visual perception in accordance with his own philosophy. He was also endeavoring to find and to work out a logical basis for a system of technical means and to make rational use of them in order to give fitting expression to his view of nature — to absorb what is before your eyes and to attempt to elucidate it in the most logical manner possible. Cézanne's method was formed as a result of this complicated process of interaction between painter and nature.

In his works of the late 1870s, we already see a tendency toward a logical consistency of pictorial means. This becomes especially clear if we compare two self-portraits: one painted in the Impressionist period (1873–1875, Hermitage; p.69) and the other executed between 1879 and 1885 (Pushkin Museum of Fine Arts; p.79). In the Hermitage canvas, Cézanne still makes a substantially intuitive use of the law of optical perception, according to which warm tones (pinks and yellows) seem to stand out, to come nearer to us, and cold ones (blues and greens) recede into the depths. In modeling mass, he proceeds from warm to cold tones: from the bright red, burning color of the lips, through orange hues to olive, green, and deep violet tones. Cézanne is not worried that, for example, a red brushstroke on the lips is placed inaccurately, that it lends a certain asymmetry to the face, which is not characteristic of the model. Far more important to him is that the red patch of color seems to give a point of reference for the volume of the head: coming forward, it creates the illusion

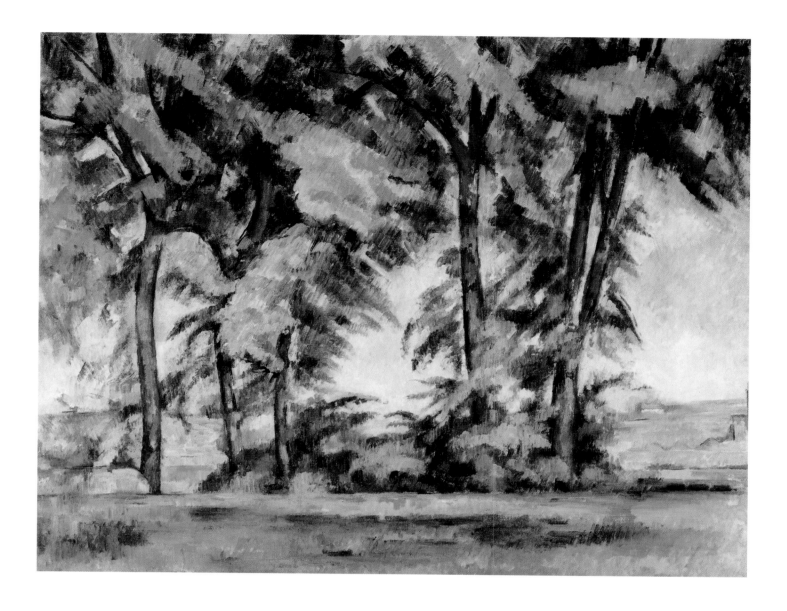

of being the most prominent area of the given surface, from which the form begins to get unevenly rounded, deepening in the cold tones of the face's hollows, or coming nearer in highlighted areas, but consistently receding into the depths at the periphery of the color mass (this method, with less differentiation, was also applied in his earlier works, for example in *Uncle Dominic as a Monk,* p.34).

In the Moscow *Self-Portrait,* these advancing and receding tones are kept under strict, rational control by the artist. His way of working on form begins to be reminiscent of the methods of an architect building a cupola or erecting a vault, only Cézanne's material consists of a wide chromatic range of paints — from cold to warm. The nearer to the periphery, the thicker their layer, the more intensive their dark cold hues. The nearer to the center, the more warm yellowish tones gradually changing to yellow, orange, and pink colors, begin to show through them. These dabs of paint are not perceived here as color reflections shifting over the surface of the object; they are transformed into certain spatial microplanes used by Cézanne to indicate the extension of form from the surface of the canvas into the depths of the picture.

By this method, the artist achieves an almost stereoscopic effect: the left-hand side of the face seems to be illuminated and is therefore approaching us while the right-hand side is plunged in shade, receding from us, giving the effect of a turning head. As a result, the form takes on a third

The Great Trees in Jas de Bouffan,
1885–1887.
Oil on canvas, 64.7 x 79.5 cm.
Courtauld Institute Galleries, London.

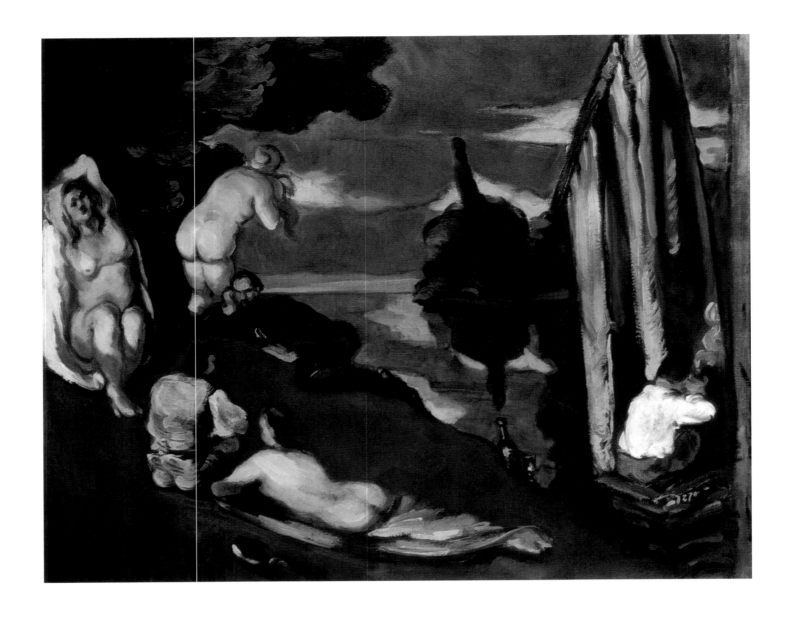

dimension before our very eyes, demonstrating the unimpeachable logic of its construction. This, however, is not the only method Cézanne uses to represent volume. He also employs the interaction of illuminated and shadowed parts of the painting. The upper left-hand corner of the background, adjacent to the best-lit part of the head, is painted in the most dense layer of color and is like part of a solid wall in its density, while the darkest part of the face is bordered by space from whose depth emanates a gentle, twinkling light. The light flooding the left-hand side of the face seems, by some strange means, to bypass the background adjoining it, gliding over it into the depths and illuminating the shimmering reflection from there. Because of this simple method, the lit part of the volume stands out even more prominently and the darkened area creates a sensation of a smooth rounding of form. The combination of lit volume and darkened plane produces a tangible effect of their physical contact. The man in this portrait seems to be trying to overcome some force — which turns his head in the same direction as his body, that is from left to right, from the solid substance to the hazily shimmering depths — and becomes frozen in a dynamic and intense equilibrium. The inner intensity of the image is revealed here exclusively by plasticity of form, which seems to bear the imprint of the volitional impulses of Cézanne's creative process — his persistent intellectual and physical efforts to conquer the resistance of the inertia of matter and erect on the canvas an optical illusion of volume.

Pastoral, c. 1870.
Musée d'Orsay, Paris.

At the risk of indulging in paradox, one might call this *Self-Portrait* a self-portrait of Cézanne's creative process. Although the Moscow picture is less colorful than the Hermitage one, it excels the latter in the significance and inner intensity of the image. One can hardly apply the traditional point of view to Cézanne's portraits, which are often compared to still lifes. In this case, Cézanne undoubtedly strove to express what he thought to be the most essential thing: an intensity of will and the *pathos* of creatively mastering the material which comprise a kind of "plastic psychology" in the Moscow portrait. While the apple and the head are treated above all as a volume, the artist invests the plasticity of these volumes, both in portraits and still lifes, with a special dramatic intensity which is difficult to convey in the language of psychological categories but which is undoubtedly related to it.

Perhaps there is no other European artist of the past two centuries in whose work still life has occupied so honored a place. This is quite understandable: Cézanne took up this genre as a result of his heightened interest in plastic form. In the 1880s, he produced numerous variations depicting fruit, crockery, vases, and tablecloths, that is everything that was stable and unchanging that could be painted carefully for a long time. He studied the form of all objects, the relations between them, their existence in their own right and in space. The still life *Fruit* (c. 1879–1880, Hermitage; p.73) is one of a long series of still lifes of this kind.

Here we find the same devices as seen in the Moscow *Self-Portrait*: Cézanne builds up the forms of the objects with the aid of warm, advancing tones and cold, receding color planes. As firm as billiard balls, the orange-colored fruit press down upon the surface of the table with all their perceptible weight, the yellow lemon acquires three dimensions in the greenish shadows at the edges, and the bluish color of the faience bowl shines with a lustrous gleam. Each brushstroke of a warm or cold hue, helping to build up the volume of the object concerned, brings out the degree of illumination of that part of the canvas on which it is laid. Therefore, for example, the fruit, which include many warm tones in their natural colors, seems in Cézanne's still lifes to be brightly illuminated and the blue metal and greenish glass merely gleam slightly in the shadow. In this way, light ceases to be something external to the object. The gleaming fruit do not lose their colorfulness in the darkened part of the picture. The objects seem somehow to be clots of materialized color. In some places, they burn from within and their inner fire bursts through to the surface in hot patches of red and orange: in others, they scintillate with bluish glints, or become frozen in their dull blackness. With Cézanne, light becomes a quality of the object's natural color.

It is probably here, above all, that Cézanne makes his break with the painting of the Impressionists, with whom light reflections were transformed into complex fluctuations of warm and cold tones, and the object became the bearer of these color fluctuations. The more complex the interaction of color reflections, the more strongly they dissolved form; the more intensively the color contrasts resounded, the duller and weaker the local tones of the object. For Cézanne, color relations became an immanent quality of form: the more radiant the tone of an object, the more tangible its volume and the fiercer its local coloring.

Consolidating and deepening his discoveries in color and form, Cézanne succeeds in coupling the color and plastic elements of the picture and even reveals their interaction. At the end of the 1870s, he makes his first steps in this direction.

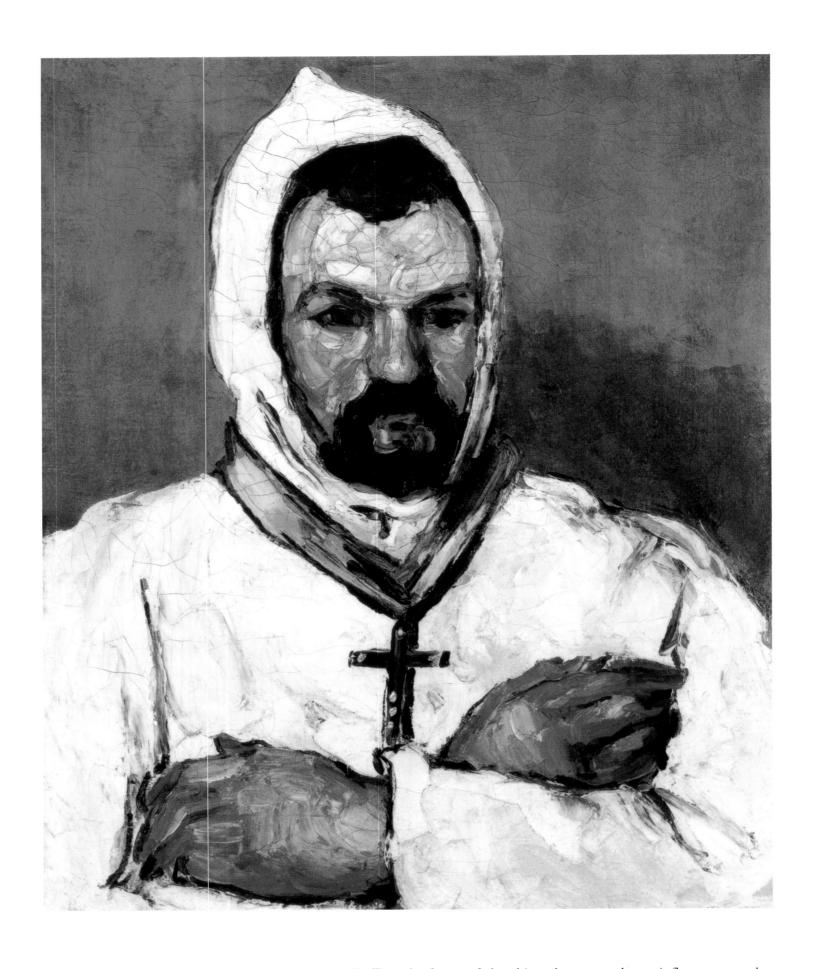

Uncle Dominic as a Monk, c. 1865.
Collection Mr. and Mrs. Ira Haupt,
New York.

In *Fruit*, the forms of the objects have scarcely any influence on each other; they are set against one another in conforming with to the principle of the contrast of hard and soft, the flat and the three-dimensional; local color is limited to the form of each object and does not create reflections around it. At the center of this composition, Cézanne places a tablecloth

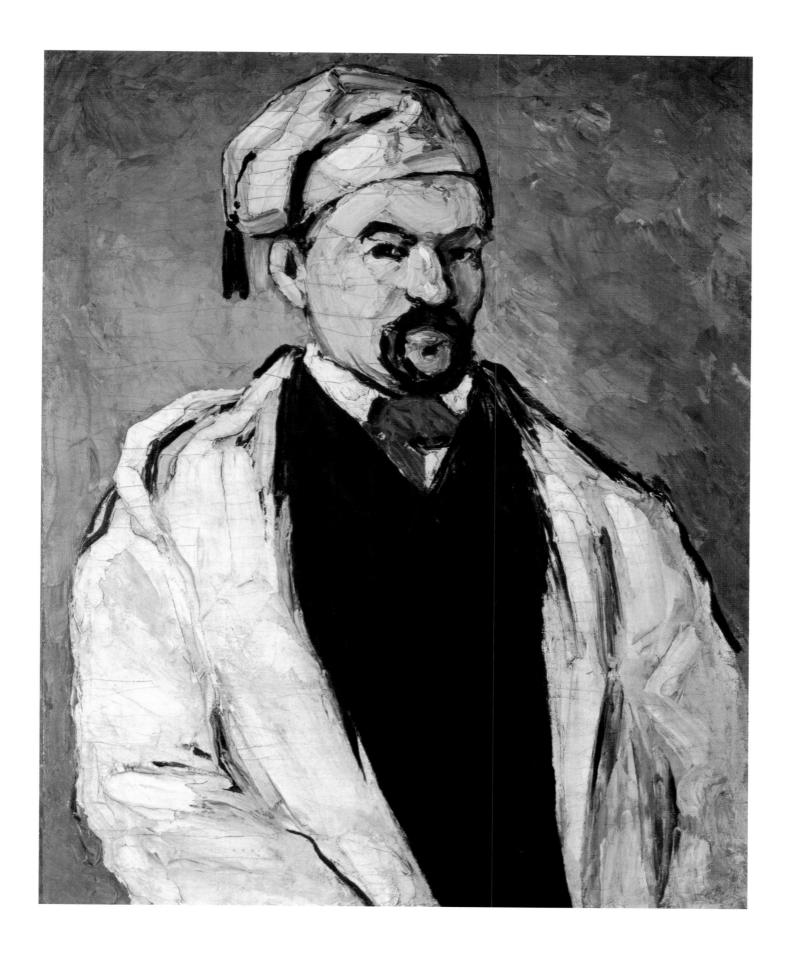

whose soft, amorphous mass does not link the surrounding objects into a single whole but, on the contrary, emphasizes the autonomous existence of each object in pictorial space. They display a separateness, an independence of their plastic essence, rather than any uniting quality. Subsequently, Cézanne's development proceeds in three main directions: revealing the rich

Man in a Cotton Hat (Uncle Dominic),
1865.
Oil on canvas, 79.7 x 64.1 cm.
The Museum of Modern Art, New York.

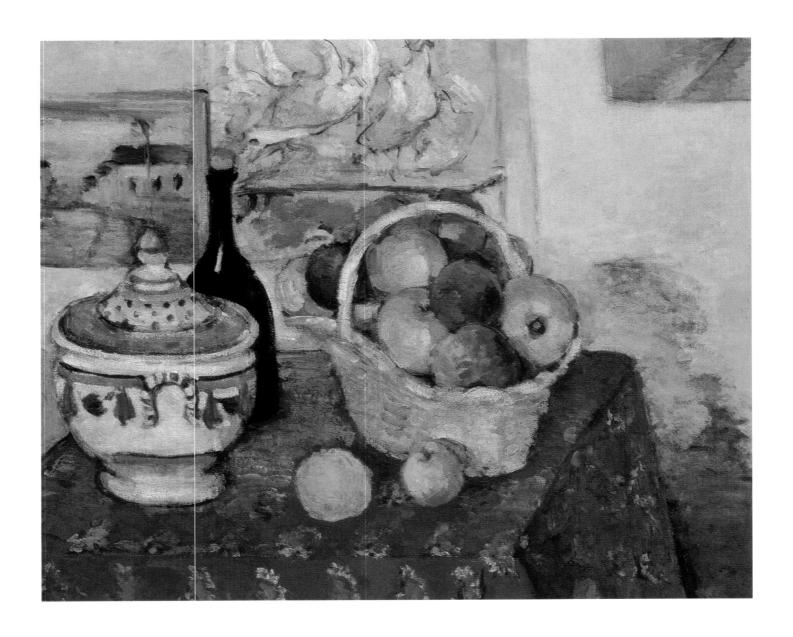

Still Life with a Soup Tureen, c. 1877.
Musée d'Orsay, Paris.

color relations between objects, the relations between their forms and volumes, and those between objects and the space in which they exist. Two still lifes housed in Russian collections, *Peaches and Pears* (1888–1890, Pushkin Museum of Fine Arts; p.117) and *Still Life with Curtain* (1898–1899, Hermitage; p.129), completed ten years later, illustrate the stages of his development.

In comparison with *Fruit*, where the contrast between dark and light still plays a rather significant role, in *Peaches and Pears* light has not only ceased to exist as an external source, it has been transformed into the objects' natural color. However, it is not confined within the bounds of form, but becomes an inseparable element of pictorial space by virtue of its reflections. The dark table surface absorbs both the reddish tones of the fruit and the deep blue of the pottery, while the white tablecloth collects the color reflections of everything that is in any way in contact with it. But the forms of the objects are not dependent upon light; they reveal constant, eternally inherent characteristics. Here we find neither the soft surface of the peaches nor the fragrant juiciness of the pear, nor the folds carefully pressed into the tablecloth by the iron — something that gives seventeenth-century Dutch paintings their charm. Cézanne's still lifes are not associated with man's life and are independent of consumer values. They demonstrate qualities of volume and form, bringing out the fundamental properties of

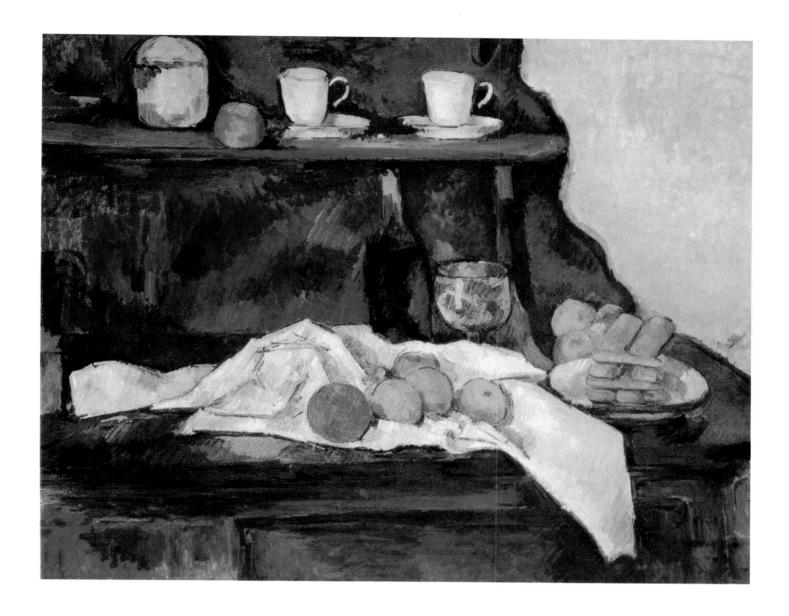

matter — weight, length, mass, sometimes compressed and hard, sometimes loose and soft. The artist's eye roves from one object to the next, attentively studying their material structure; on the flat tabletop they represent a kind of extract, the quintessence of their physical properties. These diverse forms do not contrast sharply with one another but harmonize in a surprising fashion; the spheric shape of the peaches merges into the circle of the plate, whose round surface mutes the contrast between them and the plane of the table; the undulating lines of the tablecloth repeat the outlines of the pears.

Diversity of color and form is ruled by a strict order, is reduced to a common denominator and merges into a single whole, as if some universal matter, becoming transformed by way of hundreds of nuances, shades, modulations, and intermediate stages, has adopted a definitive aspect.

In handling pictorial space, Cézanne does not reject the principles of classical composition based on singling out the central point and arranging the parts in an equilibrium bordering on symmetry. He merely makes these principles more complex, transforms them. He counts depth from the front edge of the table, parallel to the plane of the picture, while, in the background, space is bounded by the dark diagonal strip of the plinth, which also serves to link two vertical forms — the jug and the legs of the

The Buffet, 1873–1877.
Oil on canvas, 65 x 81 cm.
Szépmüvészeti Muzeum, Budapest.

table. The entire, basic rhythm of the composition rests upon the crossing of diagonals running to the center (marked by the dish of fruit, around which the remaining fruit and objects are grouped), uniting in one place into triangles, in another into a semicircle, and in yet another at a right angle. This drive toward the center is echoed in the disposition of the tablecloth and the movements of its folds and also in the direction of the pink stripes of its pattern. The strict order and the complex equilibrium so typical of Cézanne's constructivist period, a period that came to an end in about 1890, reign in this painting. One gets quite a different impression from *Still Life with Curtain* (p.129) kept at the Hermitage. The dishes of fruit are pushed to the side, the fruit hang onto the sloping surface by a miracle governed by the laws of pictorial gravity, obviously in contrast to Newton's. They occupy a large part of the table's surface, seemingly leaving no room for real depth. All the same, they are three-dimensional, demonstrating their full-blooded volumes independently of their position, in the foreground or in the depths of the picture, affirming their absolute stability, their unshakable place in space.

Here we see none of the contraposition of objects to their place in space, which is characteristic of classical painting. The objects are not so much disposed in space as they construct it themselves. They indicate its extent just as the brushstrokes mark off their spatial volume and, therefore, weld them firmly to space, making them of the same "colorful pulpy mass." Here space becomes a function of volume, volume a function of color, color is built upon a complex interrelationship of cold and warm, and brushstrokes resemble the cells of some universal matter. It is by these cells that Cézanne constructs a fabulously rich world, radiant with local colors, enticing the viewer's gaze by contrasting forms that seem to be developing before our very eyes in the swelling volumes of fruit and the undulating folds of material, breaking in collision one with another. These are some features of Cézanne's still lifes, one of his basic genres.

The still life, in which the artist could freely arrange objects, was for him a kind of laboratory. There in he worked out the laws of pictorial space, always relying on visual perception and finding endlessly diversified yet heavy and solemn rhythms. Thus he realized the idea of constructing a painting as an integral whole. Nikolai Punin, a well-known art connoisseur, aptly and precisely characterized Cézanne's constant concern for the organization of indivisible pictorial space, when he said: "Take a still life by a seventeenth-century Dutch master and try in your mind's eye to remove from it any of the objects — a lemon, a dish or a tablecloth — and this object will immediately appear to be in your hands. But if you attempt to remove from a Cézanne still life just one peach, then it will drag the entire painting with it." There is no better way to explain the integral nature of Cézanne's pictorial space. But how can such integrity in landscape be achieved when the painter, working in the open air, is dependent upon a given space?

Cézanne must have constantly confronted this problem. Its complexity was aggravated by the fact that the artist, relying on the visual authenticity of his perception, also tried to express the all-encompassing, synthetic picture of nature that would accord with his keen sense of the world's great cosmic forces. Cézanne's words *refaire Poussin sur la nature* (do Poussin again, from nature) concisely define one of the most fundamental problems of his art. Despite his frequent complaints of insufficient realization of his sensations, Cézanne worked stubbornly to achieve his aims. He had to isolate himself from all outside influences and plunge wholeheartedly into

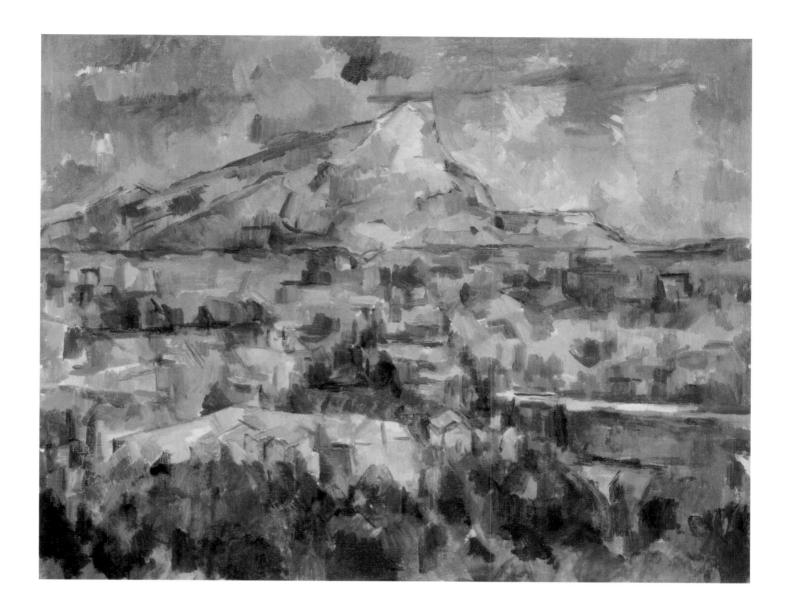

titanic labor. "One is neither too scrupulous nor too sincere nor too submissive to nature; but one is more or less master of one's model and, above all, of the means of expression. Get to the heart of what is before you and continue to express yourself as logically as possible."[23] This simple truth expounded by Cézanne was one he scrupulously followed.

Landscape always occupied a prominent place in Cézanne's work. He was drawn to this genre as far back as his romantic period in the 1860s. What attracted him then to nature was either the originality of an unusual motif or the picturesque character of a landscape. True, even then, following in Courbet's footsteps, he tried to transfer powerful, massive forms onto the canvas. However, the work of those years in no way revealed him as the master of composition he later proved to be. It was only between 1870 and 1871, during his pre-Impressionist period, when for the first time he turned to the images of L'Estaque and Mont Sainte-Victoire in Aix, that the first signs of a new orientation appeared in his landscapes. A particularly important transition in his evolution as a landscape artist is exemplified by two paintings of 1870, *Melting Snow at L'Estaque* (Wildenstein Collection, New York; p.40) and *Trench at the Foot of Mont Sainte-Victoire* (Neue Pinakothek, Munich; p.42), in which two types of Cézanne's landscape compositions can be discerned — the "baroque," with a dynamic diagonal structure (*Melting Snow at L'Estaque*), and the classical, with an alternation of

Mont Sainte-Victoire, View from Lauves,
1902–1904.
Oil on canvas, 69.8 x 89.5 cm.
Philadelphia Museum of Art, Philadelphia.

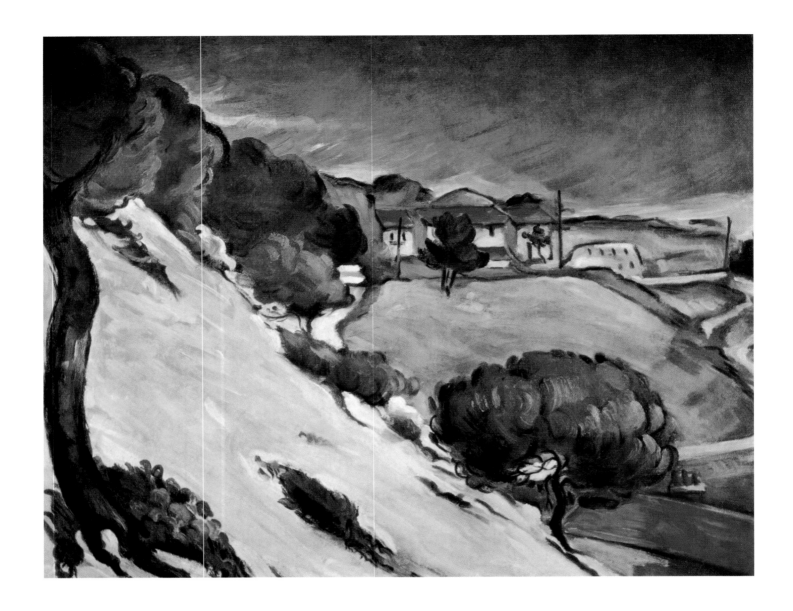

canvas-wide parallel color zones (*Trench at the Foot of Mont Sainte-Victoire*). These two canvases are, of course, merely early experiments; they lack observation of nature and there is no aerial medium whatsoever. But here one can already see Cézanne's grasp of great spaces and his synthetic image of nature. During his Impressionist period, Cézanne developed his perception of space and trained his eye. Finally, in 1880, when Cézanne was at his peak, he produced numerous landscape compositions in which he brought his visual experience into accord with the logical system of constructing a painting. This period is well represented in Russian museums.

Plain by Mont Sainte-Victoire (1882–1885, Pushkin Museum of Fine Arts; p.85) has some compositional similarity with the *Trench*. But how far the artist has departed from the former image, how complicated space has become in this, at first glance elementary, compositional scheme. Whereas in the early landscape the dark patch of the trench, cutting across the mountain path, creates an obstacle and catches the viewer's eye, there are no artificial barriers at all in the later work. As in the *Trench*, the mountain retracts into the distance, but now it dominates the space of both sky and earth. The artist leads the viewer's eye to the mountain by means of parallel color zones that imperceptibly taper off into radii. The trees and the green of the valley are subordinated to the slow rhythm of ascent. The planes rise

Melting Snow at L'Estaque, c. 1870.
Wildenstein Collection, New York.

higher and higher in places receding into the distance and in others coming closer, like the movement of sea waves. This rhythmic crescendo creates the internal dynamics of the Moscow canvas, leaving at the same time a clear impression of the mountain receding endlessly into the distance however much one moves forward.

At first glance, it seems that the compositional scheme of this canvas is based on the traditional recipe for a classical landscape. However, the method of alternating parallel color zones is quite different here. Some color areas come forward while others recede according to what color in the contrasting combination holds one's attention and to what color is correspondingly perceived by peripheral vision. Because of this, they do not follow one another but constantly change places, which imparts a lively mobility to space. The compositional scheme of *Trees in a Park* (1885–1887, Pushkin Museum of Fine Arts; p.96) also has an affinity with the traditional. Nineteenth-century artists often turned to the so-called *sous-bois* composition, conveying a sense of depth through a barrier of trees. Cézanne himself often resorted to such schemes, for example in his Moscow picture *Road at Pontoise* (p.71). In *Trees in a Park*, the trees predominate, absorbing into their orbit everything around. To a certain extent this disguises Cézanne's unconventional understanding of depth. But if one looks carefully at the way the space of the earth, the carpet of grass, and the buildings unfold from the lower edge of the picture to the top, it becomes clear that the artist is breaking down the normal conception of perspective foreshortenings. The surface of the earth is built up here, as in *Plain by Mont Sainte-Victoire* (p.85), by an alternation of parallel color planes.

However, the sharp edge at the junction of the yellowish-brown and green contrasting surfaces produces an impression not of their smooth transition, but of a connection at an angle, as a result of which the zone in the foreground looks as if it is sloping, and the adjacent one as if receding into the depths of the picture. In the same manner, Cézanne reorganizes relations between all objects, violating scale, creating the effect of depth and immediately breaking it down by plunging into inverse perspective. Therefore, objects in the background seem remote and near, and the space of the earth both flat and deep. This rearrangement of perspective and spatial organization in a picture is linked to the necessity of endowing all the elements of a composition with a unified rhythm, which, in large measure, is determined by the artist's manner of applying the brush. In places dense and thick, in others rarefied and transparent to the point of allowing the primer to show through, his brushstrokes make the color masses oscillate and create a mobile painted surface. This is particularly well perceptible in the rendition of the chestnut leaves.

From one landscape to another, Cézanne experimented in object and spatial relations. In his *Aqueduct* (1885–1887, Pushkin Museum of Fine Arts; p.95), the narrow space of the foreground consists of large green and orange patches, and a row of pines with their boughs raised to the sky is aligned immediately beyond it. Through their thin paling one sees in the distance the spans of the aqueduct, the valley, the Mont Sainte-Victoire massif, and further hills. But Cézanne eliminates the material differences between spatial planes. The whirling green brushstrokes model the resilient crowns of the trees while in the center of the canvas, where the pines cut across the line of the hill on the horizon, these strokes, without losing their specific texture, absorb the bluish-violet tones of the mountain separated from the trees by an immense distance, as if shreds of thickened space, filled with air, were

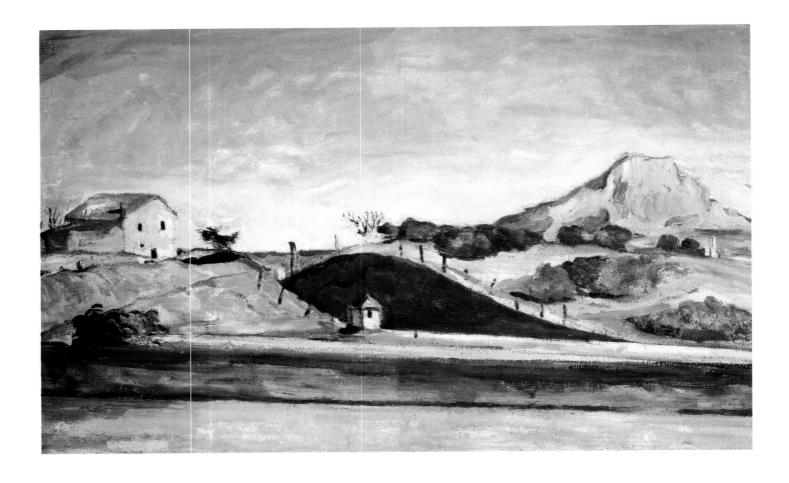

caught between the spreading branches and could not disengage themselves. All the elements of the landscape are firmly welded together and create a unified space, for, as in Cézanne's still lifes, they are made from the same "colorful pulpy mass." They seem to be simultaneously at diverse points and space is flattened between various planes which gravitate to one another, acquiring a specific Cézannesque tension.

It was in landscapes of this type that the essential aspects of Cézanne's artistic system were realized. He shifts planes, intermingles the far and the near, yet preserves a distinct sense of the three-dimensionality of space receding into the depths. In fact, he eliminates the foreground linking the space of the picture with the space of the viewer, at times unfolding it along an inclined surface (*Trees in a Park*, p.96), at others transforming it into a jumble of approaching and receding microplanes (*The Aqueduct*, p.95). In this way, and this perhaps is the most important feature, Cézanne consistently avoids indicating the precise place from which he looks at the surrounding environment. It is virtually impossible to define the vantage point from which Cézanne's landscapes were viewed and painted (and from which he makes the spectator look at his landscapes).

At one moment the artist draws near to the most distant objects, at others he moves away from them, looks at them from above, and from *en face*. To use an expression of Charles de Tolnay, he transforms himself into "an organ of world sight," whose whereabouts are not recorded anywhere, and seems to be diffused throughout space as a whole. Thus, for example, in his *Bay of Marseilles from L'Estaque* (1878–1879, Musée d'Orsay, Paris; p.43), the artist depicts the bay from a great height, whether from the cabin of a plane coming in to land (an impossibility in Cézanne's time) or from a high mountain, and there open, up before him, with almost identical clarity both

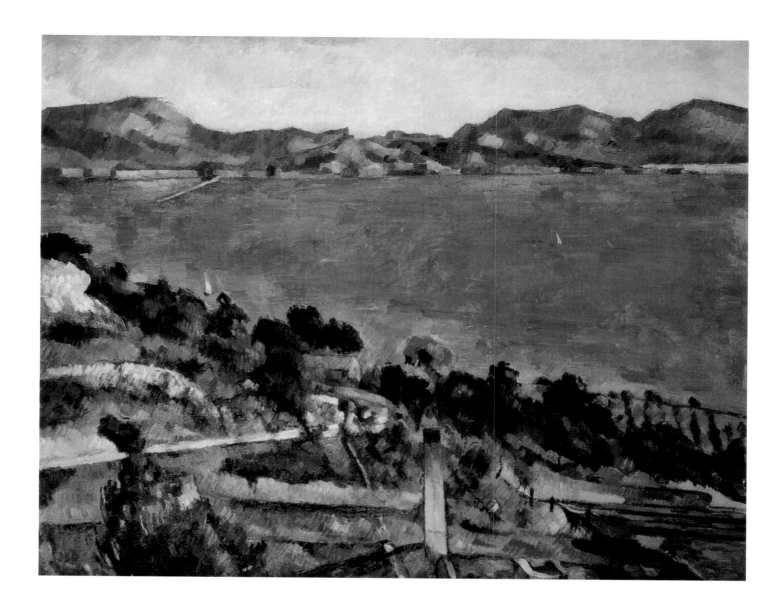

the foreground shore descending to the bay and the mountains on the opposite side that are dozens of kilometres away.

However, the principles of interrupting spatial surfaces, mingling the near and the far and, shifting vantage points were by no means based on speculative, *a priori* ideas, but rather they originated from the experience of observation. The artist took into account the perception of the human eye and the way in which it constantly changes its orientation — something quite opposite to a camera lens that takes into focus only one single fragment. These principles were in conflict with the traditional understanding of space, undermined its basis, and found their most articulate expression in Cézanne's work of the 1880s, during his Post-Impressionist period, when two lines of his development came together — his unrestrained freedom in the choice of compositional schemes, which was inherent in his art of the romantic years, and his experience of visual observation, accumulated during his Impressionist period.

Of course, Cézanne himself, being closely linked with the classical tradition of European painting, was in no way deliberately aiming to overthrow it. His experiments with spatial relations came from his constant unconscious striving to faithfully copy nature, to embrace it as a whole; for him this meant revealing behind the chaos of visual impressions a certain hidden order and on this basis recreating not an illusion of reality but the very harmony of nature on canvas. The harmony

Bay of Marseilles from L'Estaque,
1878–1879.
Musée d'Orsay, Paris.

of nature and the illusion of reality were in many respects contradictory concepts for him.

To attain the harmony of the whole, to overcome the illusoriness of a separate fragment of nature, Cézanne needed to establish equilibrium between two poles — between the spatial model of the world and the canvas's plane, on which it was to be unfolded. He did not always succeed in this, but in his best works of the late 1880s he came close to achieving such an equilibrium. Two of his paintings, both dated 1888, *The Banks of the Marne* (*Villa on the Bank of a River*) (Hermitage; p.99) and *The Banks of the Marne* (Pushkin Museum of Fine Arts; p.101) show the means used by the artist to solve the problem. When working on these paintings Cézanne attempted to show two different elements — the firm, stable surface of the earth and the constantly moving surface of the water — the interrelations of immobility and movement, chaos and order.

In *The Banks of the Marne* (*Villa on the Bank of a River*), Cézanne only poses this problem but does not completely solve it. He introduces two elements, two sides of the material world, but does not unity them. The massive, rounded forms of the vegetation on the river bank seem to roll down on each other, jostle each other, and press from all sides on the building of the villa whose straight geometrical outlines can hardly withstand their chaotic onslaught. The reflection, in the water reproduces with almost symmetrical accuracy the sky, the foliage, and the house, filling the river to the brim, as if sinking into it. In this reflection the elemental dynamics of the forces of nature seem to be halted, frozen into unshakable calm. In this way, Cézanne modified one of the problems of Impressionism to whose exponents the moving, reflecting surface of the river presented inexhaustible possibilities for unfolding the picture of the transient, unstable phenomena of nature in all its lustre. Cézanne, in contrast to the Impressionists, opposed the elemental movements of the earth's surface with the static quality of the water, and chaos and disorder with harmony and peace. But he drew too sharp a boundary between these two worlds. He separated the reflection in the water by a clear-cut horizontal and constructed it by means of a well thought-out system of straight vertical and horizontal brushstrokes that rectify slopes and smooth the roughish forms of the objects. The two parts of the picture are sharply opposed to each other, not brought into general harmony. This lack of homogeneity in the brushstrokes and images is not to be seen in *The Banks of the Marne* kept at the Pushkin Museum of Fine Arts in Moscow.

The quiet waters of the Marne lovingly carry a reflection of the buildings and trees on its banks, enhancing their massive, immobile forms. Not the slightest stirring of air or water disturbs the pristine tranquillity of nature that seems to be frozen into an immobility, eternal and full of profound meaning. The dynamic lines of the bank are balanced and calmed by the mass of the trees, mirrored in the unruffled surface of the river. All the forms are as free of anything superfluous as the color built upon gradations of green, blue, and yellow.

The sloping lines of the bank impart depth to the landscape. But the diagonal character of these lines is deceptive, for the upper line forms a strictly horizontal parallel to the lower border of the picture, and both of them, enclosing the mass of the bank, produce the impression of an elongated wedge driven into the surface of the canvas and dividing it into two parts. The river bank vanishes beneath the bridge, cutting it at an angle. But this impression, too, is deceptive: the upper line of the bank is strictly

The Old Woman with a Rosary,
1900–1904.
Oil on canvas, 81 x 65.5 cm.
The National Gallery, London.

The Card Players, 1890–1892.
Oil on canvas, 95 x 81 cm.
The Metropolitan Museum of Art,
New York.

parallel to the line of the bridge. Both lines are parallel to the horizon formed by the treetops in the background. Thus Cézanne constructs diagonally receding space by means of the horizontals and verticals of the tree trunks, the piers of the bridge, and their reflections in the water.

The same rational orderliness is seen in his system of brushstrokes. Foreground and distant planes are painted by elongated strokes of diluted paint, identical in size, and in a technique recalling that of watercolor. They strictly follow the verticals and horizontals of the compositional axes, and whatever sector, background or foreground that each one of these brushstrokes designates, it emphasizes the plane of the canvas, brings out its two-dimensionality. Viewed as a whole, they form a dense network and by their direction they create a third dimension of the landscape, its depth. But the miracle of Cézanne's painting is that this three-dimensionality, this depth, is based on nothing but the movement and cohesion of his brushstrokes. It is precisely the microplanes of his brushstrokes — these "protoatoms" of the very tissue of his painted surfaces — that build everything we see here: both the forms of the real world and the spatial relations between them. Nature itself, mirrored in the water, seems to be a reflection of eternity and its unbreakable laws.

Cézanne's work from the late seventies to the late eighties is usually termed his Constructivist Period because of his strictly logical method,

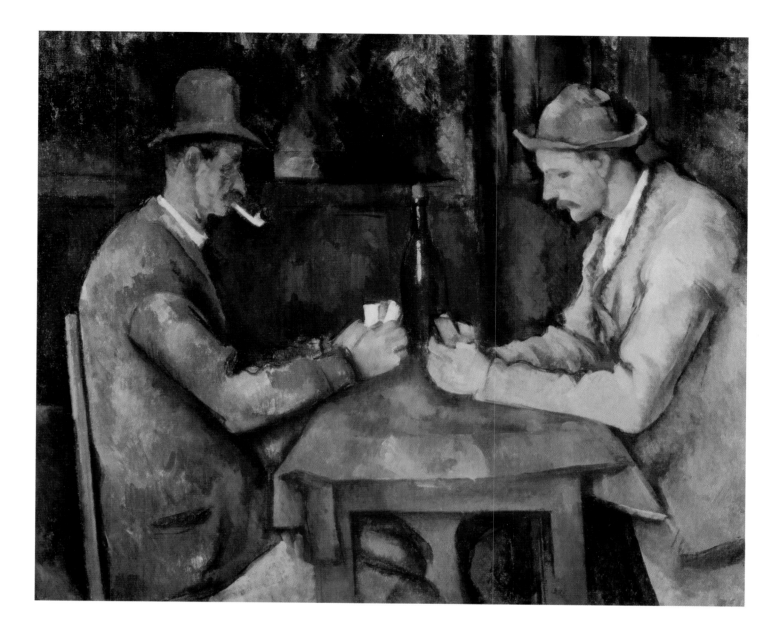

rational composition, and so on. These principles determine the style of his portraits, still lifes, and landscapes painted at the time. Perhaps they are most evident in his figure compositions. In 1888, simultaneously with *The Banks of the Marne*, Cézanne created another masterpiece, *Pierrot and Harlequin (Mardi Gras)*, in which he depicted the traditional characters of the French folk theater (1888, Pushkin Museum of Fine Arts; p.103).

Popular tradition has invested these characters with definite traits: Harlequin, the victor in all kinds of light-hearted tricks, with a cunning resourcefulness; Pierrot, the failure and dreamer, with shyness and timidity. Their costumes also serve to bring out their salient features: Harlequin's domino, which covers him all over with flashing, vivid diamonds, has to symbolize swiftness, fickleness, and agility; the white loose overall of Pierrot has to conceal his puny body and his awkward movements.

It is precisely the stable, immutable qualities of these popular characters that might have attracted Cézanne to this subject. In his picture, Pierrot and Harlequin enter the stage in traditional costumes, one with a proud bearing, the other stooping as if to hide behind his partner's back. Harlequin's head is thrown back, his glance, wary and appraising, is directed at the audience. Pierrot's head is bowed, the gaze of his wide-open eyes seems to be turned inward on himself, the delicate features of the intelligent face are those of a dreamer.

The Card Players, 1890–1892.
Oil on canvas, 47.5 x 57 cm.
Musée d'Orsay, Paris.

There is no gainsaying that Cézanne's interpretation of the images is traditional, but instead of the usual burlesque clownery, he creates something different. He avoids everything that might seem transient — a spontaneous gesture or fleeting smile. He precludes the slightest possibility of an accidental turn of figure, marking a transition from one movement to another. For this purpose, Cézanne distorts the form of Harlequin's leg, who, while stepping along an inclined surface, preserves full stability of posture. In his interpretation, the basic personal qualities of Pierrot and Harlequin are cast into eternal, immutable forms frozen, as it were, into a stony silence.

The figures are inscribed into a well thought-out pyramid, and volumes are delineated by wide synthesized color contours. This geometric pattern might have seemed schematic had not the richness of color softened a certain harshness about the folds in the clothing and the curtain, creating a multitude of transitions from one color to another, and welding the space of the picture into a single whole. In this painting, there is greatness and solemnity with no trace of pomposity. Cézanne achieves all this by a strict regulation of composition, a proper selection of poses, and by stability of movement.

The search for stability was not exclusive to Cézanne. At almost the same time as Cézanne's *Mardi Gras*, Renoir created his *Baigneuses* and Seurat his *Sunday Afternoon on the Grande Jatte*, works in which both artists, each in his own way, achieved a stable composition, basing them on the principles of complex equilibrium, attempting to restore what had been lost by Impressionism. Three of the Moscow masterpieces, the still life *Peaches and Pears* (p.117), the landscape *The Banks of the Marne* (p.107), and the figure composition *Pierrot and Harlequin, Mardi Gras* (p.103), are striking examples of Cézanne's work along these lines.

In 1886, a change in Cézanne's fortunes occurred. His father died, leaving him the house in Aix, the villa Jas de Bouffan, and a substantial legacy to him and his sisters. Shortly before, Cézanne had married Hortense Fiquet. At last, he was freed of constant financial problems and everyday worries. Up to that time the jury had only once, in 1882, admitted one of his paintings into the Salon, and that only on the insistence of his friend Antoine Guillemet, while those works which were occasionally displayed at unofficial exhibitions met furious onslaughts by critics and public alike. Even his closest friend, Émile Zola, in his novel *L'Œuvre*, published in 1886, rejected the new trend in painting, for in his view it had not brought the expected fruits, and foretelling a sad end for Cézanne; the novel's principal hero, Claude Lantier, who in many respects was modeled on Paul Cézanne, commits suicide before his own unfinished masterpiece. Fortunately, Zola's prophecy did not come true. The blows of fate only spurred Cézanne to work harder. From the beginning of the nineties until his death he lived almost without a break in Aix, traveling occasionally to Paris to visit his family. Every morning Cézanne would set off to paint. He executed landscapes, portraits, and still lifes. In his studio or at home, he painted peasants who posed for him for long periods, retaining throughout their unhurried manner, immobility, and patience — qualities his more intellectual models could seldom attain. This was how he painted his *Card Players* series (1890–1892), the finest example of which is in the Musée d'Orsay in Paris (p.47). Here two figures and the details of the interior are incorporated into a rigid compositional scheme. If in the mind's eye one prolongs the inclinations of the figures of the two players and the lines of their hands, a distinct rhomboid is formed, the apexes of which lie outside

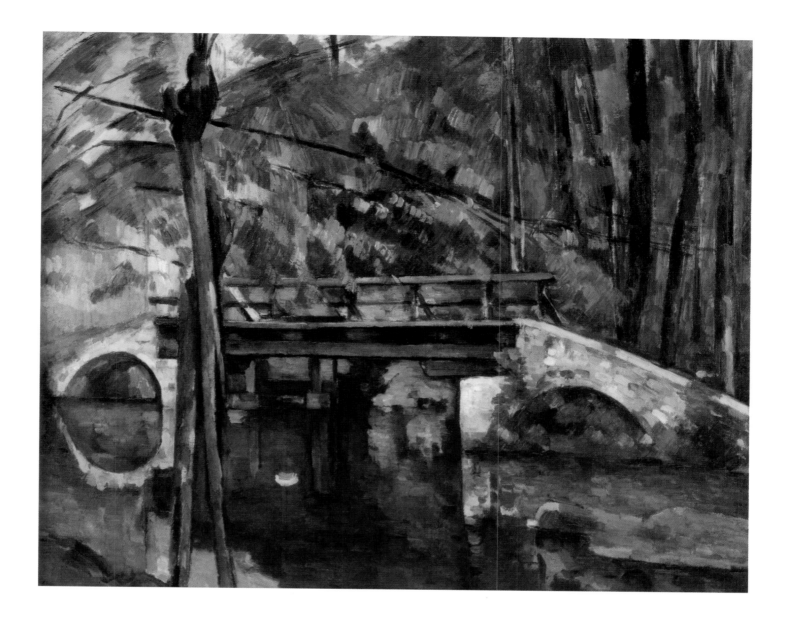

the canvas; at the same time the bottle in the center of the composition divides the rhomboid vertically, and the rear edge of the table horizontally. This constructivist logic gives the composition a surprising stability and imparts a monumental quality to the images of the peasants.

Two paintings in Russian collections are executed in the same way: *The Smoker* (Hermitage; p.127) and *Man Smoking a Pipe* (Pushkin Museum of Fine Arts; p.125), both dated 1895–1900. A tangible three-dimensionality is built up here by the sides of the tables receding into the depths, but the brushstrokes placed without regard for their diagonals turn space inside out. In *The Smoker*, the curtain on the right creates the illusion of a side wall with the man drawn up so closely against it that one can even see the coloring of his jacket reflected there. In the Moscow painting, Cézanne blurs the outline of the figure in places (the right shoulder of the smoker), applying to it the brushstrokes proper to the background (the method of shifting spatial planes used in *The Aqueduct* and other landscapes). The figures are firmly welded to the space of the interiors, they abide there amidst tables, bottles, pipes, and curtains, acquiring a quality of almost absolute immobility.

These pictures, close in style to those of the eighties, were done at a period when the principles of Cézanne's approach to nature were undergoing a radical change. But it is precisely in figure compositions (and

The Bridge in Maincy near Melun, c. 1879.
Oil on canvas, 58.5 x 72.5 cm.
Musée d'Orsay, Paris.

49

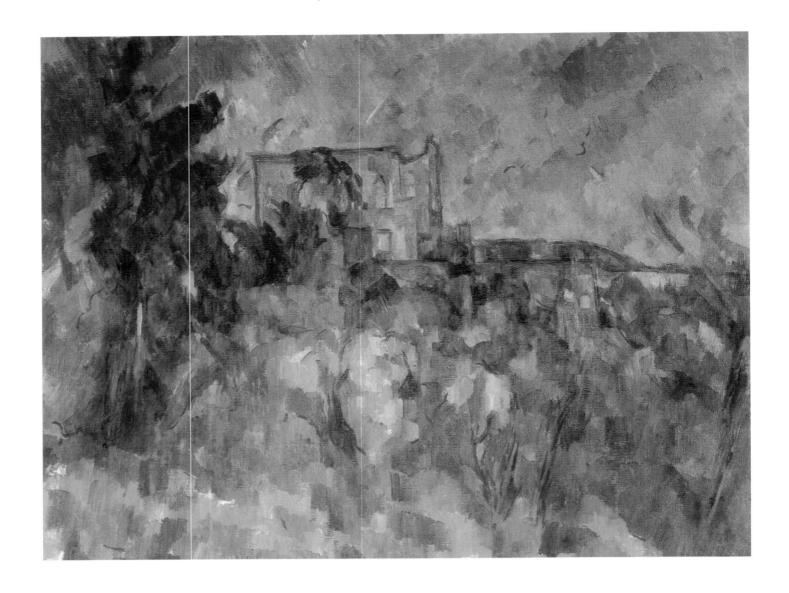

In the Park of the Château Noir, 1900.
Musée d'Orsay, Paris.

at times in portraits) that he continued to develop and apply the formal methods of his previous canvases. There was logic in this: when working out problems of form, Cézanne always endeavored to reveal the essence of what he was depicting. "To look at things according to nature means to bring out the character of one's model."[24] When examining this view of Cézanne's, it must be remembered that he was far from indifferent to the character of his models: in portraying a man, he always inwardly correlated him with his perception of the universe, as another motif in a landscape or another apple in a still life. "I love above all the aspect of those people who have grown old without having done violence to custom, and who have simply yielded to the natural action of time."[25]

Thus Cézanne himself appears before us in his self-portraits, and in his card players and smokers one can see the link between these peasants and the law of natural time with its measured alternation of day and night, summer and winter, whose advance man has no power to hasten, hold back, or halt. The peasants are portrayed in real interiors, amidst real things, but they do not enter into any subject-time relations with the latter. It is not that they are indifferent to these things. It is simply that their existence flows along a different time channel: it is subject not to the transience of the transformations of human life, but to the prolonged, extended rhythms of natural time. An instant recorded by the Impressionists is always in a continuum of the time of human existence: it flows from the past, is fixed as the present, and it disappears into the future, carrying within itself the

potential of both one and the other. In Cézanne's paintings, time is torn from this continuum and placed in the vaster continuum of natural time, whose movement cannot be caught by the human eye. That is why in Cézanne's compositions "nothing happens." However, the figures only seem to be immobile, and the fixed instant only seems to come from and to go nowhere. In his smokers and card players the artist glimpsed above all their peasant communion with the rhythms of natural life, which has been lost by man in the industrial epoch; the close kinship of their existence with that of the earth is elevated by him to an ethical ideal. Consequently, as Venturi so aptly put it, "the peasant painted by Cézanne is as individualized as a portrait, as universal as an idea, as majestic as a monumental, and as sound as a clear conscience."[26]

One would have thought that the end of the 1880s saw Cézanne achieving his desire: he transformed Impressionism into "something solid and durable, like the art of the museums." In place of the fragmentary character of an Impressionist painting, Cézanne asserted the composition structured according to classical laws, in place of the fleeting nature of atmospheric and psychological states came Cézannesque stability, based on an equilibrium between immobility and movement. Evidently, this too could not completely satisfy the artist whose main aim was to "embrace reality as a whole."

In Cézanne's landscapes painted in the late eighties and early nineties, such as *Bridge and Pool* (1888–1890, Pushkin Museum of Fine Arts; p.107), created soon after *The Banks of the Marne* (p.101), there is no trace of the indifferently measured movement of the brush over the surface of the canvas. Vigorous brushstrokes, clashing at acute angles, convey the movement of the foliage; they stretch along the horizontals of the bridge, and with equal energy are applied in large patches of color onto the surface of the water, producing an effect of reflection. The coloring of the landscape becomes almost monochromatic: Cézanne rejects yellow, leaving only green and very little blue and brown. At times the paint thickens to emerald-green and deep blues, at others its intensity thins down to a light green; these intermingling microplanes build up a homogeneous flickering space of the landscape over the entire surface of the canvas. The magnificent immobility of nature is resolved here in feverish movement, its massive forms shift from their places, mixing with and turning into one another. Here Cézanne seems to return to the aesthetics of movement and changeability of Impressionism, for which reason the style of his later landscapes has sometimes been called Neo-Impressionism. However, this may appear to be the case on superficial and formal inspection only, for the basis of his vision and his recreation of the world grows at this time more original and farther removed from Impressionism than before.

In Impressionist paintings, the recorded time flow affects only the external layer of reality, the inconstancy of lighting and atmospheric states influences the texture and color of the surface of things, without touching their inner structure. The forms of the objects in Claude Monet's paintings may dissolve almost completely in the light-and-air medium, but they remain in their places, they are firmly fixed in real space. The same thing was true of Cézanne's landscapes up to the 1880s. For example, in his *Bridge at Maincy near Melun* (c. 1879, Musée d'Orsay, Paris; p.49), which is similar in motif and manner of execution to the later *Bridge and Pool*, the patches of color slip over the surfaces of the trees, the bridge, and the water, creating a sensation of a scintillating play of light and shade. In the later landscape,

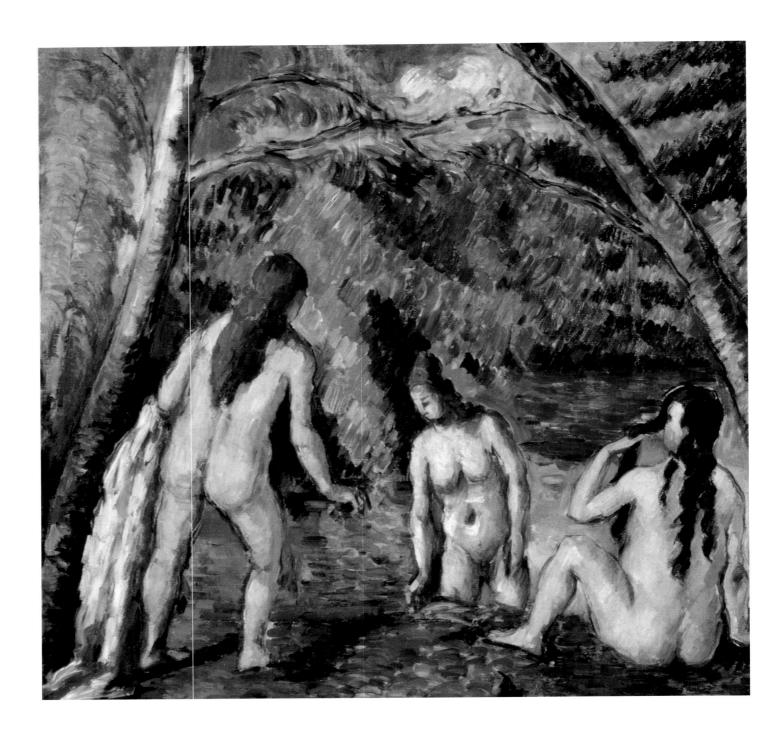

the very brushstrokes, some thick and saturated, some light and transparent, construct the forms of the world of objects; they are mobile, they move rapidly, but now not over the surfaces of objects, but over the plane of the canvas, with equal vigor in the foreground and background, drawing with them and mixing all the forms, local tones, and spatial zones, as if the very vibrating stream of existence were reflected in the magic mirror of Cézanne's art. For where this stream becomes less intense, a thick color layer lies next to exposed patches of primer.

Does this give grounds for considering such landscapes unfinished? Yes and no. No, because Cézanne has said everything he wanted to say on the subject. Yes, for he has not by any means said everything about the universality of nature. The reflection of nature in Cézanne's later landscapes became direct and spontaneous. This evolution in his work was not influenced by any new artistic or intellectual conceptions. Leading the life of a hermit, he was cut off more than everfrom all new winds of change, relying, as always, on his own perception of nature. "The Louvre is a book

Three Bathers, 1875–1877.
Musée du Petit Palais, Paris.

52

to consult, but it must not be more than an intermediary,"[27] and "after seeing the great masters there, a painter must hurry out and refresh, in contact with nature, his own instincts and sensations."[28] Cézanne always held similar views, but toward the end of his life he relied even more strongly on his own world outlook. "To give the image of all we see, forgetting everything that has appeared before,"[29] — this was how Cézanne now formulated his aims and the possibilities of attaining them. In fact, he proclaimed the need to get away from all preconceived notions and look at the world directly — with eyes unclouded by the influence of the systems of other painters.

In his later years, Cézanne experienced a re-awakening of the sensations of his romantic youth — sensations of the intense and dynamic life of the universe. To him the realization of this meant the coupling of one more, and now the last, link to his system of embodying reality; it meant setting down on the immobile surface of the canvas the motion of formative rhythms and processes of life as they come into being, at the same time preserving the material stability of natural forms. It was a formidable task which necessitated a reassessment of all his old ideas.

In his landscapes of the late eighties and early nineties, signs of this new orientation appeared. Cézanne painted them almost entirely in the countryside near Aix, producing variations on a few favorite motifs: trees, and between them a huge eminence, Mont Sainte-Victoire, seen from different sides, a pine or a group of pines between which that same Mont Sainte-Victoire can be glimpsed. Cézanne's field of vision was bounded by this scenery, well known to him since childhood and revisited a thousand times so that it had become part of himself. The mountain of Cézanne's childhood — Sainte-Victoire — was for him the focus of the life of nature, the embodiment of nature's formative forces, just as the sacred Mount Fuji has been for Japanese artists.

One of the supreme achievements of Cézanne's later period is undoubtedly *Mont Sainte-Victoire* (1896–1898, Hermitage; p.137). The dynamic motion permeating this landscape can be sensed both in the movement of the brushstrokes and in the energetic curving of the lines and vibrations of the light-and-air medium. If one looks at Mont Sainte-Victoire from the side Cézanne painted it, one gets quite a different view from that shown in his painting. Cézanne placed houses which in reality are hidden by trees at the very foot of the mountain; he considerably increased the size of the mountain in comparison with the adjacent hollows and tracts of forest. As a result, though the mountain comes closer to the viewer, there is no loss whatsoever of the impression of inaccessible distance, like the sensation experienced when looking from a valley at a mountain ridge which seems near and far at the same time.

Long hours of intense study and observation of nature revealed to the artist both the logic of the geological structure and the current of vital forces, invisible yet tangible. It was as if he had his finger on the very pulse of nature and recorded on canvas the measured beat. Because of this, every tree, every mound exists here not as an entity in itself, but only as part of nature's general stream of life. The whole enormous extent of the landscape is included in the formative process of building up an immense mass: the rounding spatial and color planes run diagonally toward the center, to the base of the mountain — unseen, for it is hidden by the foliage of a tree on the left, but clearly implied, receding far into the depths of the earth. It is here, too, that the Mont Sainte-Victoire, like a

living creature, grows out of the curving planes of its base, converging toward the canvas's center.

Once, in search of man's harmonious unity with nature, Poussin populated his landscapes with nymphs and giants. Cézanne, working simultaneously on both *Mont Sainte-Victoire* and his huge picture *The Bathers* (1898–1906, Philadelphia Museum of Art), which remained unfinished, wanted, in his own words, "to combine, as in Poussin's *Triumph of Flora*, the roundness of the feminine breast with the shoulders of the hills." Two and a half centuries after Poussin, Cézanne in his *Mont Sainte-Victoire* brings nature and Polyphemus into one: all the forms of the landscape have more the soft curves of a live body than of the frozen geometrism of inanimate nature. In this merging of the organic and the inorganic, the animate and the inanimate, one hears the concluding chord of the search for some universal principle uniting all the manifestations of reality.

Mont Sainte-Victoire is a characteristic example of Cézanne's spatial conception as it develops in his later works. The massif not only organically out of the landscape but also grows firmly into it, and the lines of the spatial zones settle and sag under its weight. Down on earth they seem to skirt the body of the mountain, and in the sky, currents of dense air flow round it; everything here is built up around the compositional center, producing an effect of a curving space stretching at the foot of Mont Sainte-Victoire like a gigantic bowl. In his *Great Pine near Aix* (late 1890s, Hermitage; p.121), Cézanne was also concerned with developing spherical space. The tree trunk is framed on all four sides by an uneven ring of color in which the green tones of the pine and the carpet of grass are mixed with bluish-violet reflections of air and distance. In the center, behind the mighty spreading branches of the pine, one catches a glimpse of sunlit distances, and the reddish-orange tones suddenly tear this plane away from the depths, bringing it far nearer to the viewer. Here Cézanne constructs the space of the landscape just as he constructs the volume of a peach or a head: toward the periphery of this spatial volume Cézanne's brushstroke increasingly absorbs intensive cold tones, but as it moves away from the periphery it grows warmer, concentrating in the red splash of the roof in the center of the picture. This creates a definite effect of three-dimensional space, as if the landscape were not painted on a flat canvas, but on a convex, spherical surface. Scholars have more than once noted the presence of this "spherical space" in Cézanne's work.[30]

However, claims that Cézanne was the first in this field require a little correction. Elements of spheroid (or spherical) perspective appeared in Western European painting at virtually the same time as linear perspective and were developed throughout the fifteenth and sixteenth centuries in the Netherlands. Artists of that period took as their starting point the medieval symbolic conception of the earth as a sphere and unfolded the action in their religious and genre scenes within its curving space. With the passage of time the minds of people discarded the symbolic conceptions, and the scientific rationalism of modern European culture prompted the construction in art of a spatial model of the world in accordance with the optical laws of its perception by the human eye — laws by which parallels converge at one point in space and lines in nature seem to us straight all along their length, et cetera. Having broken out of servitude to symbolic conceptions, human vision fell captive to scientific ones, for parallel lines do not really meet in space, but the crystalline lens of our eye bends them in its spheroid surface: they seem to us to be straight only when we make a

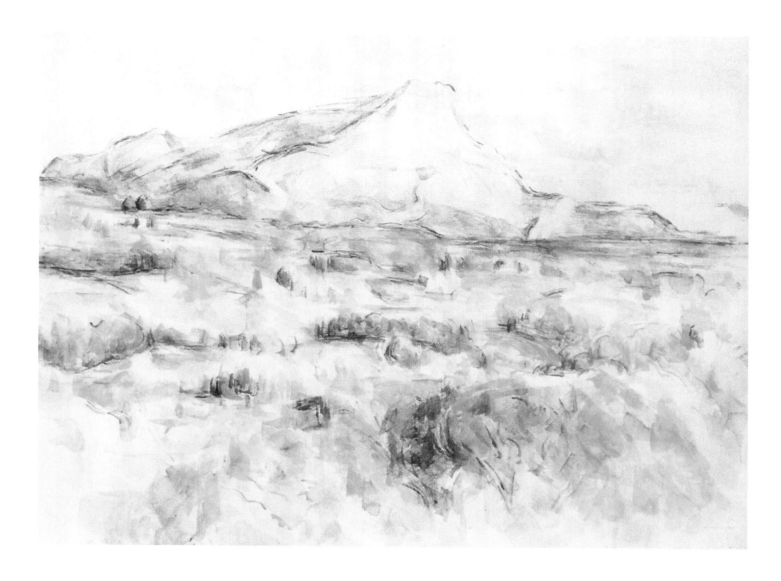

rational correction to our natural perception, looking at the world through the lens of the notions of our culture.

In his mature years, Cézanne's vision not only became free of symbolic conceptions, but of a host of artistic canons as well. He eventually noticed that in nature all lines bend, curve or incline, and to portray parallels converging in space was to him tantamount to "copying truth from a preconceived type," whereas he wanted "to imitate nature in accordance with truth." To some extent this led to stories that Cézanne had defective eyesight. For example, even in a favorable comment on his painting, Joris Karl Huysmans wrote: "This is an artist with a defective retina: by dint of desperate effort, and exerting visual receptivity, he discovered the horizons of a new art."[31] Cézanne himself was very near to believing that his sight was defective and ascribed to it the fact that "the planes overlap each other,"[32] while "absolutely vertical lines seemed to me to be falling."[33]

But Cézanne did not want to change his vision of nature and he could not do so. Incidentally, his spatial conception can hardly be reduced to a definite geometrical scheme nor its essence be expressed in one term. In his later work, he combined elements of spherical perspective with those of straight, inverse, and oriental perspectives (the latter was called by the Chinese the perspective of the trembling tail of a dragon). But for Cézanne, his experiments with space were by no means formal; they were all aimed at a fuller expression of his vision, understanding, and sensation of nature. The spherical character of space helped him to convey in the best possible way his pantheistic perception of the dynamic life of nature as a single

Mont Sainte-Victoire, 1902–1906.
Watercolor and lead pencil,
42.5 x 54.2 cm.
The Museum of Modern Art, New York.

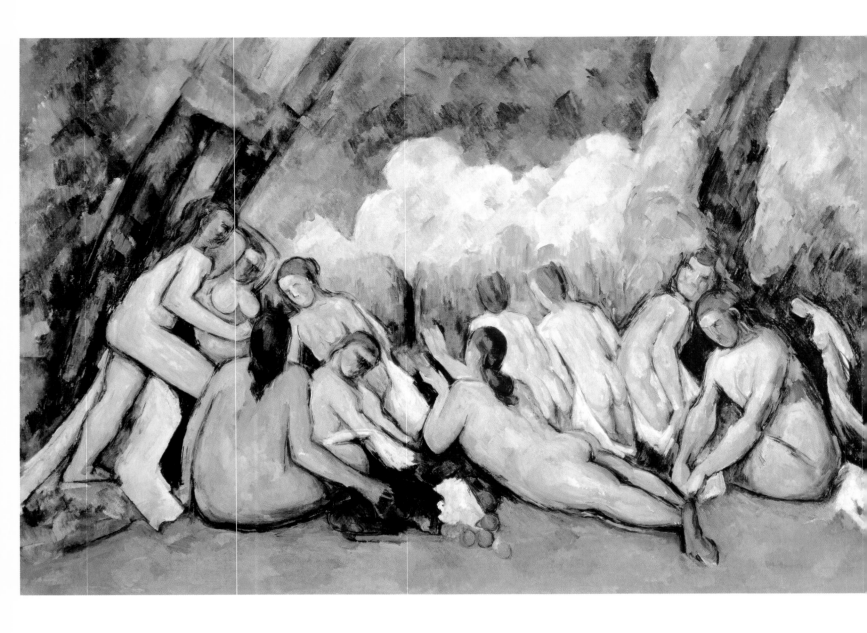

The Great Bathers, 1900–1905.
Oil on canvas, 125 x 196 cm.
The National Gallery, London.

process uniting and forming in its course all the elements of nature's visual aspect. This world view, which first manifested itself in Cézanne's earlier work, achieved its fullest expression in his paintings of the 1890s and 1900s. In the canvas *Great Pine* (p.122), the distant plane sagging slightly toward the center is viewed like the horizon, but beyond it, almost as high as the treetop, is a cumbersome mass of hills and buildings. Through the prickly brushstrokes of the pine needles, one sees blue snatches of background, the green of the pine gives way to the soft carpet of the grass on which blue and violet patches lie — clots of air or space. Not only the near and the far, but also the top and the bottom become relative categories for Cézanne, for with its base, top, and branches, the trunk of the pine recedes into and dissolves in the material medium which is almost homogeneous along the entire periphery of the canvas and which is built up with greenish, light blue, and violet dabs of paint.

One might say that Cézanne's pantheistic world perception was seen earlier in his *Bathers* series in which he tackled the task of uniting human figures with landscapes. He had turned to this theme back in the 1870s and continued with it throughout his artistic career. His small study *Bathers* (early 1890s, Pushkin Museum of Fine Arts; p.109) is part of this series.

A group of bathers is depicted on a narrow strip in the foreground, and behind them the color patches of the foliage are interrupted by the light

blue patches of sky. But is it the sky, or is it the wide blue surface of the river, reflecting sky and bank? It may be one or the other, or more likely it is the blue of water and sky, it is the green of leaves and grass, it is the golden scattering of the sun's rays and the chilling violet of the distant planes, and all of it is inter-reflecting, merging with the next, making up a single painterly substance which is shot through with light and air.

This kind of work was possible only after the discoveries of the Impressionists in the rendition of light and after Cézanne's transformation of these discoveries into something contrary to Impressionism. Light penetrates everything; as in the artist's later still lifes, it acquires the quality of color and volume of natural forms themselves. It makes the element of air visible, it pours from the depths of the landscapes together with the blue patches of the distances, it illumines the bodies of the bathers, which glow like precious pearls in the mother-of-pearl frame of space, with a pinkish-violet radiance. Woven from its currents is the bulk of Sainte-Victoire, the mass of the hill, and space itself, where the familiar categories of near and far, and of top and bottom dissolve in their dynamic nature. It was in this way that Cézanne painted everything in his later period — from broad, "cosmic" landscapes to modest still lifes.

In *Flowers* (c. 1900, Pushkin Museum of Fine Arts; p.135), the position of the bouquet in space is, in fact, not fixed, and space is not orientated on a specific viewpoint. The background consists of dabs of the paint from which the shapes of the bouquet are gradually formed. On the periphery of the portrayal they assume the aspect of vague bluish swellings and then, gathering the strength of color, converge toward the center in physically tangible forms. Here the pinkish, violet and orange hues, innumerable in their gradations, convey the fresh resilience and tenderness of the opening petals. It is most likely that we are looking at these flowers from above, penetrating into the very heart of the opening buds (although we also see the vertical stems of some of the flowers). The middle of the bunch becomes, at the same time, the center around which the space of the still life unfolds. Our eye runs in a circle, following the color accents, and the bunch becomes a wreath, which can be regarded from any point in space.

Cézanne's conception of reality as a dynamic process of development and formation reaches a culmination in his later canvases, especially in his *Mont Sainte-Victoire* cycle. *Landscape at Aix (Mont Sainte-Victoire)* (1905, Pushkin Museum of Fine Arts; p.145) belongs to the very last and most perfect works of this cycle. As in his previous landscapes, Cézanne carefully reproduced here everything he saw and knew: every tree, unevenness of terrain, or ledge on the mountain occupies a place on his canvas in complete accordance with its position in real space. Here, however, nature is subjected to a far greater degree of generalization: in the color patches scattered throughout the space of the picture, we recognize only with difficulty its concrete forms. Furthermore, warm and cold strokes modeling the forms of boughs, trunks, et cetera, simul-taneously perform a constructional function of receding and projecting planes that build up space in the landscape. At times vertical, at others horizontal, they rise like steps to the foot of the mountain and skirt it on either side. Other brushstrokes fulfilling the role of specks of light or outlining convolutions of natural forms, converge from left and right toward the center, slipping in curves all over the ledged surface of the landscape and thus creating an effect of spherical space. Under the influence of their dynamic movement everything here begins to curve and turn around the central point, as in the Hermitage picture of the same name, but with far greater intensity.

Paul Cézanne concentrating on a motif in the region of Auvers-sur-Oise, c. 1874. Unknown photographer.

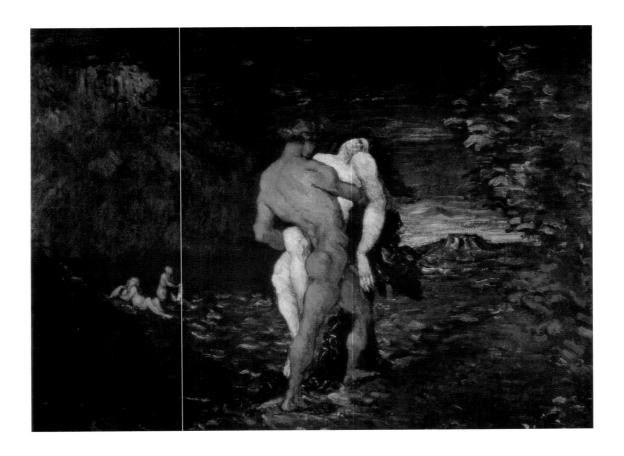

The spherical effect is heightened by yet another device: the central zone of the landscape takes in the greatest number of warm orange hues and, coming into prominence, they tear the distant plane away from the depths, which, as in *Great Pine near Aix*, evokes the feeling that the very surface of the canvas is rounded. The central zone of the picture, painted with dense brownish-orange brushstrokes, is reminiscent of an upturned image of the mountain, as if its huge shadow covers a considerable area of the landscape. However, against all optical laws, this shadow is a great deal lighter and warmer in tone than the object casting it, which produces an impression not of shadow but rather of a reflection of the mountain in the surface of the landscape. The circular movement below, created by variously directed brushstrokes, is repeated at the top, in the sky, where rhythmically dense and rarefied air streams wash the mountain. And, continuing all over the surface of the canvas, the movement returns to its starting point, becomes enclosed within itself, in the repeating rhythm of revolution, and keeps halting, creating a sense of dynamic calm, nature's eternal state.

In this way, in his later landscapes, Cézanne synthesized the principles of organization of pictorial space worked out by him earlier. He was motivated by the same striving to embrace reality as a whole, which now, as ever before, meant for him the fullest possible expression of his sensation of nature. And to achieve this, he perfected to the utmost his method of discarding secondary details in order to penetrate the essence of what was portrayed. In these landscapes, nature in many respects loses the concreteness of its forms but acquires instead the dynamic intensity of its existence. Unlike the Impressionists, Cézanne did not dissolve natural forms in the light-and-air medium; rather he fused them together, and from this alloy, which had absorbed all the colors and shades of reality, he built the world anew. And this process of creation broke off only with his last heartbeat, the last stroke of his brush. Cézanne died on October 22, 1906, from pneumonia, after catching a cold while working on his last "motif."

The Abduction, c. 1867.
Oil on canvas, 93.5 x 117 cm.
Fitzwilliam Museum, Cambridge.

58

Notes

1. L. Venturi, *Da Manet a Lautrec*, Florence, 1950, p.107.

2. A. Nürenberg, *Paul Cézanne*, Moscow, 1926, p.33.

3. É. Bernard, "Souvenirs sur Paul Cézanne," *Mercure de France*, 1907, No. 248, p.627.

4. Letter to Numa Coste, February 27, 1864.

5. Letter to Émile Zola, May 8, 1878.

6. Letter to Ambroise Vollard, January 9.

7. Letter to Claude Roger-Marx, January 23, 1905.

8. Letter to Émile Bernard, September 21, 1906.

9. É. Bernard, *op. cit*. No. 247, p.399.

10. "Imagine Poussin redone according to Nature. That would be classics" — these words of Cézanne's are quoted by Émile Bernard (É. Bernard, *op. cit.*, p.627).

11. Letter to Charles Camoin, January 28, 1902.

12. Letter to Joseph Huot, June 4, 1861.

13. Émile Zola, *L'Œuvre*, Paris, 1886, p.483.

14. J. Rewald, *History of Impressionism,* 1946, p.139.

15. A. Barr, "Cézanne d'après les lettres de Marion à Morstatt. 1865–1868," *Gazette des Beaux-Arts*, 1937, vol. 17, January, pp.52–57.

16. Letter to Émile Zola, October 19, 1866.

17. J. Rewald, *op. cit*, pp.356, 357.

18. Pissarro refers to Cézanne's first personal exhibition of 1895.

19. Letter to Émile Zola, April 14, 1878.

20. Letter to Charles Camoin, February 22, 1903.

21. There are examples in a letter to Émile Zola, November 20, 1878, or in a letter to his son, October 15, 1906.

22. J. Gasquet, *Cézanne*, Paris, 1921 or 1926, p.198 (cited after Brion-Guerry 1966).

23. Letter to Émile Bernard, May 26, 1904.

24. L. Venturi, *op. cit.*, p.119.

25. *Ibid.*

26. *Ibid.*

27. Letter to Émile Bernard, May 12, 1904.

28. Letter to Charles Camoin, September 13, 1903.

29. Letter to Émile Bernard, October 23, 1905.

30. Thus, speaking of Cézanne's landscapes, V. Prokofyev remarks: "The spheroid quality of space in which we have our existence has been made visible for the first time in the history of art." From the epilogue to A. Perruchot, *Cézanne*, Moscow, 1966, p.351 ff. (in Russian).

31. J. K. Huysmans, *Certains*, Paris, 1908, p.43.

32. Letter to Émile Bernard, October 23, 1905.

33. Émile Bernard, *op. cit.,* Nos. 247, 248.

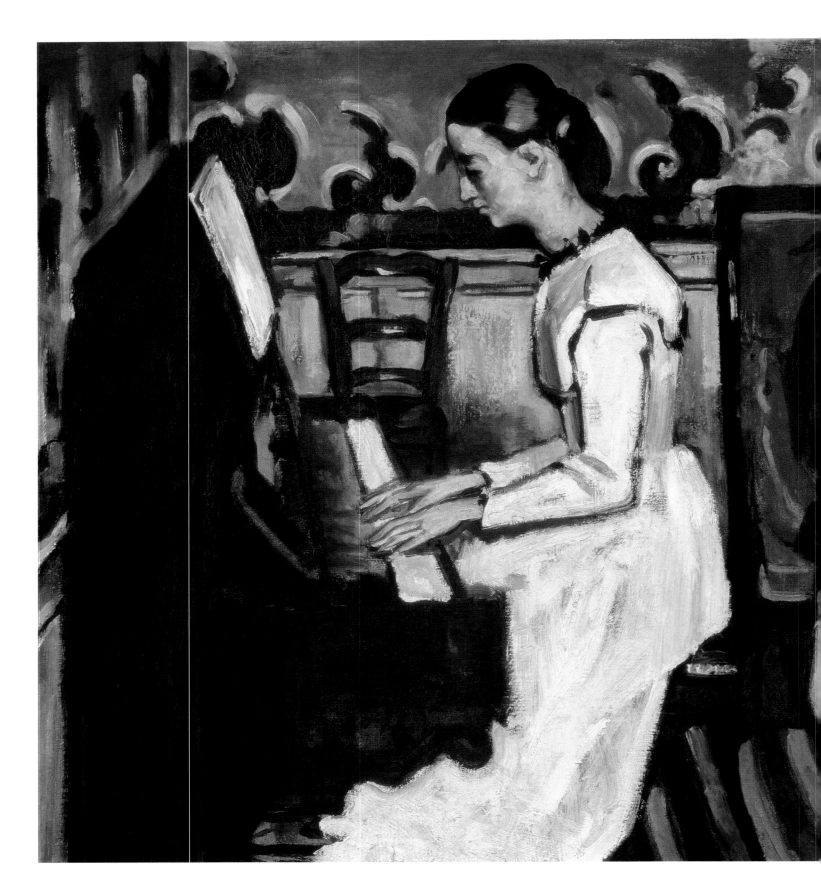

His Work

1. Two Women and Child in an Interior

Early 1860s.
Oil on canvas. 91 x 72 cm.
Pushkin Museum of Fine Arts, Moscow.
Inv. No. 3409.

Cézanne was fond of painting interior scenes, particularly at the start of his artistic career. It was then, at the beginning of the 1860s, that this work was painted, the earliest of his pictures in Russian museums.

The background is dark, almost black. Black is also used for the shadows on the faces and the folds of the dresses. The painting is even semi-impasto. The overall dark color range indicates that this is one of Cézanne's early works. The choice of theme proves the same: the beautifully draped dresses with crinolines were of considerable interest to an artist who was just beginning. Bernard Dorival dates the picture 1861 and believes that Cézanne borrowed the theme of the women's figures in crinoline dresses from the magazine *L'Illustrateur de mode*. Lionello Venturi assumes that the canvas depicts the artist's mother and two sisters Marie and Rose. He points out that the black-haired Marie (left) is portrayed with blonde hair. Perhaps Cézanne deliberately changed the color of his model's hair. He also painted his sisters some years later in *The Promenade* (c. 1870, collection of Paul Cézanne Junior, Paris, V. 119) and *The Conversation* (c. 1870–1871, Bernheim-Jeune collection, Paris, V. 120).

The canvas in the Pushkin Museum, sometimes called *Women in an Interior*, was bought by Ivan Morozov from Ambroise Vollard in 1913. The bill sent by Vollard to Morozov has been preserved in the Museum archives (H/12, sheet 12). In the bill, the painting was referred to as *Scène d'intérieur*.

2. Girl at the Piano
(Overture to "Tannhäuser")

1868–1869.
Oil on canvas. 57 x 92 cm.
Hermitage, St. Petersburg.
Inv. No. 9166.

This picture, painted c. 1868–1869, depicts an interior in the villa Jas de Bouffan, the Cézanne family estate near Aix. According to Boris Temovets and Gerstle Mack, the girl at the piano and the woman listening to her are the artist's elder sister Marie and his mother Anne-Elizabeth Cézanne, née Auber. However, Venturi disputes the identification of the pianist as Cézanne's sister, since at the time the picture was painted Marie was older than the girl at the piano and judging by her photograph bore little resemblance to the model. From the correspondence between Cézanne's close friends Anthony Valabrègue and Antoine Guillemet with Émile Zola and that of Édouard-Fortune Marion with the German musician Hemrich Morstatt, published in the 1930s by John Rewald and Alfred Ban, we know how the picture came to be painted. From Marion's letter of 28 August 1866 we learn that Cézanne "in one morning painted a remarkable picture… It will be entitled *Overture to "Tannhäuser"*… A girl at the piano. White on blue, everything in the foreground. The piano is painted in broad strokes, an old man is shown in profile sitting in an armchair; at the back of the room a boy is listening to the music with a rather stupid expression on his face. The whole gives an impression of furious and overwhelming strength."

In the fall of 1866, the picture, mentioned by Valabrègue (October 2) and Guillemet (November 2) in letters to Zola, was finished. However, a year later, January 6, 1867, Marion stated that Cézanne had "returned to the subject you are familiar with: *Overture to "Tannhäuser,"* but in light tones… The head of the girl with her fair hair is very beautiful and rendered with surprising strength. My profile is a good likeness and painted, moreover, with great skill, without the former clash of colors and repellent crudeness of his other works. The piano, too, is splendid, as it was in his first version, and the folds of the curtain, as always, are most convincing." This evidence shows that Cézanne began work on the *Overture to "Tannhäuser"* theme in the late summer of 1866 and that in 1867 he painted a second version, lighter in tone. We must therefore assume that the Hermitage canvas is the third and sole surviving version of the subject, in which the artist reduced the number of people to two. The father and the profile of Marion are missing, and the boy has been replaced by the artist's mother. There still remains the armchair, which has strong associations with Cézanne's father, his family, and their friends. It appears in the large portraits of Louis Auguste (V. 91) and Cézanne's friend Achille Empéraire (V. 88). In the Hermitage version of the picture, the basic principle of the original composition is retained in full ("everything in the foreground"): the armchair, the piano, and the profile of the girl in white against a background of blue paneling ("white on blue"). For the third painting, Cézanne chose a new canvas, since X-rays have failed to reveal any trace of previous versions on it. Evidently the other pictures were destroyed by the artist. The first version may be connected with a large portrait of his father holding a newspaper (V. 25) and two studies of a boy (V. 109 and V. 95), obviously associated with the lad at the back of the room referred to by Marion.

Girl at the Piano combines two main themes from Cézanne's early work: the family and society. This is the most important of his series of interior scenes painted in the mid-1860s. At the same time, its treatment brings to mind avant-garde painting of the period. Cézanne and his friends called the picture *Overture to "Tannhäuser,"* since it was conceived as a tribute to Richard Wagner, whom the young artists of the 1860s hailed as one of the outstanding exponents of avant-garde music.

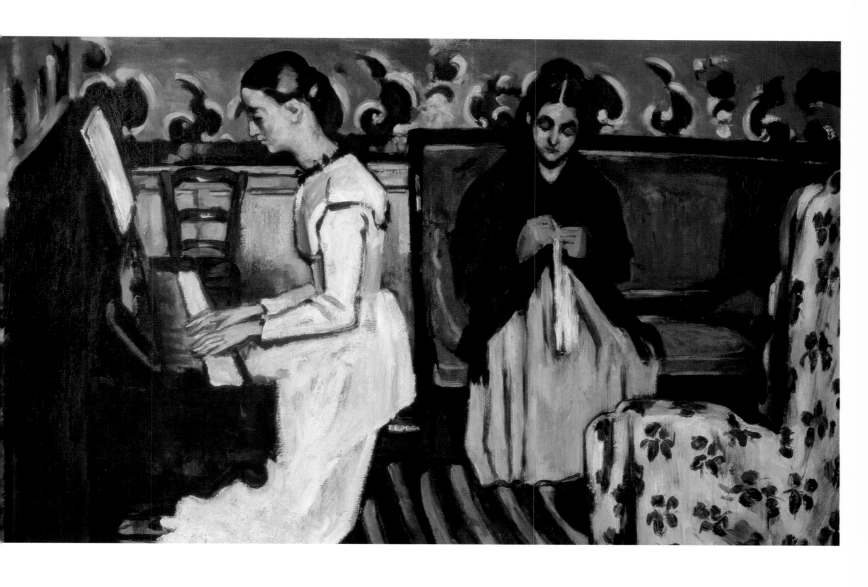

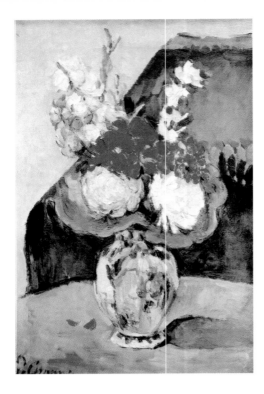

Flowers in a Little Delft Vase,
1873–1877.
Oil on canvas, 41 x 27 cm.
Musée d'Orsay, Paris.

3. Flowers in a Blue Vase

1873–1875.
Oil on canvas. 56 x 46 cm. Signed below left: *P. Cézanne*.
Hermitage, St. Petersburg.
Inv. No. 8954.

At the end of 1872, Cézanne settled in Auvers-sur-Oise. From 1872 to 1875, he closely associated himself with Camille Pissarro, and they worked together *en plein air*. It was precisely then that Cézanne's Impressionist period began, a period of direct contact with nature, keen observation of light reflections, and a lightening of his palette. In Auvers, at the home of Dr. Gachet, an art lover and a friend of the Impressionists, Cézanne, like van Gogh after him, painted many still lifes. The Hermitage *Flowers* was evidently also created there. As this still life is close in the manner of execution to *Bouquet of Dahlias in a Delft Vase* (Musée d'Orsay, Paris) it may be ascribed to approximately the same period, that is between 1873 and 1875.

The Hermitage canvas was probably painted at the same time as the still life in the Paul Durand-Ruel Collection in Paris (V. 181), which portrays the same vase of flowers but with falling petals. One should also note its resemblance to Adolphe Monticelli's *Flowers* reproduced in *The Burlington Magazine* (1938, January–June, p.75).

Cézanne signed this picture, something he did quite rarely. As the artist was usually dissatisfied with the results of his work, this time he obviously considered his still life a success, or perhaps the picture was intended for Victor Chocquet, and Cézanne signed it as a token of deep gratitude to his enthusiastic admirer. Chocquet placed Cézanne's work on par with the art of Delacroix.

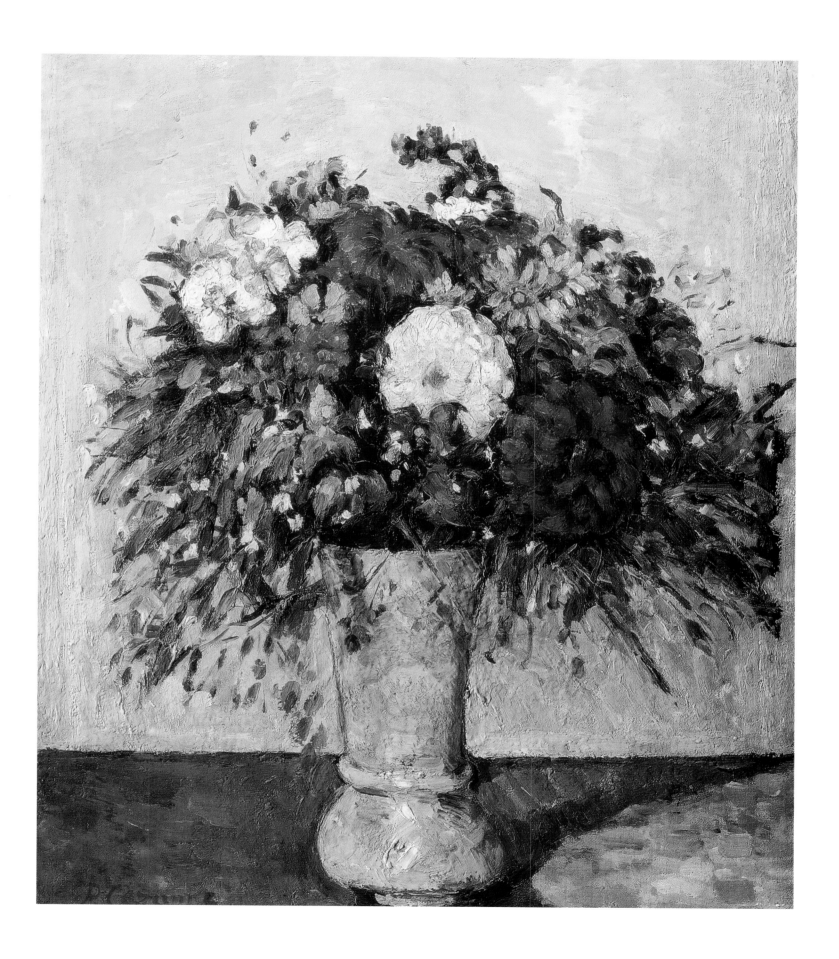

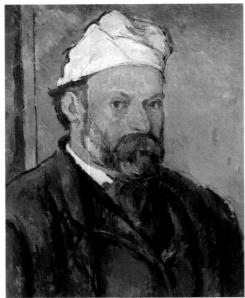

Self-Portrait, 1881–1884.

Self-Portrait in a White Hat,
1881–1882.
Oil on canvas, 55.5 x 46 cm.
Bayerische Staatsgemälde-
sammlungen, Neue Pinakothek,
Munich.

4. Self-Portrait in a Casquette

1873–1875.
Oil on canvas. 53 x 38 cm.
Hermitage, St. Petersburg.
Inv No. 6512.

This canvas belongs to the artist's Auvers period. Venturi dates it to 1873–1875, which is evidently the case for in the *Portrait of Cézanne* painted by Camille Pissarro in 1874, the artist is of the same age (see: L. Pissarro and L. Venturi, *Camille Pissarro, son art, son œuvre*, Paris, vol. 2, No. 58). Furthermore, although this self-portrait still retains the dark color range, the brushstrokes here are more calm and flexible in comparison to works from the 1860s. In his treatment of the image Cézanne has already departed from romantic expressiveness, aiming at greater simplicity and severity of interpretation.

5. Road at Pontoise
(Clos des Mathurins)

1875–1877.
Oil on canvas. 58 x 71 cm.
Pushkin Museum of Fine Arts, Moscow.
Inv. No. 3410.

Until 1877, Cézanne frequently painted in Auvers and in nearby Pontoise. The influence of Camille Pissarro and the Impressionists was to some degree responsible for landscape acquiring an increasingly important role in his work. Painting side by side with Pissarro, Cézanne quite often chose the very same motif as his friend. Thus, *Road at Pontoise* depicts the same scene as Pissarro's *View of the Hermitage at Pontoise* (1875), and was possibly conceived under Pissarro's influence (this, at any rate, is the opinion of Bernard Dorival).

Cézanne's views of the hermitage in Pontoise are close in motif to the Moscow canvas. The latter can with certainty be dated to 1875–1877. However, in the catalogue of the Museum of Modern Western Art in Moscow, it was dated 1876. Nina Yavorskaya holds the same view, Rewald considers it to have been done in 1873, Dorival and Venturi date it to 1875–1877, Barskaya 1876, and Feist c. 1877.

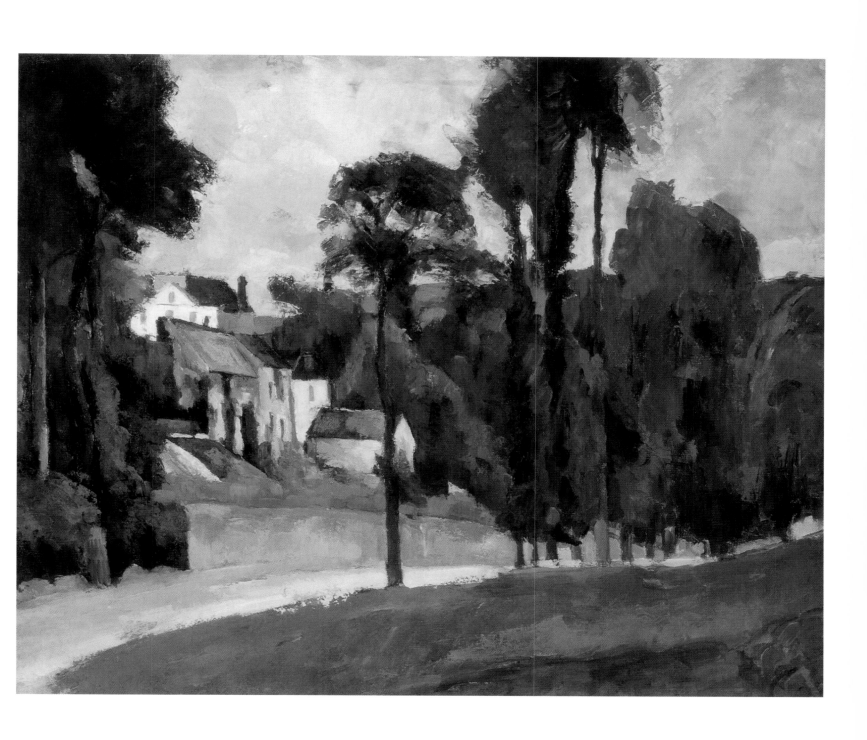

6. Fruit

1879–1880.
Oil on canvas. 45 x 54 cm.
Hermitage, St. Petersburg.
Inv. No. 9026.

Cézanne painted two groups of still lifes composed of the same objects: a milk jug, a decanter, a painted bowl, and fruit. The first group (V. 219, 220, 221) is dated by Venturi to the years 1873–1877 in Pontoise or Paris. The Hermitage canvas belongs to the second group featuring the same objects but with a leaf-patterned wallpaper in the background. Venturi dates this group (V. 337, 338, 340) to 1879–1882 on the grounds that the leaf-patterned wallpaper could have been either in Cézanne's house in Melun, where the artist spent several months in 1879 and the beginning of 1880, or in his Paris apartment at 32, Rue de l'Ouest, where he moved with his wife Hortense Fiquet and his eight-year-old son Paul in the spring of 1880. Both dates are perfectly possible, since after 1880 Cézanne did no further still lifes with a milk jug, a decanter, and a bowl, although he did stay in Paris many times later. As he was working in Pontoise mostly in 1881, and in 1882 he only paid short visits to Paris, perhaps we should date the Hermitage picture to c. 1879–1880.

In any case, *Fruit* was undoubtedly painted at a time close to 1880, when two tendencies were happily combined in Cézanne's work — an inclination to massive, baroque forms and a striving for orderly constructivism. The artist was then evolving his favorite color range of warm oranges and cool gray-blues, and his brushstroke was becoming extremely flexible, capable of conveying a sense of heavy density or almost weightless transparency. It is not by chance that in both the St. Petersburg and New York (V. 340) still lifes, he places a half-full decanter next to a milk jug. With the bunched-up form of the blue-white cloth, Cézanne made an interval between the heightened roundness of the fruit and the somewhat flattened objects in the background.

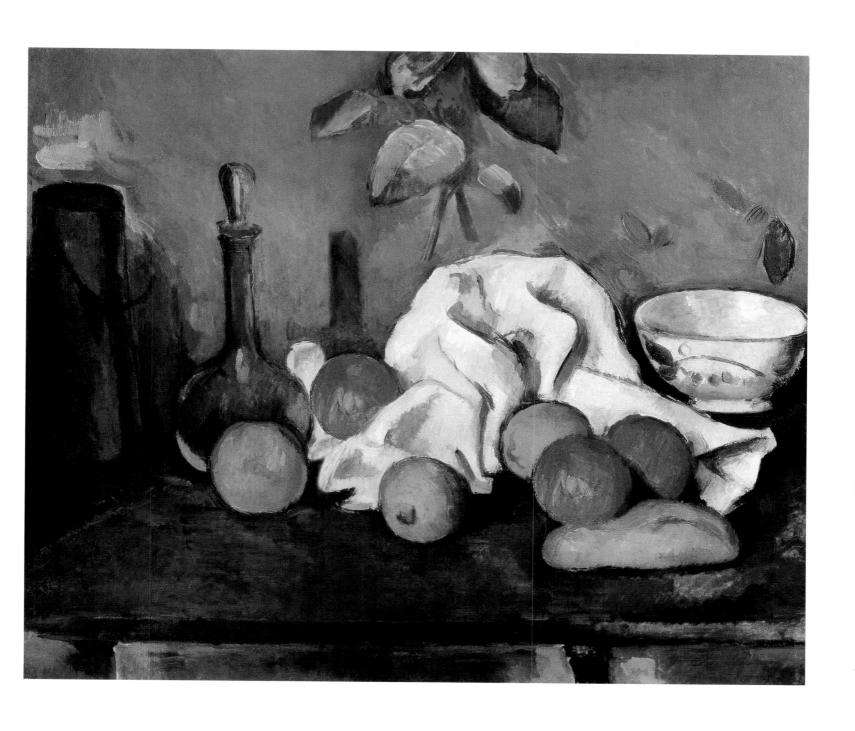

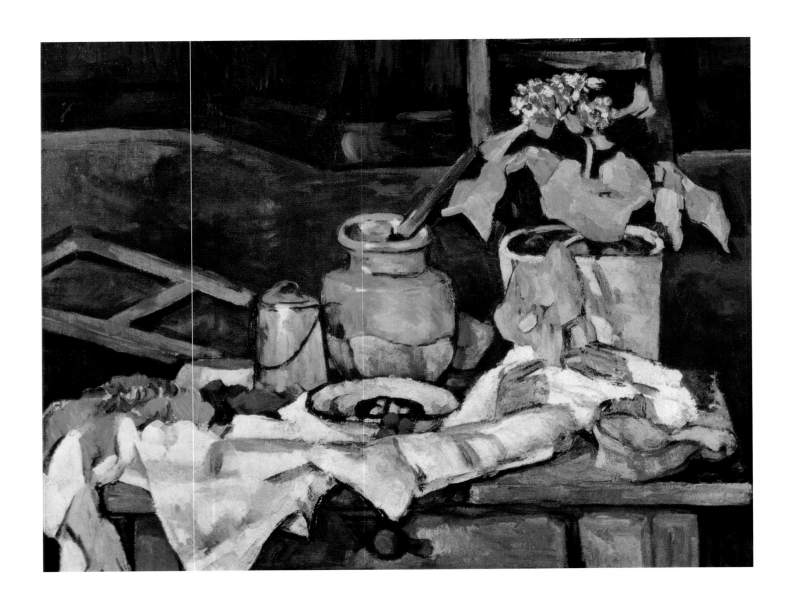

Vase of Flowers on a Table, 1882–1887.
Oil on canvas, 60 x 73 cm.
Private Collection, Paris.

Apples and Biscuits, 1879–1882.
Musée de l'Orangerie, Paris.

Pitcher, Fruits and Tablecloth, 1879–1882.
Oil on canvas, 60 x 73 cm.
Musée de l'Orangerie, Paris.

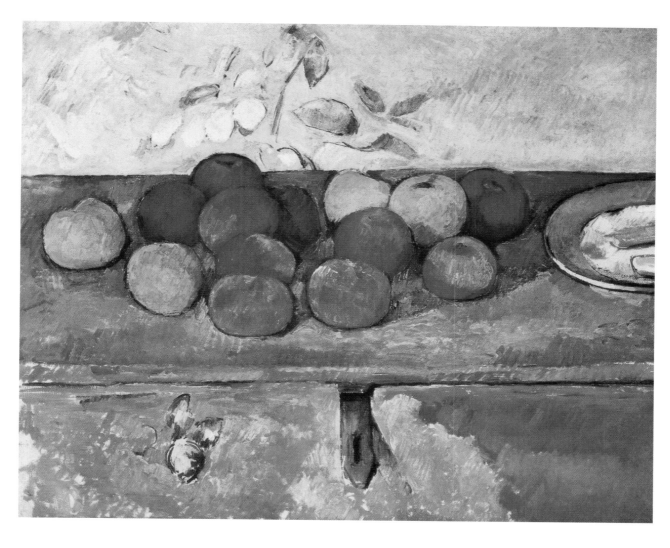

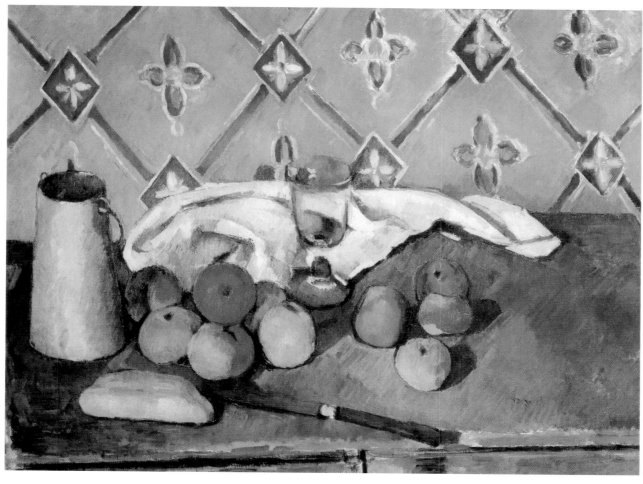

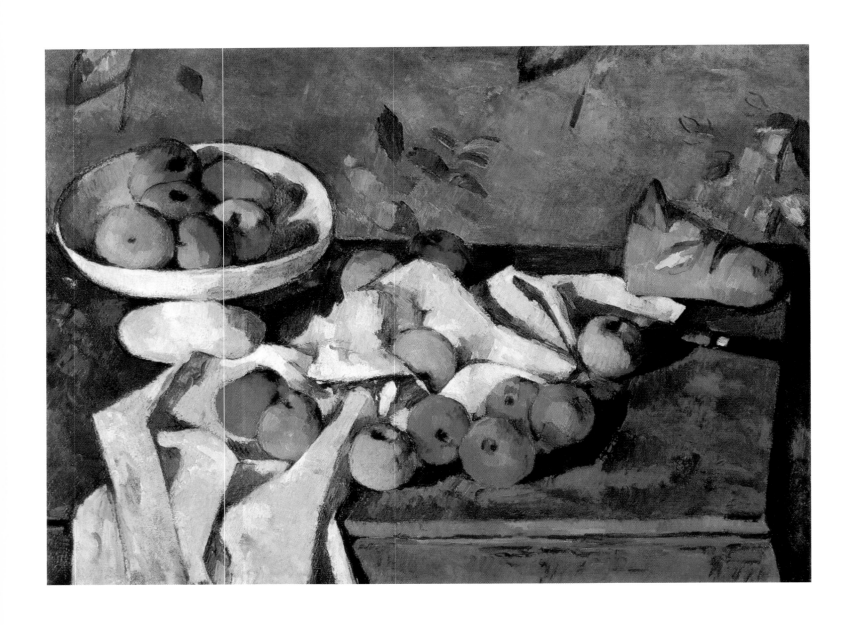

Dish of Apples, 1879–1882
Oil on canvas, 55 x 74.5 cm.
Collection Oskar Reinhart, Winterthur.

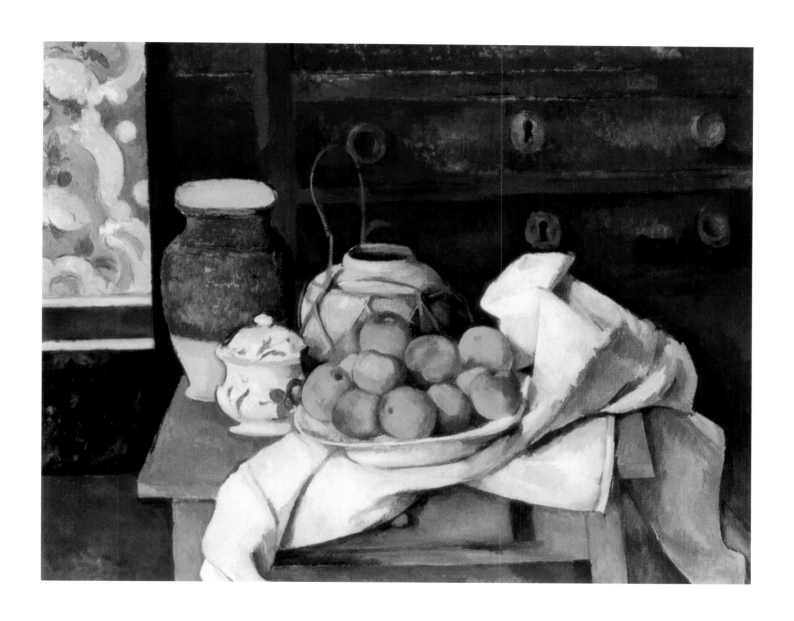

Still Life with a Chest of Drawers,
1883–1887.
Oil on canvas, 73.3 x 90.2 cm.
Bayerische Staatsgemäldesammlungen,
Neue Pinakothek, Munich.

Self-Portrait, 1879–1885.

7. Self-Portrait

1879–1885.
Oil on canvas. 45 x 37 cm. Signed below right: *P. Cézanne.*
Pushkin Museum of Fine Arts, Moscow.
Inv No. 3338.

The color modeling of the face is based upon expressive contrasts of greenish and orange tones. The manner of painting is a little harsh, with distinct contour outlines. Cézanne applies the paint with geometric brushstrokes. Barskaya is of the opinion that the portrait was executed in 1879, presumably in Paris. Ternovetz, Yavorskaya, Vladimir Prokofyev, and Istvan Genthon date it 1880. Venturi considers it to have been done in 1879–1882, while Rewald dates it to a period between 1882 and 1885. Several self-portraits similar to this one are known to have been painted between 1879 and 1885 (V. 365, 367, 371). Evidently the Moscow *Self-Portrait* was done in the same period.

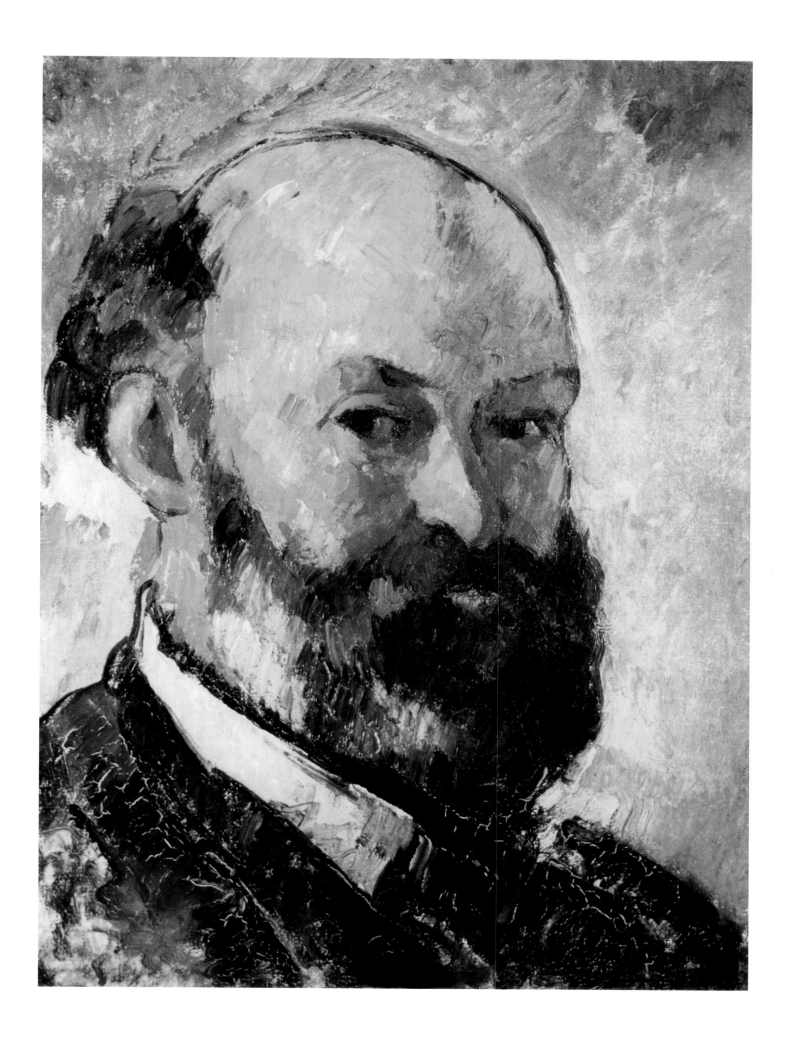

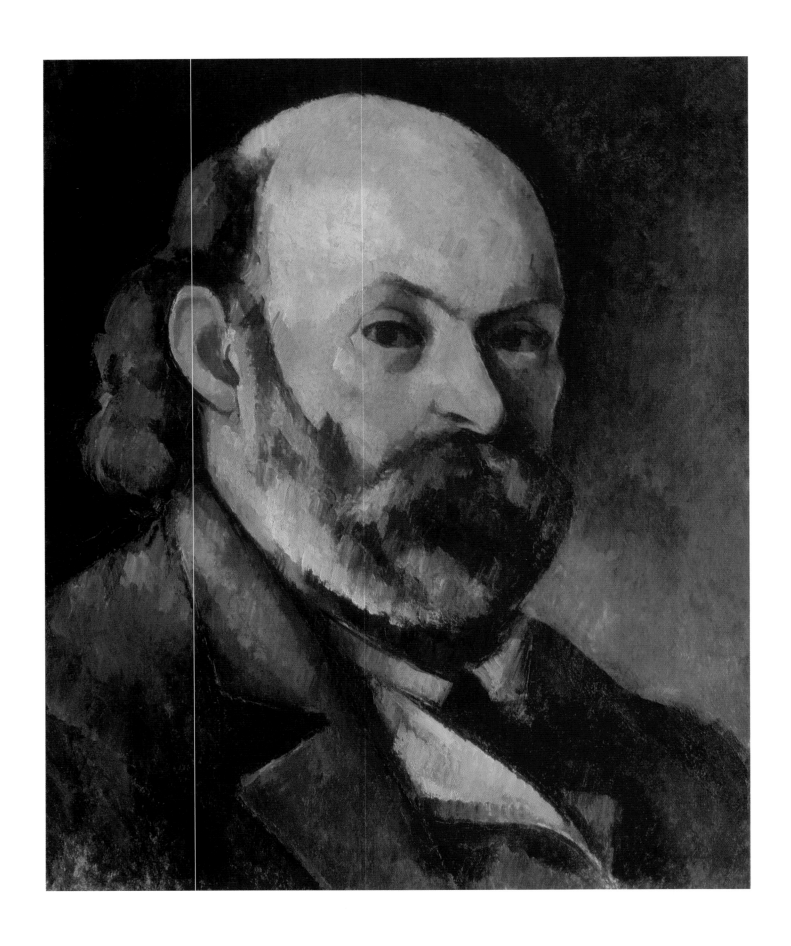

Self-Portrait, 1879–1882.
Oil on canvas, 39.5 x 24.5 cm.
Private Collection.

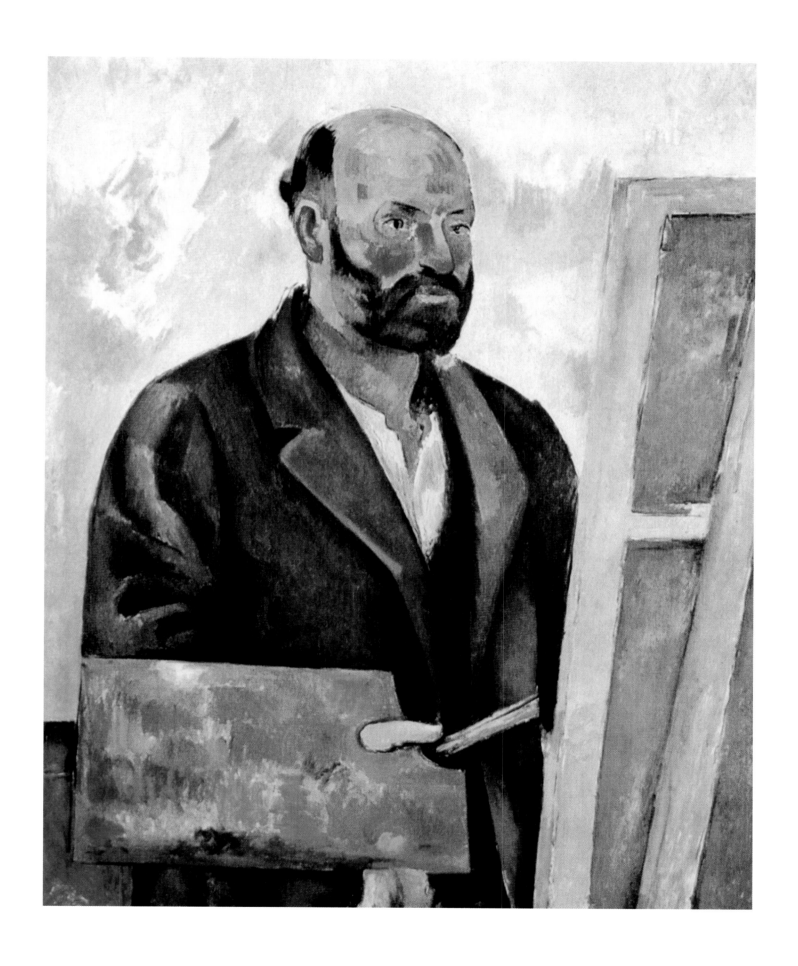

Self-Portrait with Palette, c. 1890.
Oil on canvas, 92 x 73 cm.
E. G. Bührle Foundation, Zurich.

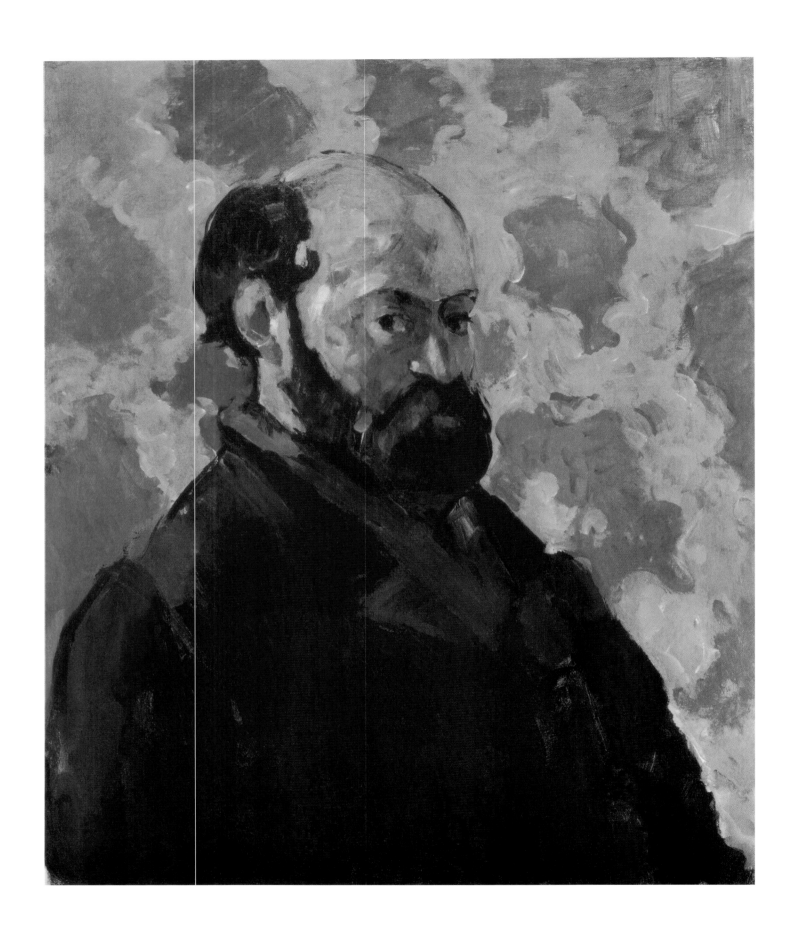

Self-Portrait with a Pink Background, c. 1875.
Oil on canvas, 65 x 54 cm.
Private Collection, Basel.

Self-Portrait, 1880–1881.
Musée d'Orsay, Paris.

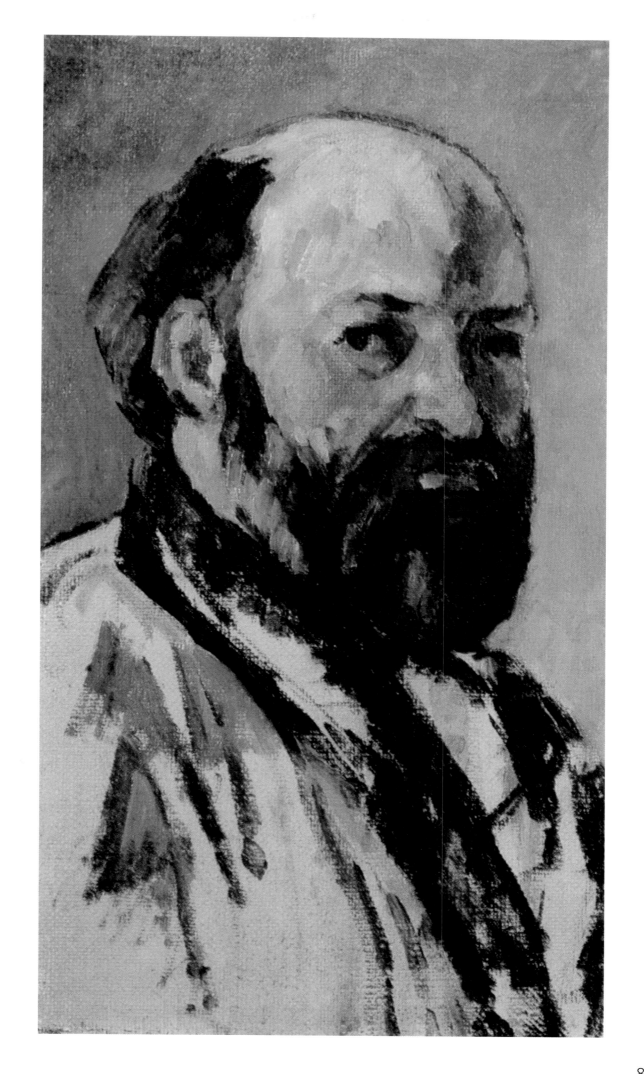

8. Plain by Mont Sainte-Victoire

1882–1885.
Oil on canvas. 58 x 72 cm.
Pushkin Museum of Fine Arts, Moscow.
Inv. No. 3412.

This landscape marks the beginning of one of the best stages in Cézanne's work, which is sometimes called his synthetic period. The painting depicts a plain on a sunny summer day, with a bluish chain of mountains on the horizon. On the left, one sees Mont Sainte-Victoire. On the stony hillsides, painted in gray and orange, bushes and trees stand out in green. In the foreground, parallel to the mountain ridge, stretches the orange ribbon of the road. On the right these is a little house. The sunlit bushes, stones, and the house in the middle ground are painted with thick brushstrokes, in contrast to the transparent blue sky and foreground. Compared to his earlier landscapes executed in an Impressionist manner, here are distinctly bounded planes, the material structure and volume of individual elements of the landscape are clearly designated, and color is intensified rather than the reverse.

Cézanne devoted an extensive series of oils, watercolors, and drawings to Mont Sainte-Victoire and its surroundings. In the Moscow canvas, one can already discern the specific color range worked out for the whole series and built up mainly on deep blues, oranges, and greens. Warm orange tones prevail since the earth takes up a considerable part of the canvas. In the later landscapes of this series, Cézanne gave preference to sonorous deep blues. Meier-Graefe dates the canvas c. 1880. In our opinion, it was evidently painted in 1882–1885, when Cézanne did a great deal of work in and around Aix. This dating is also corroborated by Venturi and Anna Barskaya. The Moscow canvas is stylistically close to another landscape with Mont Sainte-Victorie (Barnes Foundation, Merion, Pa; V. 424); a pencil drawing done for its right-hand part is kept in the Musée des Beaux-Arts in Basel (V. 1432).

84

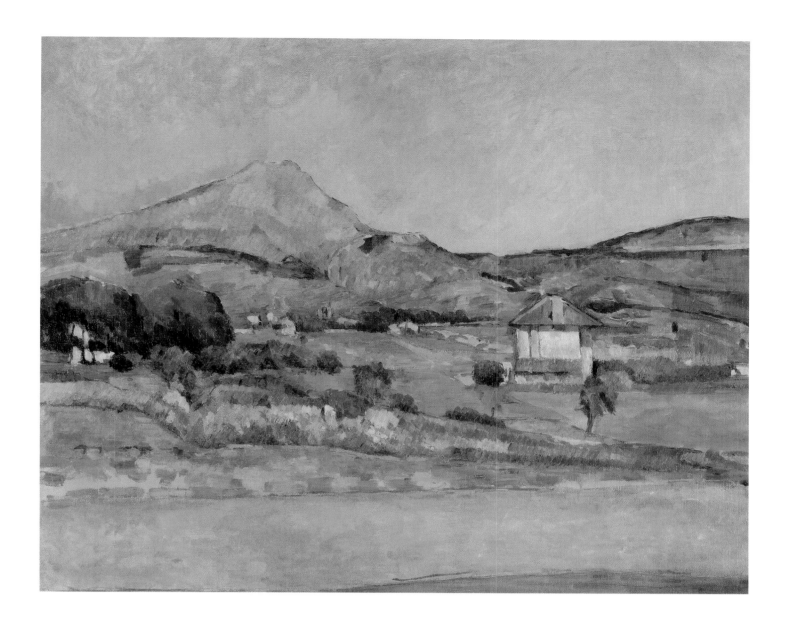

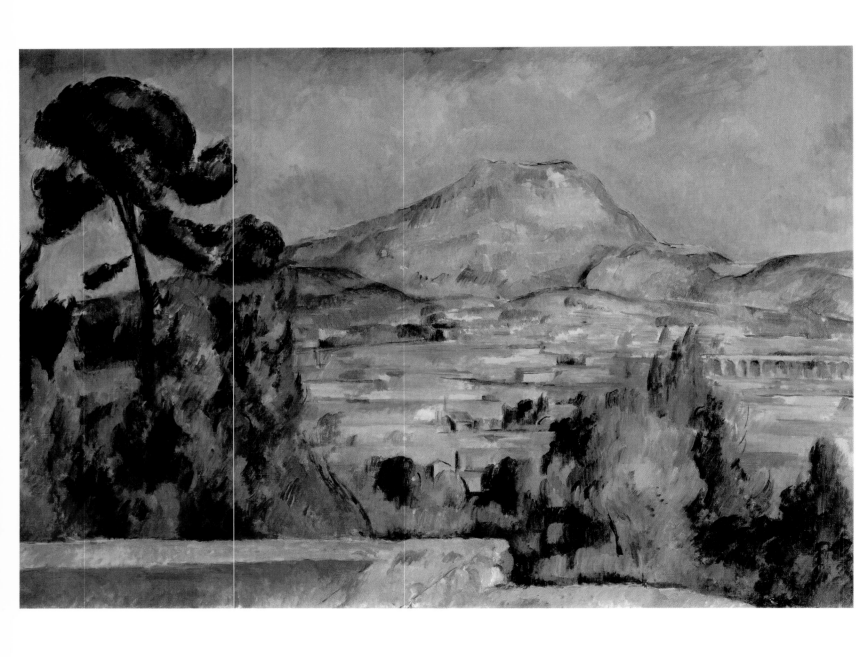

Mont Sainte-Victoire, 1883–1890.
Musée d'Orsay, Paris.

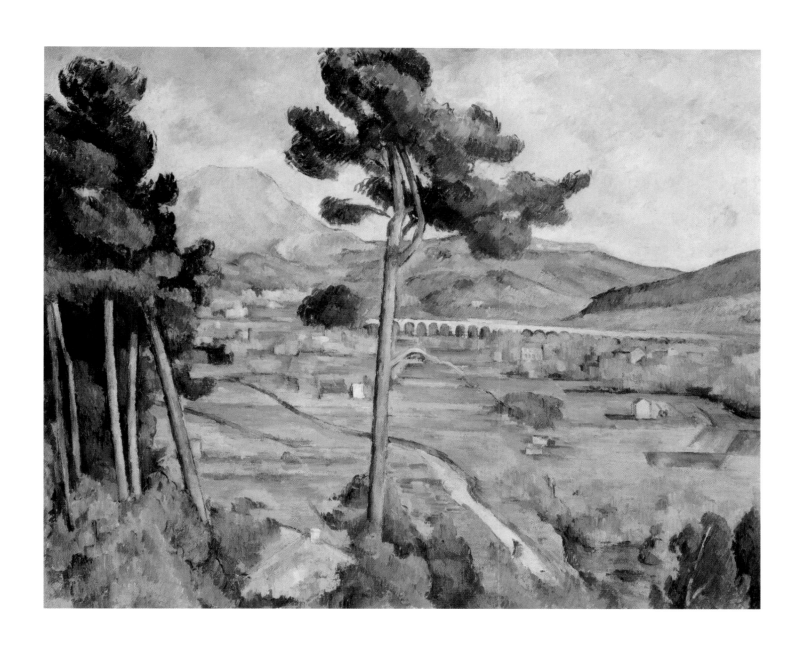

Mont Sainte-Victoire, View from Bellevue,
1882–1885.
Oil on canvas, 65.5 x 81 cm.
The Metropolitan Museum of Art,
New York.

9. Trees in a Park
(The Jas de Bouffan)

1885–1887.
Oil on canvas. 72 x 91 cm.
Pushkin Museum of Fine Arts, Moscow.
Inv. No. 3413.

Cézanne worked at his family estate, the Jas de Bouffan, not far from Aix-en-Provence, from 1859 to 1899. The estate was bought by Cézanne's father in 1859 and sold in 1899, after the death of the artist's mother. Dorival (see: Dorival 1948, p.5) mentions ten landscapes by Cézanne with views of the Jas de Bouffan and regards them as being among the finest portrayals of Provence. But Cézanne, in fact, painted views of the Jas de Bouffan more than ten times. Venturi believes that one of the first studies on this theme was painted by the artist between 1865 and 1867 (*Avenue at the Jas de Bouffan*, formerly in the Vollard collection, Paris, V. 38).

The Jas de Bouffan views are kept in various collections (V. 47, 160, 460, 461, 464, 465, 466, 467, 471, 476, 480, 648, 649, 942, etc.). The present canvas shows the park and the mansion of Jas de Bouffan. Its color range is built up of greens, blues, and yellows. The whole work is done with small dabs of thin paint, with thicker brushstrokes used for the houses. Ternovetz and Barskaya date the canvas 1885; Venturi puts it at 1885–1887, which seems more reliable. In some publications, for example a catalogue by Barskaya, the landscape is entitled *Chestnut Trees and Farm at the Jas de Bouffan*. A letter, sent by Ambroise Vollard to Ivan Morozov on June 5, 1911, and preserved in the archives of the Pushkin Museum, contains interesting information about the purchase of the painting: "I have received a cheque for 28,000 francs in payment for Cézanne's *Jas de Bouffan*." (Pushkin Museum of Fine Arts Archives, H/11, sheet 18).

Following Page:
Path in Jas de Bouffan, c. 1869.
Oil on canvas, 36 x 44 cm.
Tate Gallery, London.

Bassin in Jas de Bouffan, 1880–1890.
Oil on canvas, 64.8 x 80.9 cm.
The Metropolitan Museum of Art, New York.

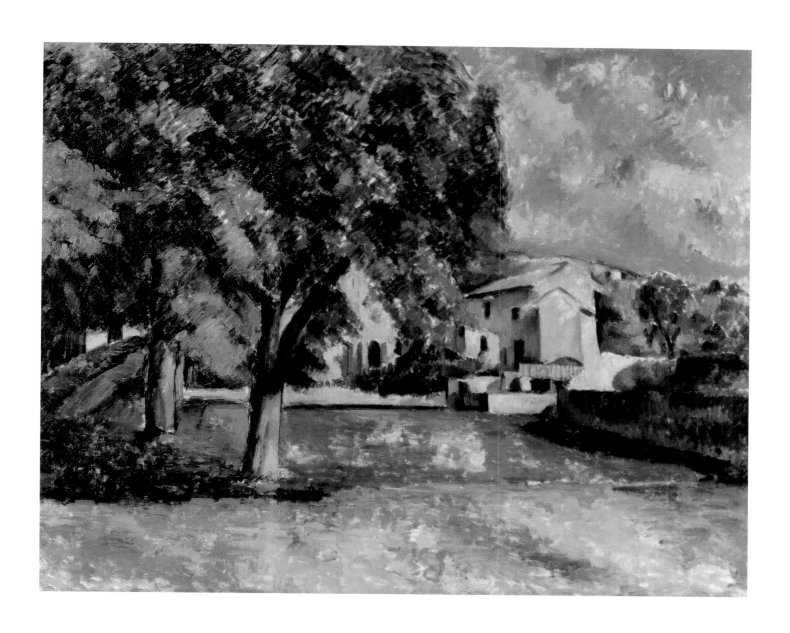

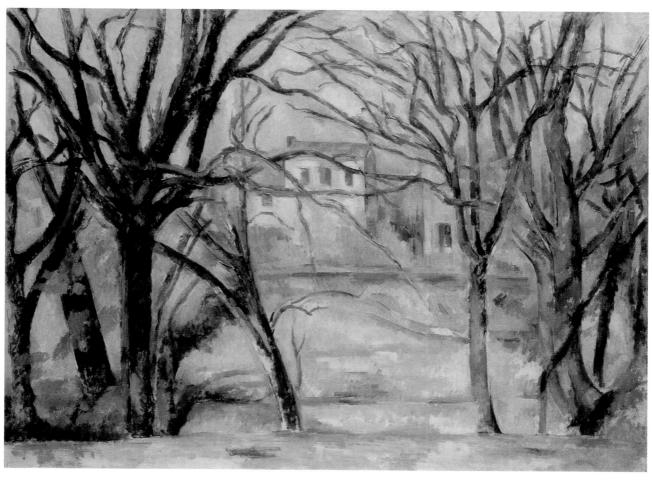

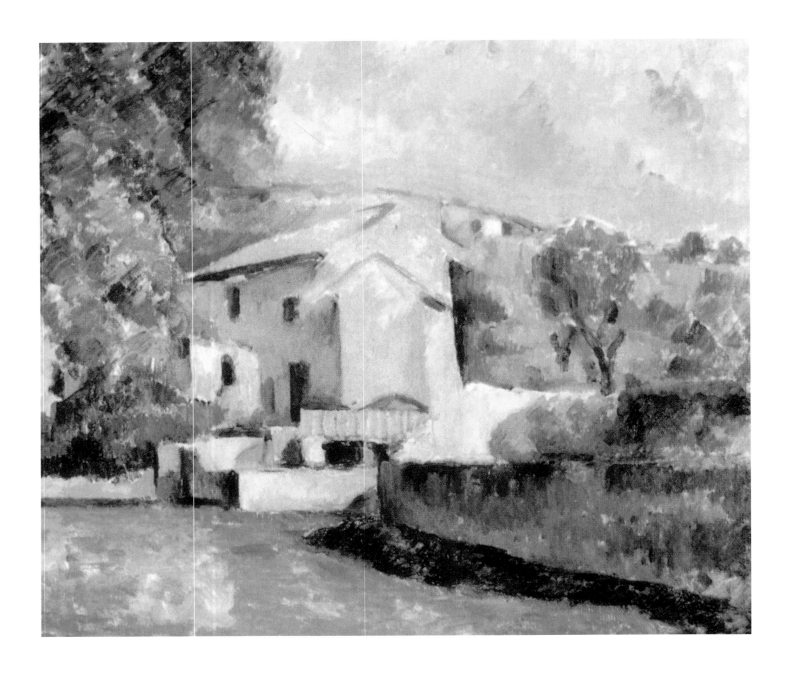

Previous Page:
Trees and House, 1885–1887.
Musée d'Orsay, Paris.

Path of Chestnut Trees in Jas de Bouffan in the Winter, 1885–1886.
Oil on canvas, 73.8 x 93 cm.
Institute of Art, Mineanapolis.

The Jas de Bouffan, 1885–1887. (Detail)
Oil on canvas, 72 x 91 cm.
Pushkin Museum of Fine Arts, Moscow.

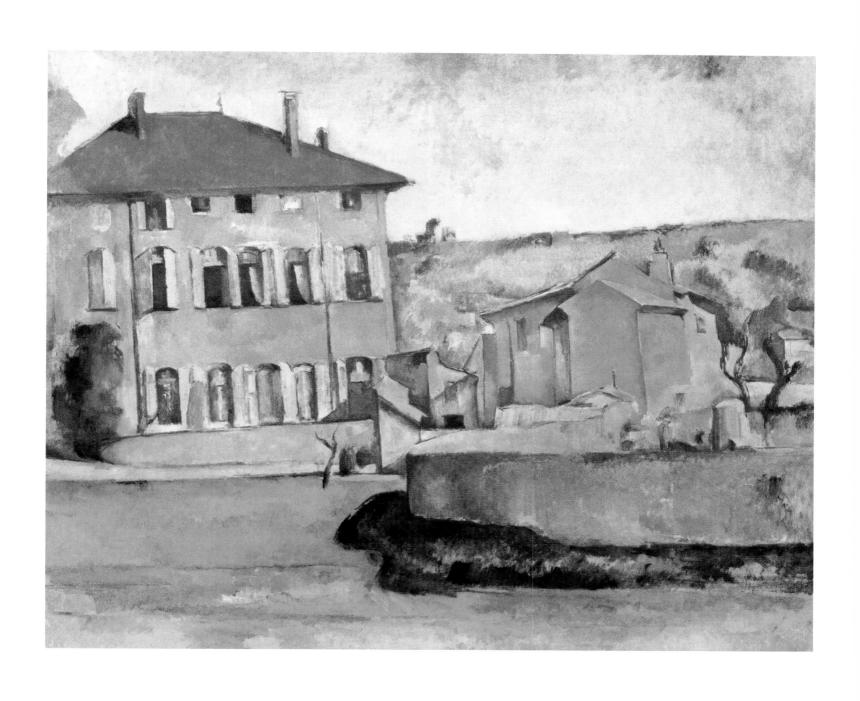

House and Farm in Jas de Bouffan,
1885–1887.
Oil on canvas, 60.5 x 73.5 cm.
Narodni Galerie, Prague.

10. The Aqueduct

1885–1887.
Oil on canvas. 91 x 72 cm.
Pushkin Museum of Fine Arts, Moscow.
Inv. No. 3337.

The landscapes painted in the vicinity of Aix belong to Cézanne's finest works in this genre. Through the group of pines with tall trunks, glimpses of the aqueduct can be seen and beyond it, on the horizon, a mountain ridge. On the left, the outline of Mont Sainte-Victoire stands out . Basically the picture is built upon a combination of three colors: blue (sky and mountains), green (grass and treetops), and orange (the sun-scorched earth). The treetops are painted in impasto; the rest is of a thinner texture.

In 1885, Maxime Conil, Cézanne's brother-in-law, bought Bellevue, an estate not far from Aix. Cézanne often worked there from 1885 onward. The same locality with the aqueduct is depicted in *Mont Sainte-Victoire* of 1885–1887 in The Metropolitan Museum of Art, New York (V. 452). In Nürenberg's monograph and the catalogue of the Shchukin collection, the Moscow painting is entitled *Mont Saint-Jean*. Charles Sterling dates it to 1889–1900, René Huyghe to 1890–1900, Peter Feist c. 1887, and Venturi and Barskaya to 1885–1887, which seems more likely. In the inventory of the Museum of Modern Western Art in Moscow, there is the following entry in regard to this work: "The painting was varnished by Matisse while in Moscow (in 1913), at Sergei Shchukin's house." The year of Matisse's sojourn in Moscow is erroneous, for in fact he was there in 1911. Several drawings relating to this landscape were published by Adrien Chappuis.

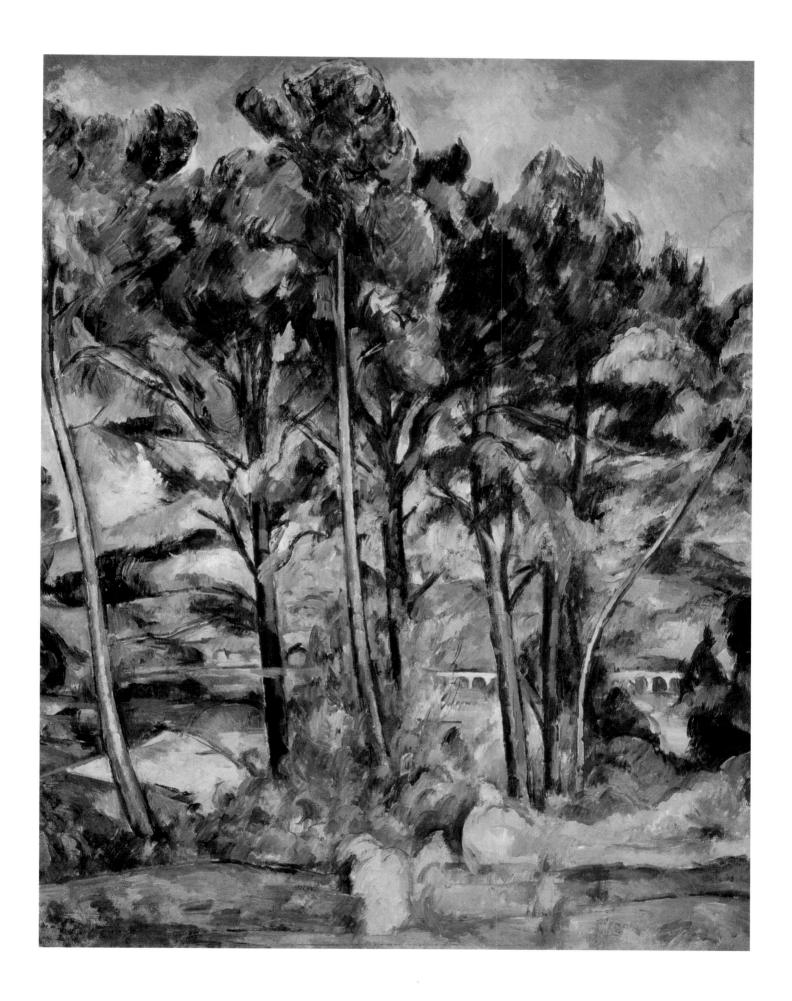

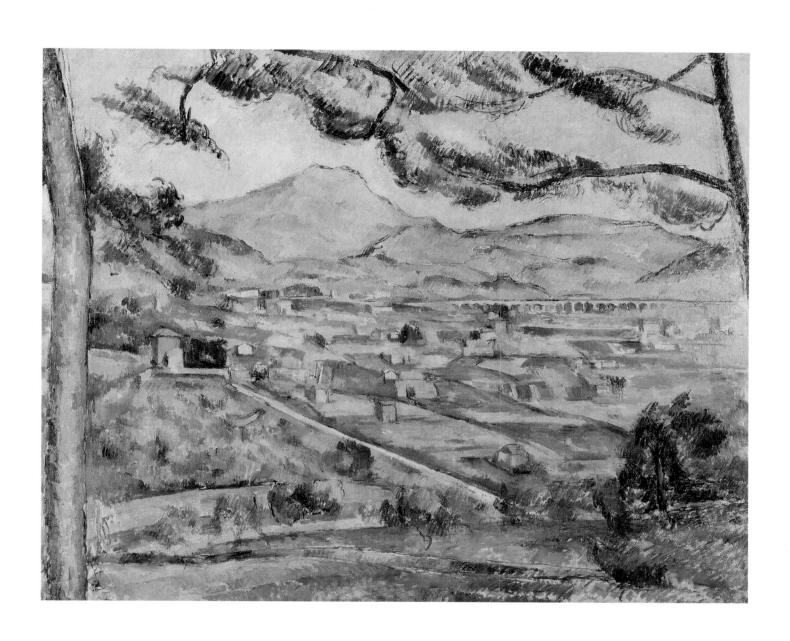

Trees in a Park, 1874.
Lead pencil, 23.6 x 17.7 cm.
Graphische Sammlung Albertina, Vienna.

The Great Pine (*Mont Sainte-Victoire*),
1886–1887.
Oil on canvas, 60 x 73 cm.
Phillips Collection, Washington DC.

11. The Banks of the Marne
(Villa on the Bank of a River)

1888.
Oil on canvas. 65 x 81 cm.
Hermitage, St. Petersburg.
Inv. No. 6513.

This picture was evidently painted in 1888, when Cézanne was living in Paris in an apartment he rented at 15, Quai d'Anjou and often working in the Parisian suburbs and on the banks of the Marne.

The date and title of this canvas are defined through a comparison with the motif of *The Banks of the Marne* (Pushkin Museum of Fine Arts; Plate 23), reproduced by Ambroise Vollard in his book on Cézanne (1914 edition) under the title *Les Bords de la Marne*, dated 1888.

Two other pictures and a watercolor that are dated the same year, 1888, and repeating the same motif are known (V. 629, and a landscape not included in Venturi's catalogue, now in the White House, Washington; V. 395 — watercolor).

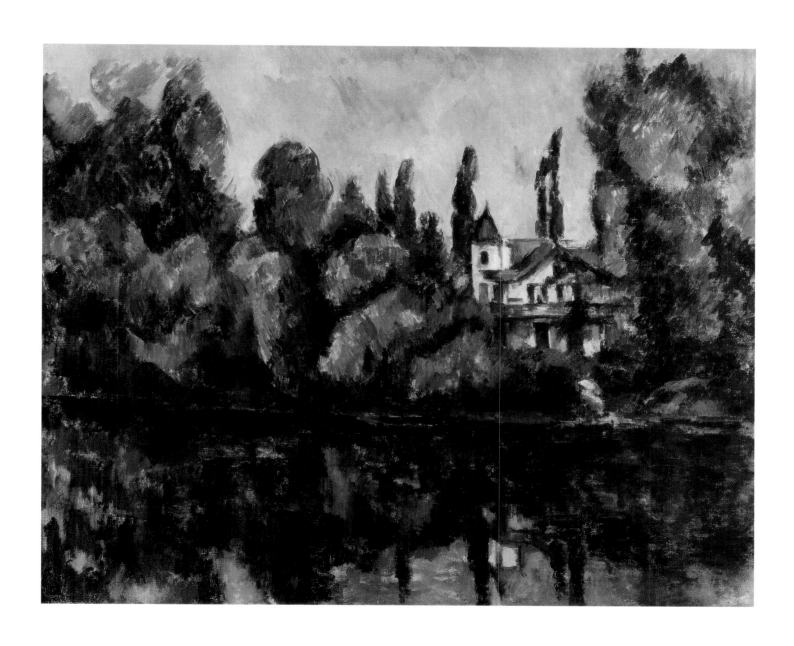

12. The Banks of the Marne

1888.
Oil on canvas. 71 x 90 cm.
Pushkin Museum of Fine Arts, Moscow.
Inv. No. 3416.

Cézanne depicted this locality on more than one occasion. It can be recognized in at least five of his works, notably the Hermitage *Banks of the Marne (Villa on the Bank of a River)* of the same year, two paintings in the Paris collections of Mr. and Mrs. René Lecomte (V. 632) and Baron Goldschmidt-Rothchild (V. 629), and also in a watercolor sketch (V. 935). Evidently the same locality figures in the *Bridge at Maincy* (Musée d'Orsay, Paris).

The landscape is painted in various shades of green: the trees on the bank in big dense spots of color, with geometric brushstrokes; the blue summer sky in less thick color, so that the canvas shows through in places. The red roof of the little house and the green grass on the bank are the most intensive color accents in this picture. The light-and-air medium is virtually absent, and the treetops are distinctly reflected in the water. *The Banks of the Marne* has an extraordinary sense of balance in the distribution of color patches and in the compositional scheme, and rightly belongs to the best of Cézanne's landscapes. It is most often dated 1888 (Vollard, Venturi, Barskaya and so forth), which appears to be correct. A number of authors, however (among them Fritz von Novotny and Clive Bell), have dated it around 1893–1895 or 1893.

The canvas is also known under other titles. Fritz Burger calls it *Bridge at Puteaux*, Venturi *Bridge at Creteil*, Huyghe *Ile-de-France. Bridge across the Marne*, and Barskaya *Bridge on the Marne at Creteil*.

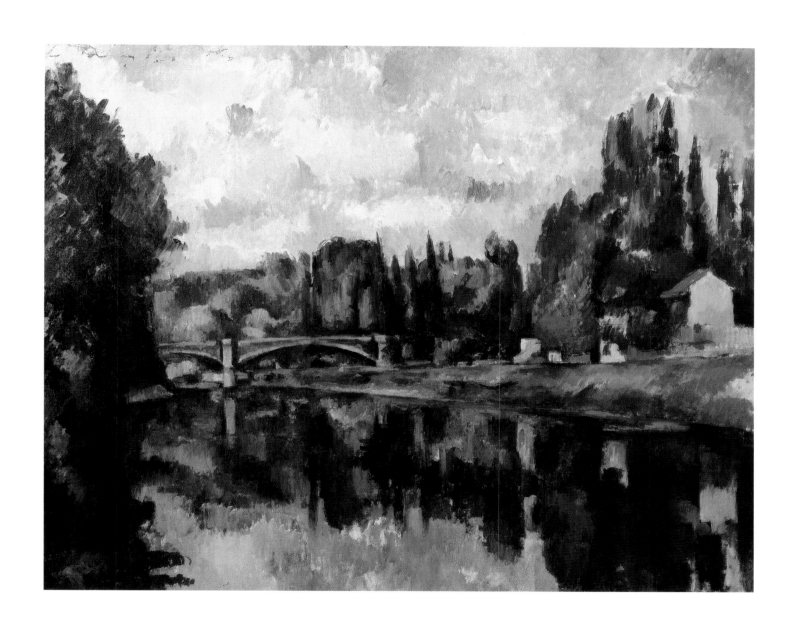

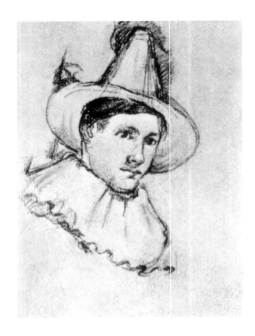

Louis Guillaume in the Costume of Pierrot, 1888.

13. Pierrot and Harlequin (Mardi Gras)

1888.
Oil on canvas. 102 x 81 cm.
Pushkin Museum of Fine Arts, Moscow.
Inv. No. 3335.

This picture portrays the characters Pierrot (left) and Harlequin (right) from the Mardi Gras carnival. It is painted in dense strokes, and outlines are clearly visible. The melancholic expressions on the faces of the models, the nature of the movement, and the specific arrangement of the figures, give the painting a mood of disquiet, almost tragedy, quite out of keeping with the theme of a carnival. Harsh contrasts are also used in the young men's costumes — the loose coat worn by Pierrot and the closely fitting ensemble of Harlequin — which differ sharply both in their form and color. The models were Louis Guillaume (Pierrot) and Paul Cézanne, the artist's son (Harlequin). On the evidence of the latter, another picture known as *Mardi Gras* was painted in 1888 in Cézanne's studio on Rue du Val-de-Grace, Paris. Three oil studies of Harlequin (V. 553, 554, 555) are known in addition of five drawings, including four mentioned by Venturi (1079, 1473, 1486, 1622); the fifth drawing was published by Adrien Chappuis (Chappuis 1973, No. 944). In his opinion, the model for the figure of Harlequin in the three studies mentioned above and the drawing published by the author was not the artist's son, but another boy. The study which is nearest to the Moscow painting is in the Pellerin collection in Paris (V. 554). Dorival ascribes the present canvas to a genre rarely tackled by Cézanne. In 1888, *Mardi Gras* was bought from the artist by Victor Chocquet and was in his Paris collection until 1889. The catalogue for the sale of Chocquet's widow's collection contains the measurements of the picture and a statement that it was sold for 4,400 francs.

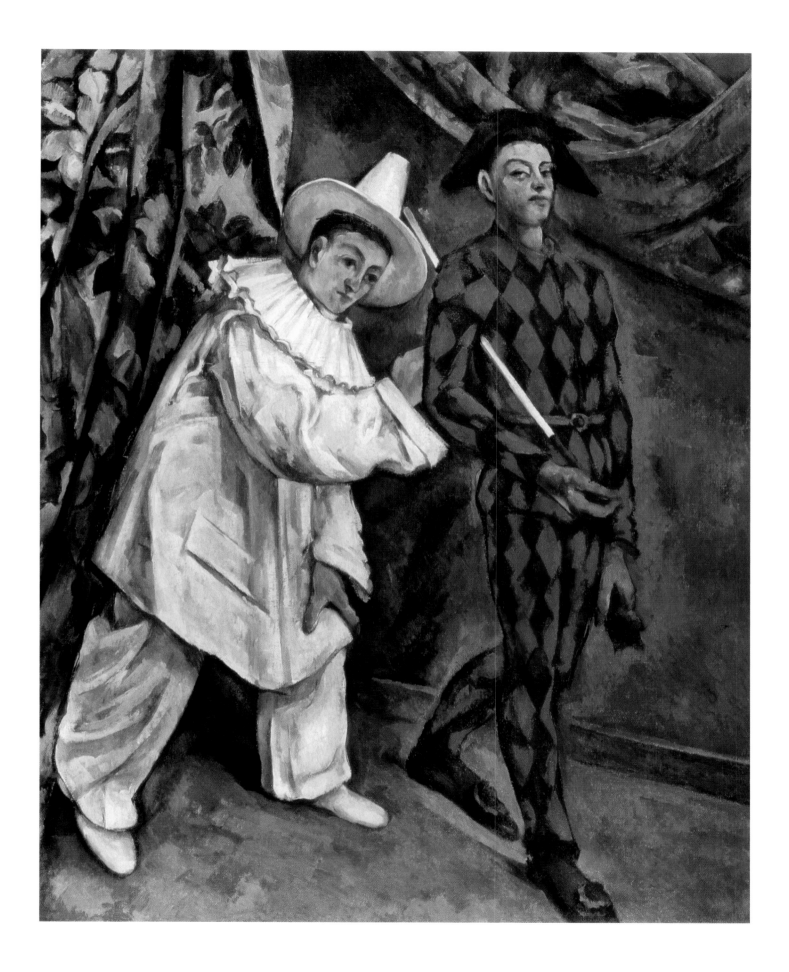

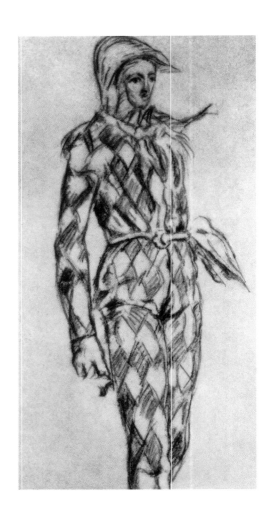

Study for the painting "Mardi Gras,"
c. 1888.
Musée d'Orsay, Paris.

Harlequin, 1888–1890.

Harlequin, c. 1889–1890.
Oil on canvas, 92 x 65 cm.
Rothschild Collection, Cambridge.

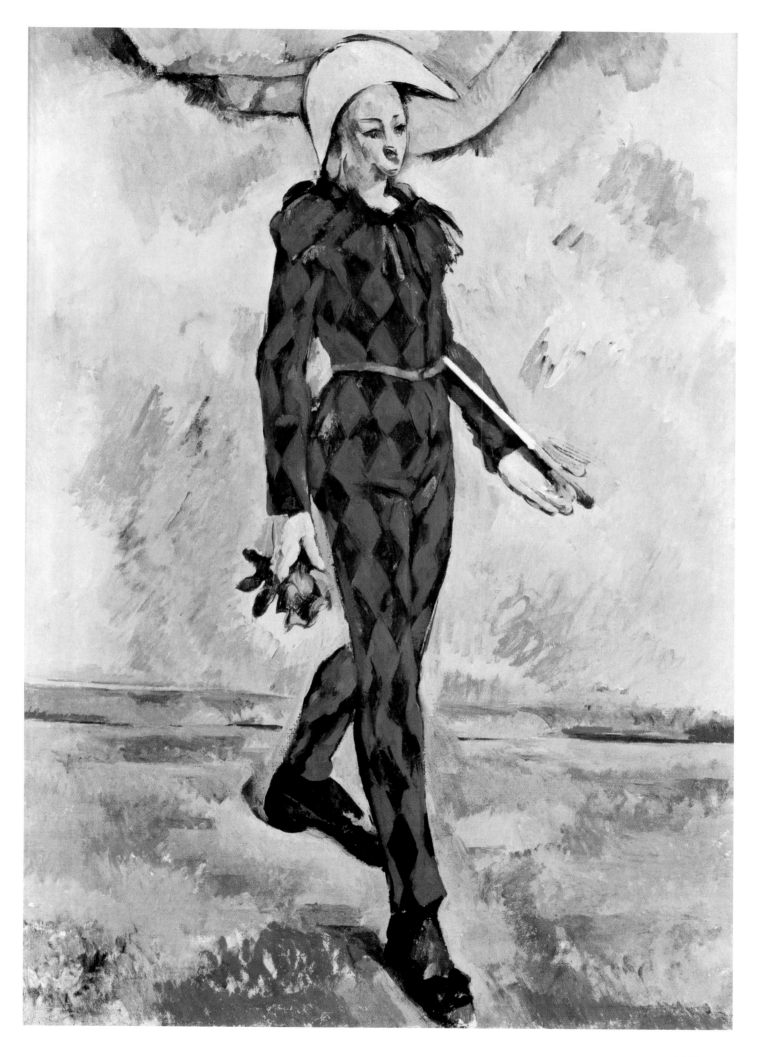

14. Bridge and Pool

1888–1890.
Oil on canvas. 64 x 79 cm.
Pushkin Museum of Fine Arts, Moscow.
Inv. No. 3417.

Most Cézanne researchers (Venturi, Barskaya, and Feist) date this painting to 1888–1890, with which one can completely agree. Stylistically it is close to *The Banks of the Marne* in the Pushkin Museum of Fine Arts and *The Banks of the Marne* (*Villa on the Bank of a River*) in the Hermitage.

The landscape is constructed on a combination of various shades of green and patches of gray canvas, which are visible here and there. Warm brown tones are concentrated in the center of the composition and predominate in the representation of the bridge. The paint is applied thinly, and the brushstrokes are geometrized, running at angles to one another. This picture shows quite clearly certain principles of Cézanne's technique that were adopted by the Cubists several decades later.

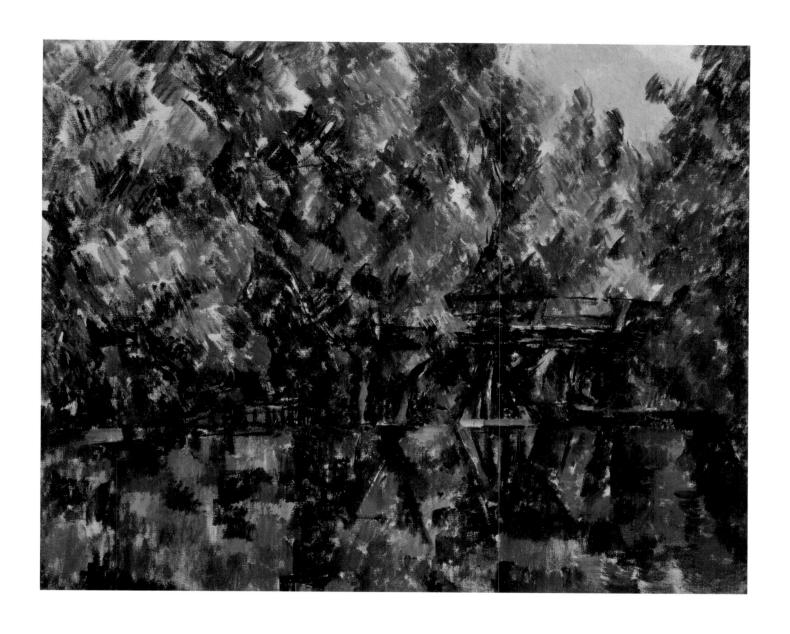

15. Bathers (Study)

Early 1890s.
Oil on canvas. 26 x 40 cm.
Pushkin Museum of Fine Arts, Moscow.
Inv. No. 3414.

Cézanne repeatedly turned to this theme in the 1880s and 1890s. The outdoor nude figures out-of-doors seemed to him an embodiment of the harmonious, unbreakable unity of man and nature, and as such were regarded as the most suitable motif for realizing his dream of a monumental composition that would convey his generalized, synthesized conception of the world. Cézanne was searching for ways of tackling this theme both in large canvases and in small studies. In delicacy and beauty of color harmony, this work is one of the finest in this series.

The study is painted lightly, the color being almost transparent, with cold halftones predominating. Its closest analogies are the studies V. 590 and 591. The Musée d'Orsay in Paris houses yet another study, *Bathers* (1890–1894), which is stylistically very similar to the Moscow work but considerably smaller and executed in a fluent manner.

There are differences of opinion about the dating of the Pushkin Museum study. Meier-Graefe dates it 1888, Barskaya around the late 1880s-early 1890s, while Venturi, Dorival, and Feist put it at 1892–1894. The lightened palette and the abundance of blue tones inclines one to the view that the latter dating is most probable.

In the collection of Cézanne's son, there is a pencil sketch for the standing figure holding a towel in the center of the study. A sketch, dated 1885, for the standing figure and raised arms is in the Chappuis collection. Both sketches have been published by Rewald in *Correspondance de Paul Cézanne* (1st ed., 1937, drawing 5; 2nd ed., 1978, drawing 7).

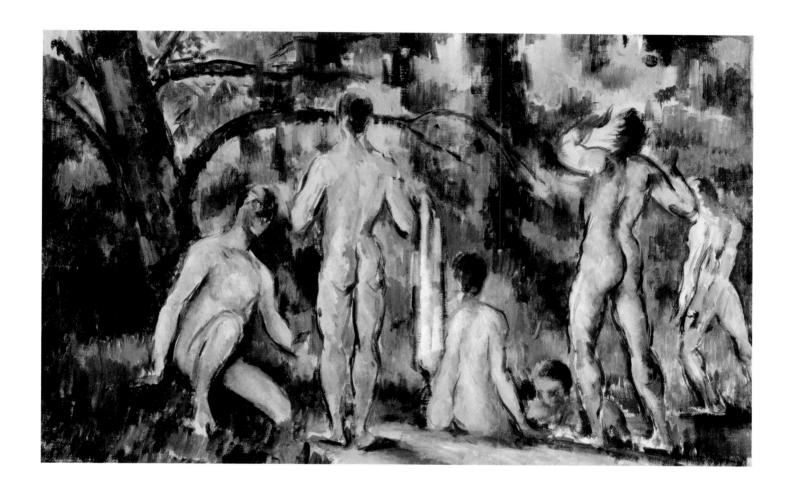

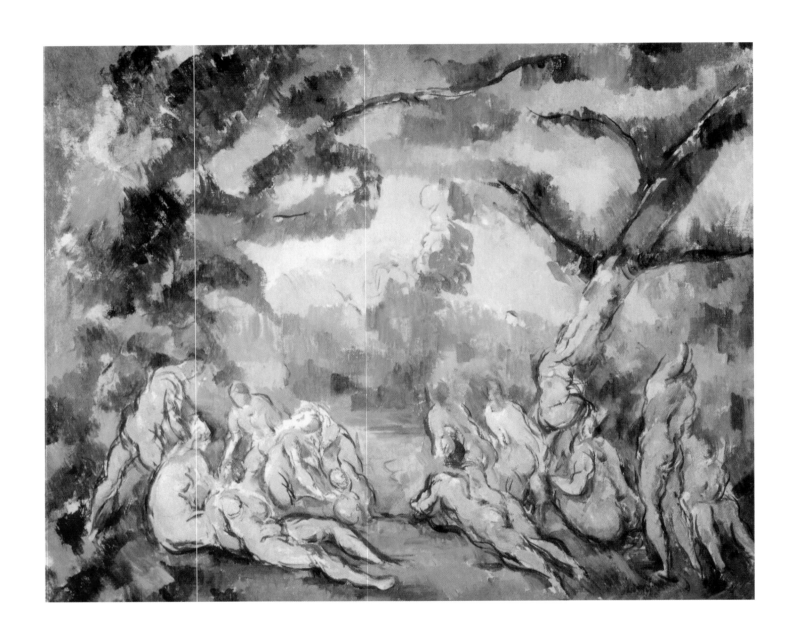

Bathers, 1900–1905.
Oil on canvas, 50 x 61 cm.
The Art Institute of Chicago, Chicago.

Bathers, 1874–1875.
Oil on canvas, 38 x 46 cm.
The Metropolitan Museum of Art,
New York.

110

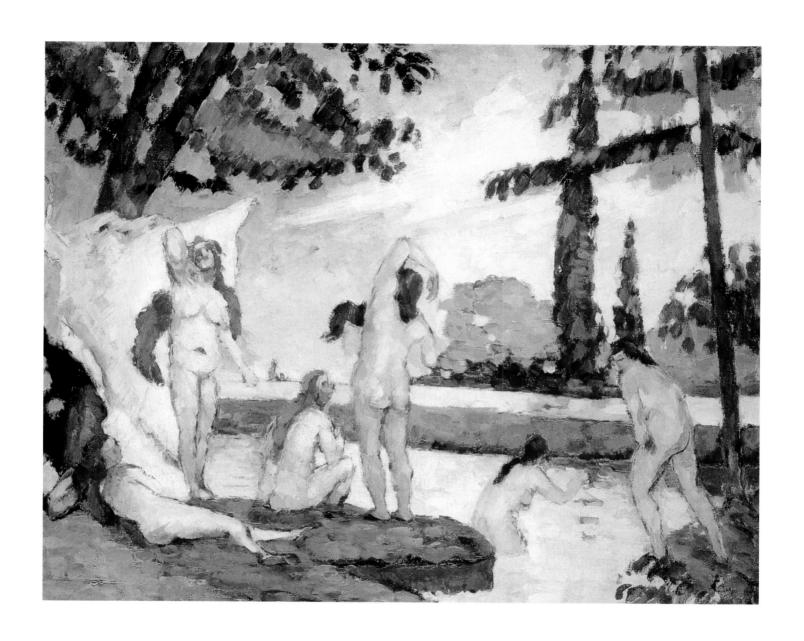

Following Pages:
The Great Bather, c. 1885.
Oil on canvas, 127 x 96.8 cm.
The Museum of Modern Art, New York.

Bathers, 1890–1900.
Oil on Canvas, 22 x 35.5 cm.
Musée d'Orsay, Paris.

Five Bathers, 1892–1894.
Oil on canvas, 22 x 33 cm.
Musée d'Orsay, Paris.

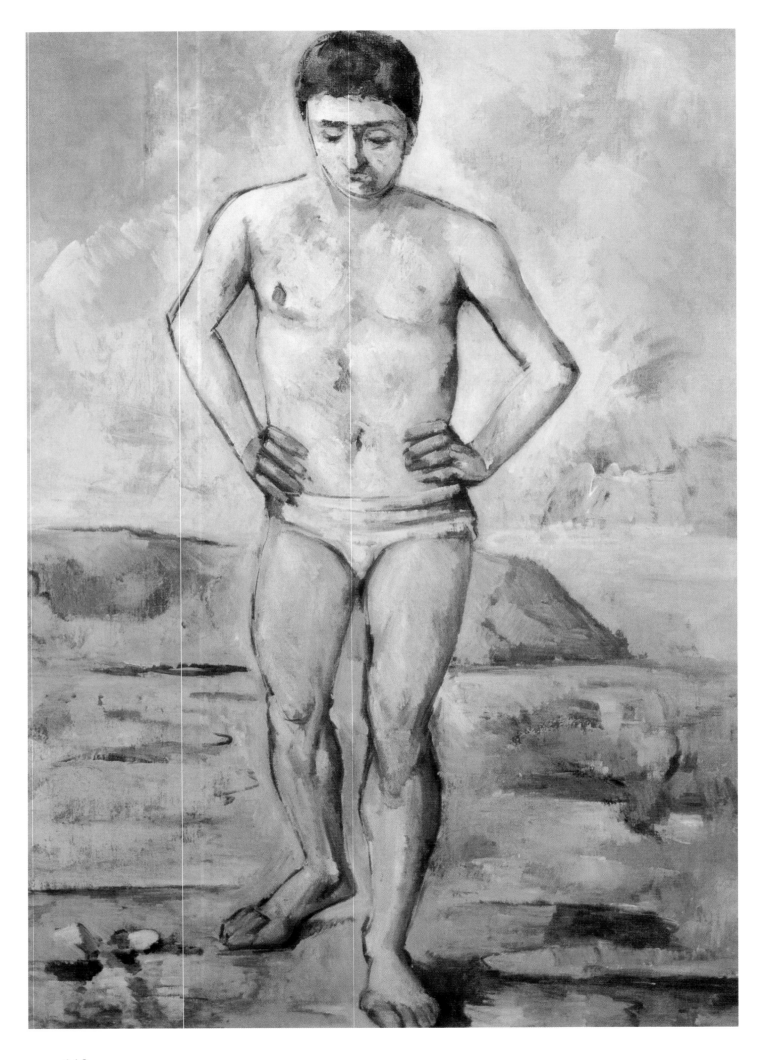

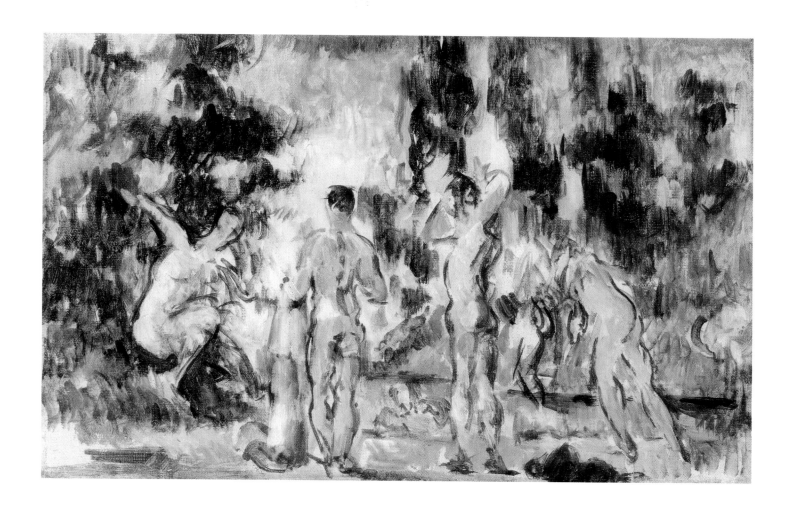

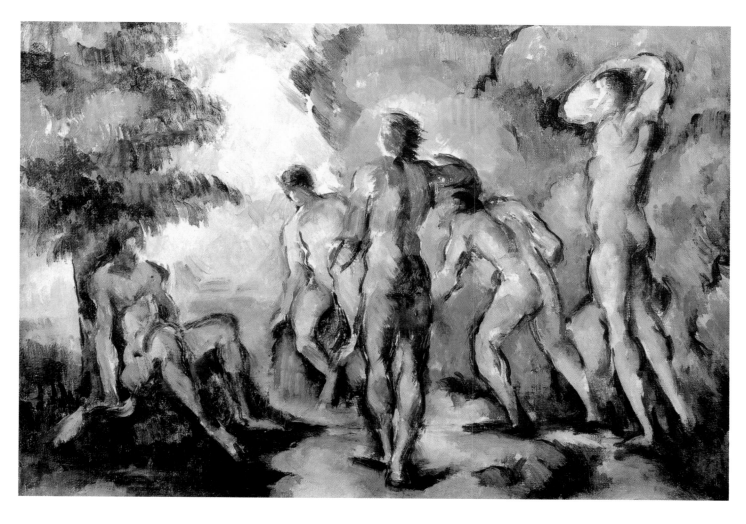

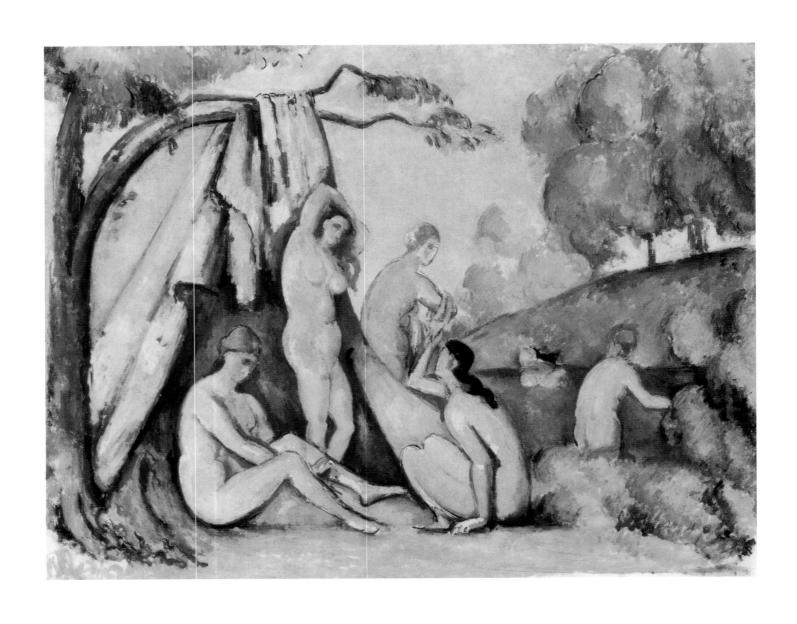

Bathers in front of a Tent, 1883–1885.
Oil on canvas, 63.5 x 81 cm.
Staatsgalerie, Stuttgart.

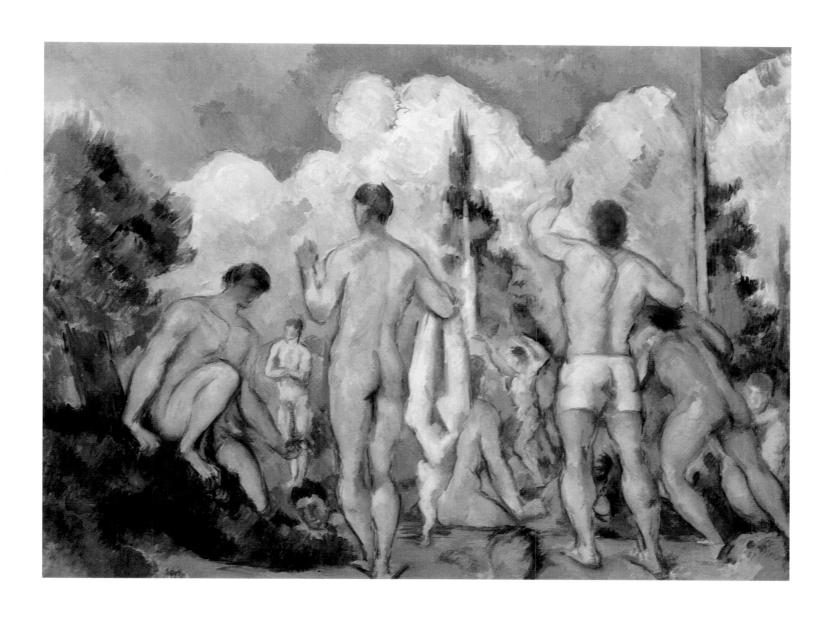

Bathers, c. 1895.
Musée d'Orsay, Paris.

16. Peaches and Pears

1888–1890.
Oil on canvas. 61 x 90 cm.
Pushkin Museum of Fine Arts, Moscow.
Inv. No. 3415.

There is no classical modeling in chiaroscuro, the picture being based on a comparison of different colors, and a special subtlety of gradations distinguishes the white objects — the tablecloth and the china. Impasto is used here, the background is painted lightly, with the canvas showing through in places. In the catalogue of the Cézanne exhibition at the Orangerie in Paris, Sterling dates this painting 1886. The dating given by Venturi and Barskaya is 1888–1890; Feist puts it at around 1889. Most probably it was painted between 1888 and 1890.

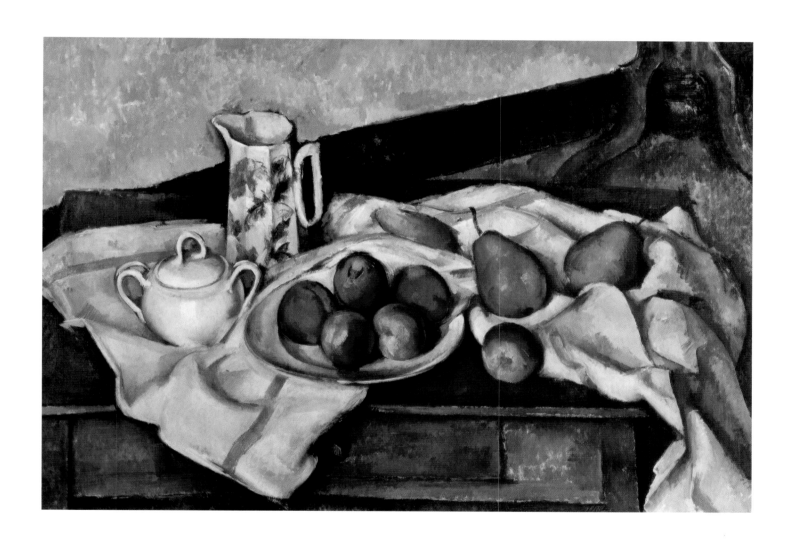

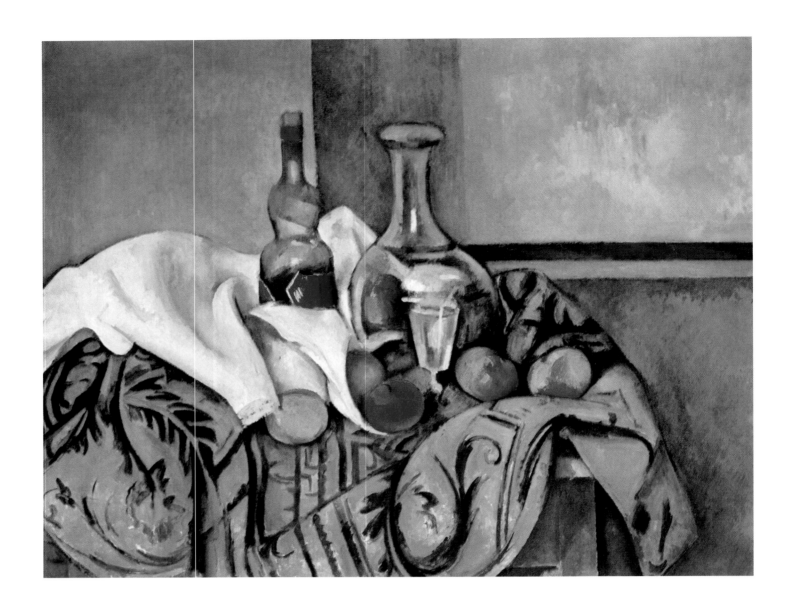

A Bottle of Peppermint, 1893–1895.
Oil on canvas, 65.9 x 82.1 cm.
National Gallery of Art, Washington DC.

Fruits, 1879–1880.
Oil on canvas, 45 x 54 cm.
Hermitage, St. Petersburg.

Still Life with Basket, c. 1888–1890.
Musée d'Orsay, Paris.

118

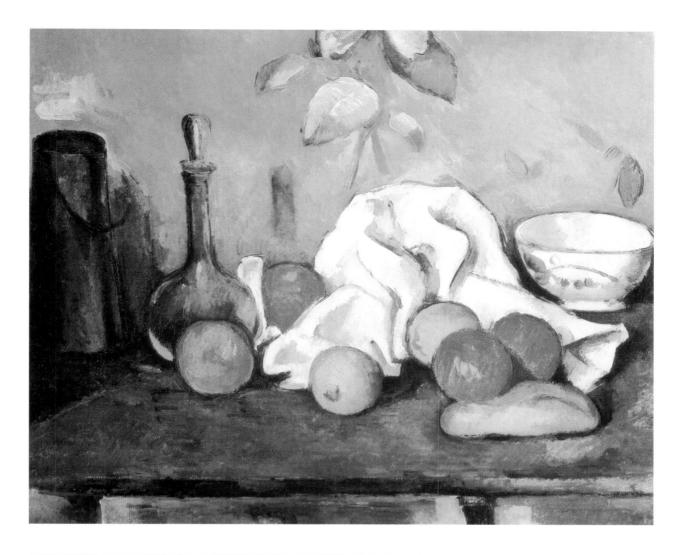

17. Great Pine near Aix

Late 1890s.
Oil on canvas. 72 x 91 cm.
Hermitage, St. Petersburg.
Inv. No. 8963.

The Hermitage painting depicts the Arc River Valley, south of Aix, with a tall pine in the foreground. Venturi dates it from between 1885 and 1887, basing his view on the fact that another canvas known under the same title and featuring the same motif (V. 459, formerly in the Lecomte collection, Paris) was produced at the same time.

However, the two pictures differ in the manner of execution. The one formerly in the Lecomte collection can with certainty be dated to the 1880s while the Hermitage canvas, as Yavorskaya justly believes, was produced ten years later. This is also supported by the reddish-brown color scheme of the picture, a scheme which Cézanne used in the mid-1880s, for example in his *Smokers* and *Card Players* series, *Portrait of Gustave Geffroy* of 1895 (V. 692), and *Portrait of Joachim Gasquet* of 1896–1897 (V. 695). Moreover, the Hermitage landscape is marked by a great freedom of treatment and a special, dynamic sensation of depth typical of Cézanne's later canvases. The trunk of the tree creates a strong vertical around which the space of the picture is unfolded; the curved, interwoven branches complicate the construction. The free blurred patches of color in the background are seen through the network of branches as a shifting spatial mass that continually retreats and advances as one looks at it. The pine-tree motif also figures in a watercolor (V. 1024) and a pencil drawing.

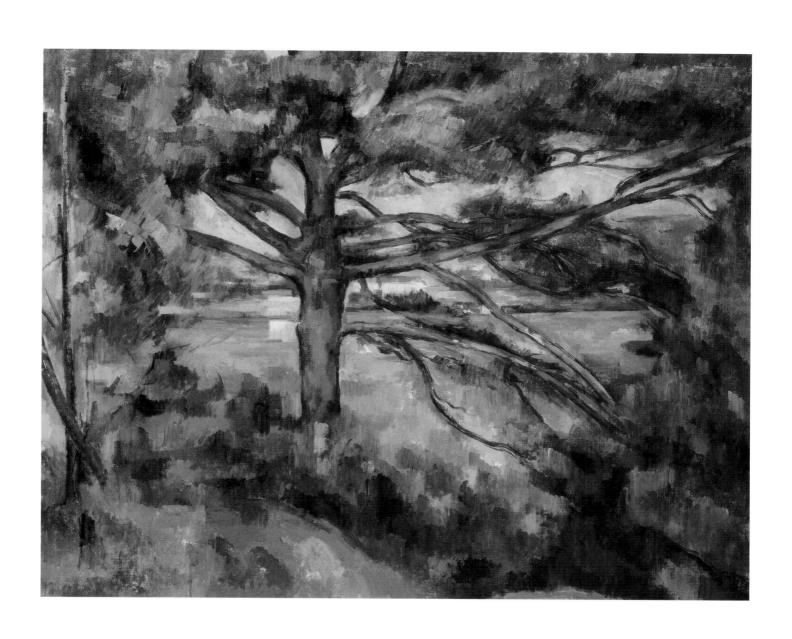

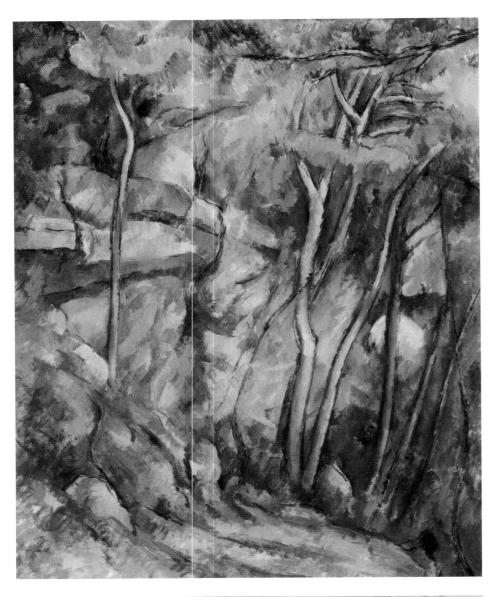

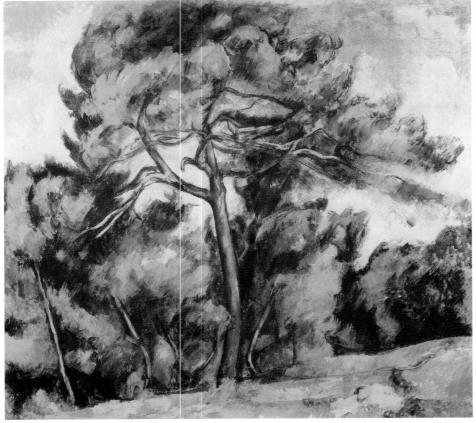

In the Park of the Château Noir, c. 1900.
Oil on canvas, 92 x 73 cm.
Musée de l'Orangerie, Paris.

Great Pine, c. 1896.
Oil on canvas, 84 x 92 cm.
Museu de Arte, Sao Paulo.

The Château Noir, 1904–1906.
Oil on canvas, 73.6 x 93.2 cm.
The Museum of Modern Art, New York.

Rocks in the Woods, c. 1893.
Oil on canvas, 51 x 61.5 cm.
Kunsthaus, Zurich.

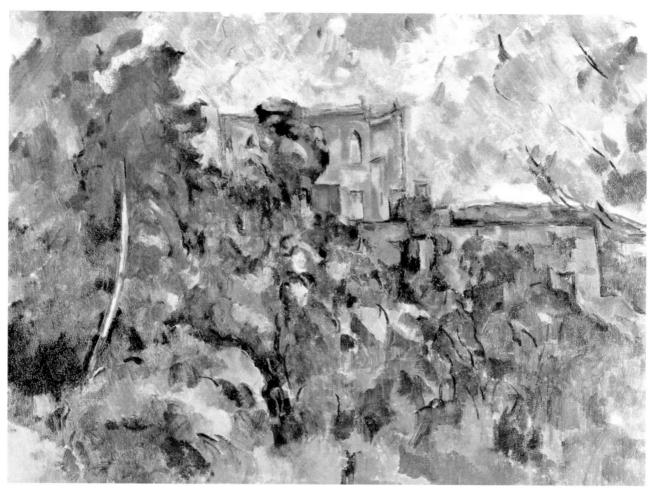

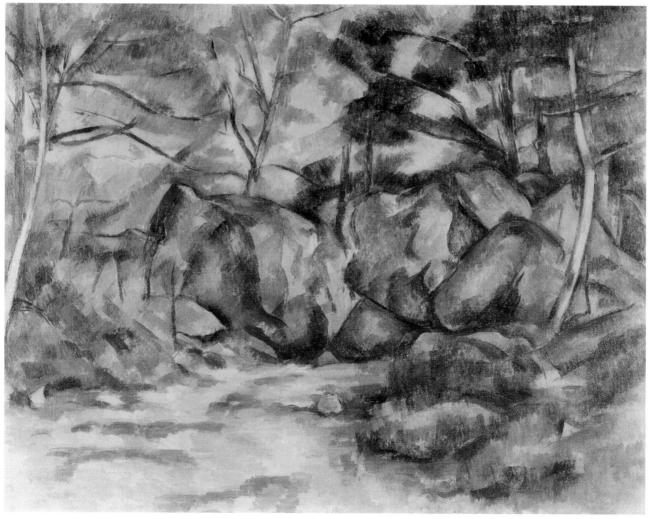

18. Man Smoking a Pipe

1895–1900.
Oil on canvas. 91 x 72 cm.
Pushkin Museum of Fine Arts, Moscow.
Inv. No. 3336.

There are several paintings and sketches by Cézanne portraying a smoker seated at a table (V. 684, 1087), for example *The Smoker* in the Hermitage in St. Petersburg (p.127). The present canvas is executed in Cézanne's typical later manner and is based on a combination of warm browns (the table and tablecloth) and cold bluish tones (the shadow on the face, the sitter's clothing, and the background). The picture is painted with small dabs of color, in places applied with a palette knife; the contours of the figure and the objects are clearly defined. On the wall, to the right, part of a picture by Cézanne can be seen. Venturi believes that it is a portrait of the artist's wife.

Ternovetz and Yavorskaya date *Man Smoking a Pipe at* about 1890. The majority of Cézanne scholars (including Venturi and Barskaya) put it at 1895–1900.

In the opinion of René Huyghe (see *De Renoir à Matisse. 22 Chefs d'œuvre de musées soviétiques et français. Grand Palais*, Paris, 1978), the peasant in this picture also posed for the right-hand figure in *The Card Players* (Musée d'Orsay, Paris; p.47), while the partially visible composition on the wall is difficult to identify as any of Cézanne's works. Huyghe suggests that this may be a slightly modified version of the *Portrait of Mme Cézanne* of 1885–1890 in the former collection of Walter-Guillaume (Musée d'Orsay, Paris).

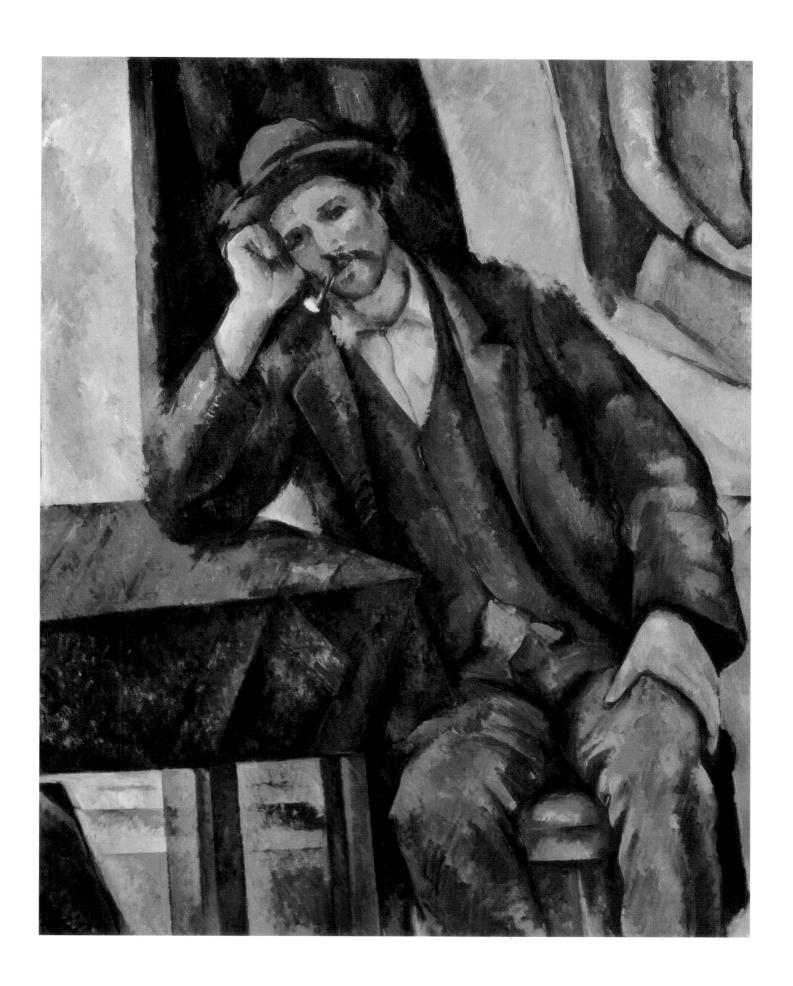

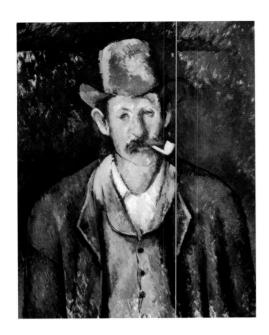

Man Smoking a Pipe, 1890–1892.
Oil on canvas, 73 x 60 cm.
Courtauld Institute Galleries, London.

19. The Smoker

1895–1900.
Oil on canvas. 91 x 72 cm.
Hermitage, St. Petersburg.
Inv. No. 6561.

In Aix in the 1890s, Cézanne produced his *Card Players* and *Smokers* series — severe, balanced compositions portraying solid human figures. In all probability the man who is depicted in the Mannheim Museum picture (V. 684) also posed for the Hermitage painting. Although Cézanne signed the Mannheim canvas, thus expressing his satisfaction with the work done, it is still difficult to decide which of the two canvases is the better. That at the Hermitage is perhaps more varied in color and more austere in the character of the sitter; the still life portrayed above the table not only enlivens the brown color range of the picture but at the same time emphasizes the massive entity of the central figure. Widely known as *Black Bottle and Fruit* (V. 71), this still life was painted in the early 1870s and belongs to the Berlin National Gallery.

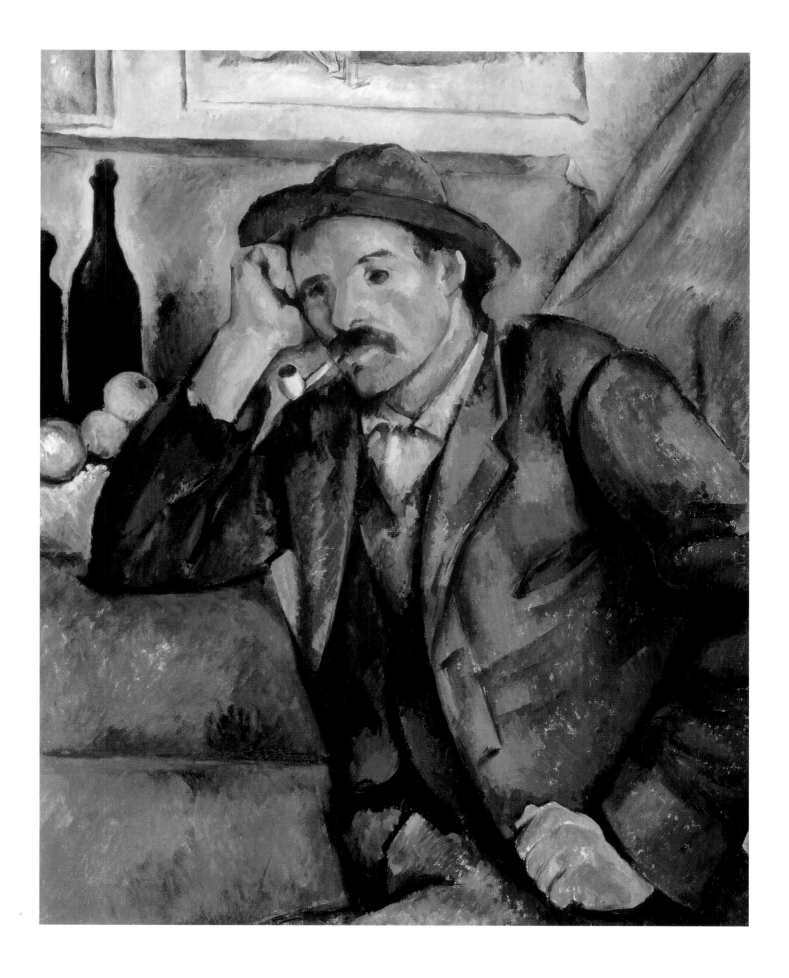

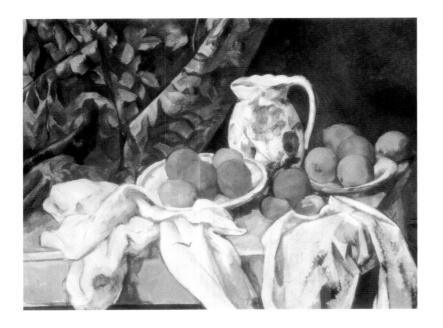

Dish with Fruits and Drapery, 1898–1899.

20. Still Life with Curtain

1898–1899.
Oil on canvas, 53 x 72 cm.
Hermitage, St. Petersburg.
Inv. No. 6514.

As with most of Cézanne's works, *Still Life with Curtain* can only be dated approximately. Experts disagree on the exact date of this canvas. For example, Venturi dates it ca 1985; Yavorskaya to the 1890s. Bernard Dorival put the date of a similar picture in the Louvre (*Apples and Oranges*, V. 732) at 1898–1899. This analogy prompted Charles Sterling to give the same date for the Hermitage painting. The most convincing suggestion is that it belongs to a group of still lifes painted in 1898 and 1899, which are very close to the Hermitage one; the suggestion was made by Lawrence Gowing based on Joachim Gasquet's statement that, while in Paris in the fall of 1899, Cézanne worked on large still lifes. In his catalogue of Cézanne's later works, Rewald also defines the date as c. 1899. This is all the more probable in that the curtains with a leaf pattern are to be found in a number of Cézanne's pictures, such as *Pierrot and Harlequin* (*Mardi Gras*) in the Pushkin Museum of Fine Arts (Plate 25), which are definitely known to have been painted in Paris.

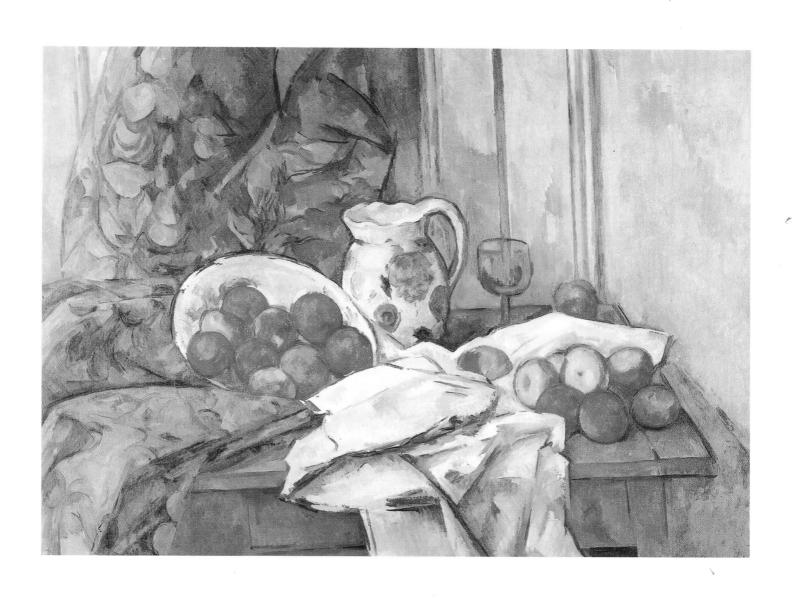

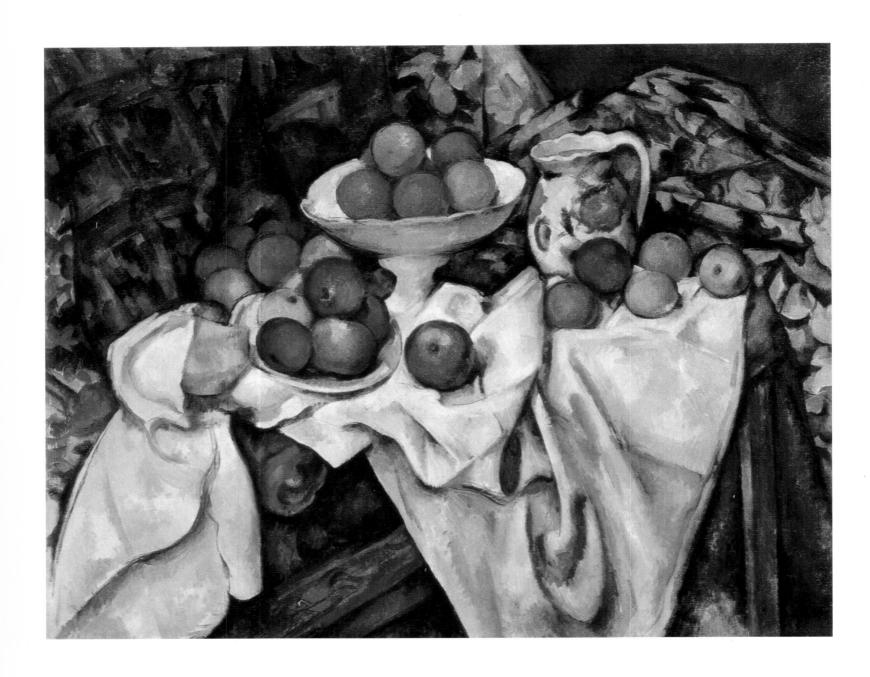

Apples and Oranges, 1898–1899.
Musée d'Orsay, Paris.

Still Life with Dish, Glass and Apples,
1879–1880.
Oil on canvas, 46 x 55 cm.
Paris Collection, Paris.

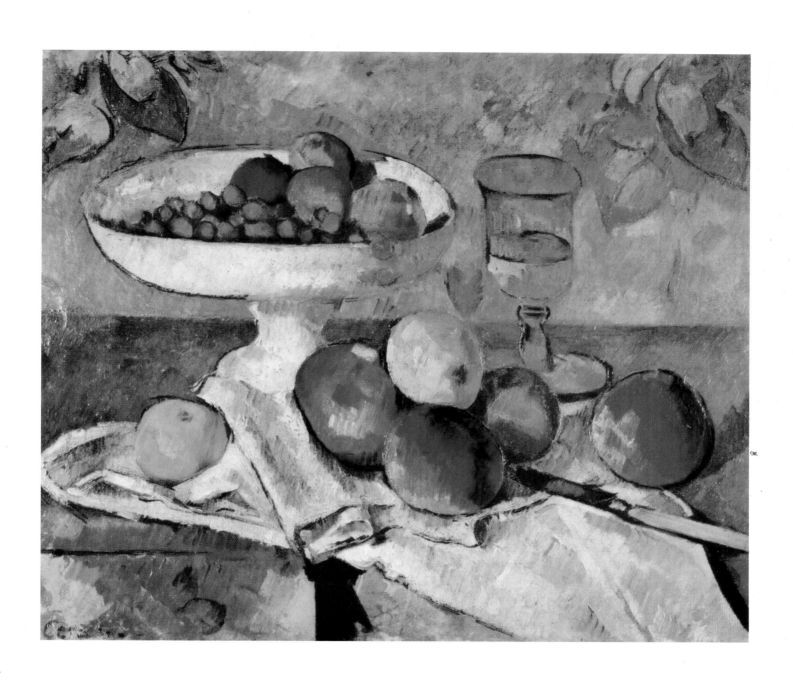

Woman with a Coffee-Pot,
1890–1894.
Oil on canvas, 130.5 x 96.5 cm.
Musée d'Orsay, Paris.

21. Woman in Blue

1898–1899.
Oil on canvas. 88.5 x 72 cm.
Hermitage, St. Petersburg.
Inv. No. 8990.

Some of Cézanne's later portraits are remarkable for the strained pose of the model, either full or half-face, and for the position of the hands, which, form an elipse giving the image stability and significance in spite of the everyday dress and the quite ordinary features of the sitter. Among such portraits are *Woman in Blue at the* the Hermitage and *Woman with a Book* in the Philips collection, Washington (V. 703), in which the figures are wearing the same dress. One school of thought holds that *Woman with a Book* is a portrait of the artist's wife. From this, one might conclude that the Hermitage portrait also depicts Hortense Cézanne, if it were not for a total lack of facial resemblance. Nevertheless, the two works are closely linked and were evidently painted during the same period. But when and where?

In *Woman with a Book*, there is substantial detail such as the curtain with a leaf design that is characteristic of Cézanne's Paris works. In 1904, during a short stay, Cézanne could not have produced such profound canvases, as he worked extremely slowly. This being the case, we must assume that *Woman with a Book* and therefore *Woman in Blue* were painted not later than 1899, when Cézanne spent a considerable time in Paris. In his catalogue to the exhibition of Cézanne's later works, John Rewald made the suggestion that a professional model named Marie-Louise posed for both portraits. George Riviere mentions that Marie-Louise posed twice in Cézanne's Paris studio on Rue Hégésippe-Moreau: for the painting *Standing Nude* (private collection, Washington DC, V. 710) and for a large watercolor (89 x 53 cm, V. 1091). On the other hand, in his reminiscences of Cézanne, Ambroise Vollard states in the chapter *My Portraits (1896–1899)* that the artist was painting a nude model during the period when he worked on his, Vollard's, portrait. This was a unique occasion during those years: Cézanne could only allow himself to paint a nude in Paris, never in Aix, for fear of gossip. Vollard recalls that this same model posed fully dressed for two portraits. His statement is given greater credence by a certain facial resemblance between the model in the large watercolor in the Louvre and in *Woman in Blue*.

The picture has large longitudinal furrows where damage to the paint surface has been repaired. These may well have occurred in the artist's studio.

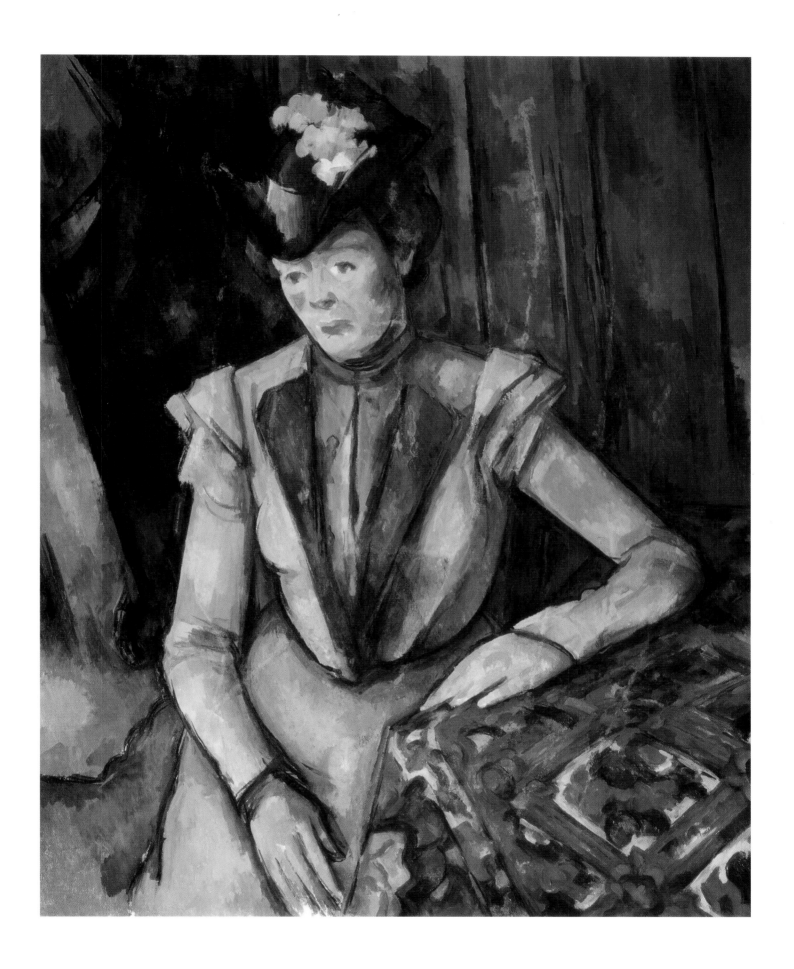

22. Flowers

c. 1900.
Oil on canvas. 77 x 64 cm.
Pushkin Museum of Fine Arts, Moscow.
Inv. No. 3411.

This is a free copy of Delacroix's watercolor *Flowers* done in 1847 (see A. Robaut and E. Chesneau, *L'Œuvre complet de Eugène Delacroix*, Paris, 1885. No. 1042). Dorival points out that Cézanne painted a copy of Delacroix's *Bouquet of Flowers* around 1890. Delacroix's watercolor has an interesting history. In his article, "Chocquet and Cézanne" in the *Gazette des Beaux-Arts*, July–August, 1969, John Rewald (who dates the picture to 1848–1850) states that Delacroix insisted that it should be included in the posthumous sale of his works, and it was entered there under No. 614. (Its subsequent owners were Peyron, Chocquet, Vollard, and Cézanne. It is now in the Louvre.) Cézanne evidently saw Delacroix's watercolor when it was in Chocquet's possession (the sale of the Chocquet collection was on July 1–4, 1899) and he admired it so much that he made Vollard give it to him (J. Rewald, *op. cit.*, pp.88, 89, and 96). However, Rewald indicates in a footnote (*op. cit.*, p.89) that in 1935 Vollard disclosed the fact that he had not just presented the watercolor to Cézanne, but had exchanged it for one of the master's pictures. In 1904, Émile Bernard saw this watercolor in a bedroom in Cézanne's house in Aix (*op. cit.*, p.89). Barskaya believes the Moscow canvas to be one of Cézanne's last copies of works by Delacroix. Venturi also dates the canvas c. 1900; it was occasionally mentioned as *Étude de fleurs* (*Apollon*, 1912) or *Bouquet of Flowers* (Dorival).

A bouquet of yellow, pinkish, orange, and bluish flowers and buds with green leaves is depicted against a bluish-gray background. The leaves are outlined in black. The manner of painting is not the same throughout the picture, the background being painted more lightly, in less dense strokes. Along the lower edge of the picture is a grayish-yellow strip, probably representing the lower edge of the table. There are several scratches, presumably made by Cézanne.

Cézanne had a high opinion of Delacroix. In a letter to Émile Bernard, dated May 12, 1904, he wrote: "I have already told you that I admire the talent of Redon very much, and that, like him, I understand and admire Delacroix. I do not know whether my health will ever allow me to realize my dream of painting an *Apotheosis of Delacroix.*" That dream remained unrealized.

In 1978, Cézanne's painting and Delacroix's watercolor were shown together for the first time at the Paris exhibition "De Renoir à Matisse." In his catalogue to the exhibition, Huyghe dates the Moscow picture around 1902.

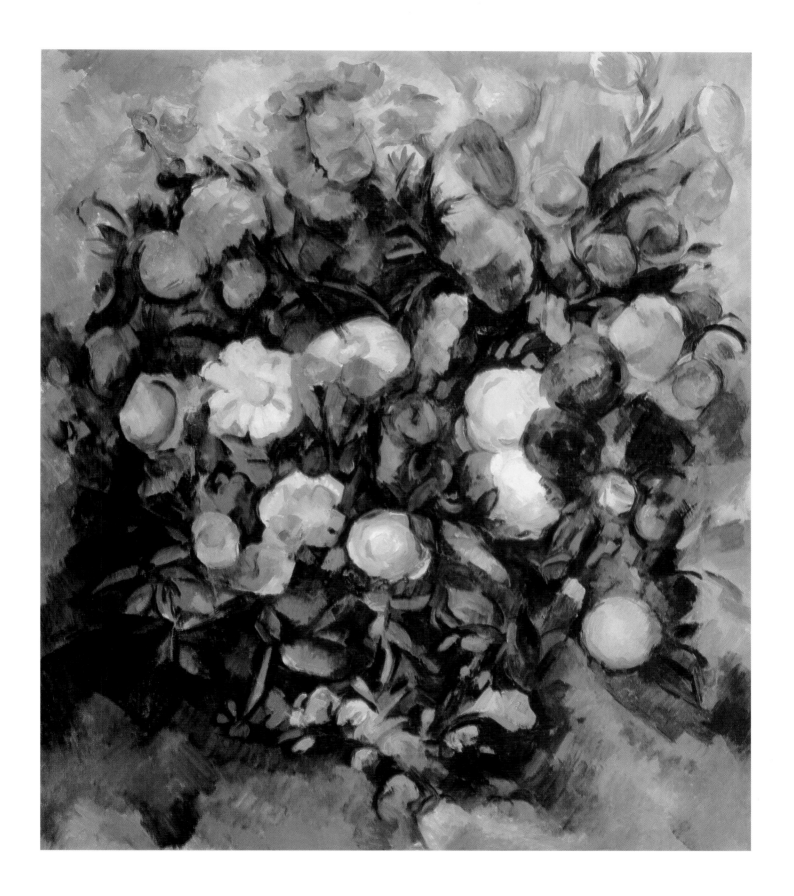

23. Mont Sainte-Victoire

1896–1898.
Oil on canvas. 78 x 99 cm.
Hermitage, St. Petersburg.
Inv. No. 8991.

In Cézanne's later period, when he was engrossed in painting landscapes around Aix, Mont Sainte-Victoire became one of his favorite motifs. Although Cézanne generalized his drawing in his search for integrity and monumentality of depiction, his images were always reinforced by the true topography of the place. This enabled John Rewald and Leo Marshutz to pinpoint the spot from which the artist viewed his subject and to photograph it from that distance. In this way, it has been proved that Cézanne painted the Hermitage picture from the west side of the mountain from the very beginning of the path leading to the Château Noir, a house half-way along the track to the mountain. Cézanne worked in this house up to 1902, when his studio was built. From the studio he could see the mountain from the other side. In view of this, Rewald dates the painting to 1896–1898, which is more precise than 1894–1900 suggested by Venturi. A similar motif is treated in a picture belonging to the Museum of Art, Cleveland (V. 666). Rewald dates it c. 1900.

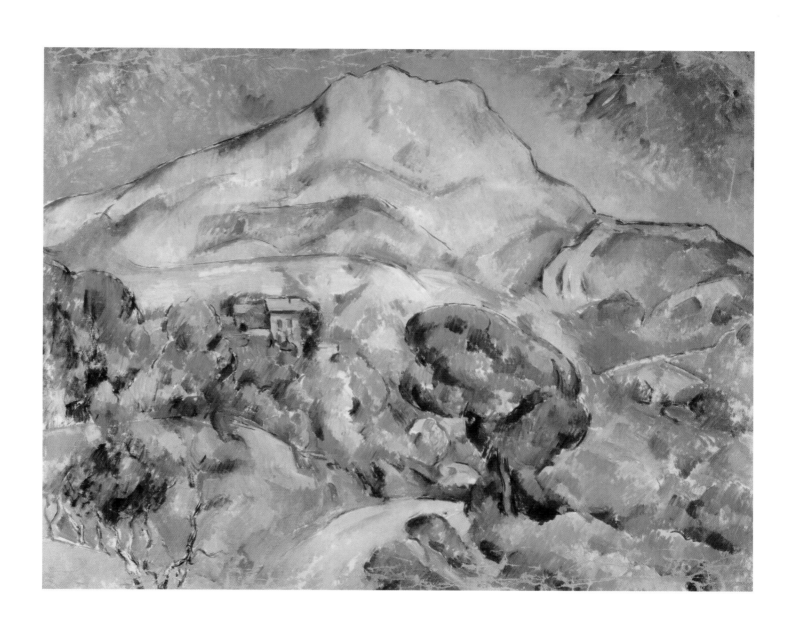

Mont Sainte-Victoire, c. 1900.
Musée d'Orsay, Paris.

24. The Blue Landscape

1904–1906.
Oil on canvas. 102 x 83 cm.
Hermitage, St. Petersburg.
Inv. No. 8993.

The Blue Landscape was evidently painted during the same period as *The Château Noir*, that is in 1904–1906. By means of brushwork alone, without designating the topography of the given locality, Cézanne produced a composition of blended shapes evoking an impression of extremely deep pictorial space.

Liliane Brion-Guerry calls the last two years of the artist's work "lyrical Impressionism." Lawrence Gowing considers that the picture is a view of the Fountainebleau Forest and accordingly dates it 1905, the year Cézanne worked in the suburbs of Paris. However, the topographical features are not sufficiently defined, and as John Rewald rightly points out, a similar spot could be found near Aix. Therefore, he also dates the Hermitage canvas of 1904–1906.

The rent in the center (with loss of the paint layer and primer), now restored, was possibly the result of a blow that the artist gave his picture in one of his frequent moments of exasperation.

It is said that *The Blue Landscape* was the favorite picture of Ivan Morozov. In his gallery, the Moscow collector left a space for a certain late Cézanne, and in 1913 the space was filled by *The Blue Landscape*.

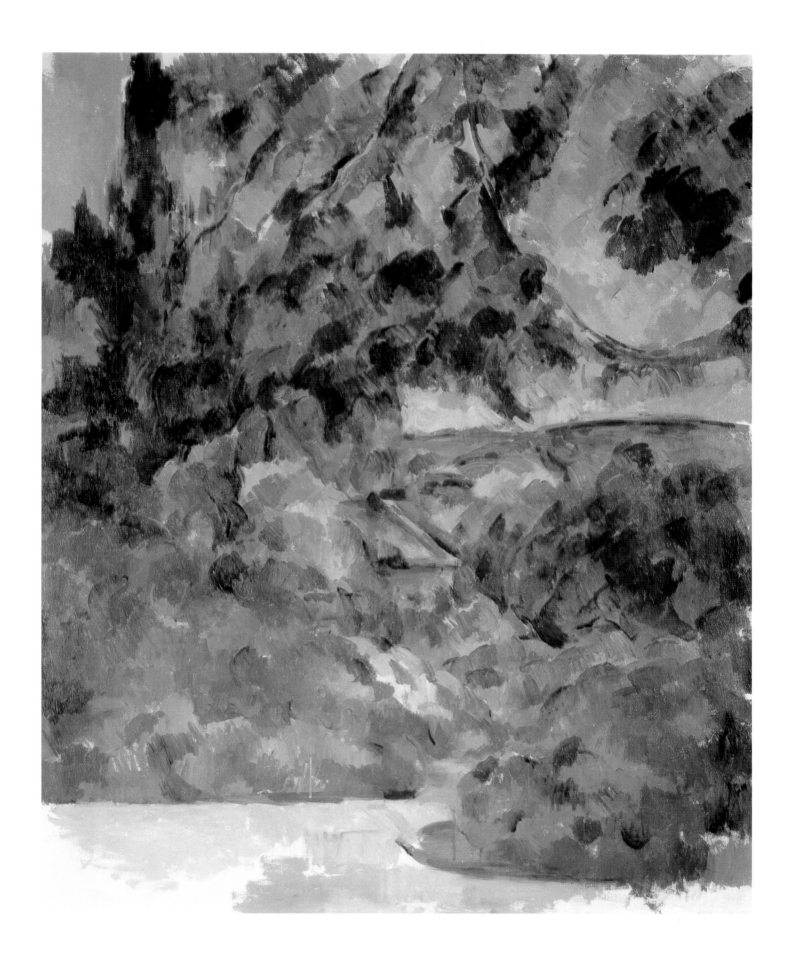

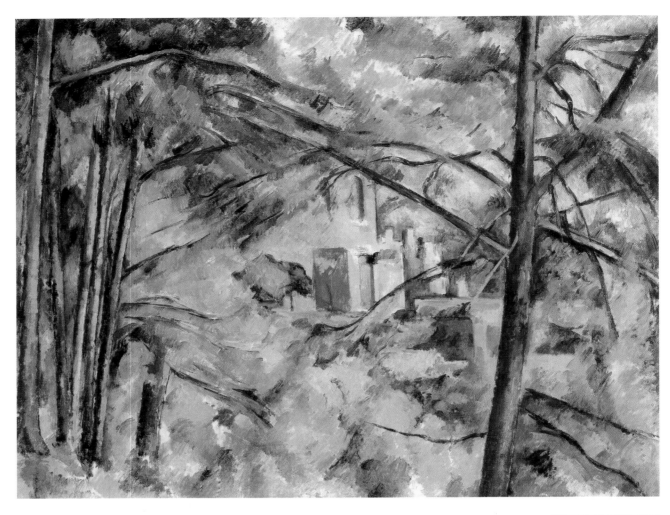

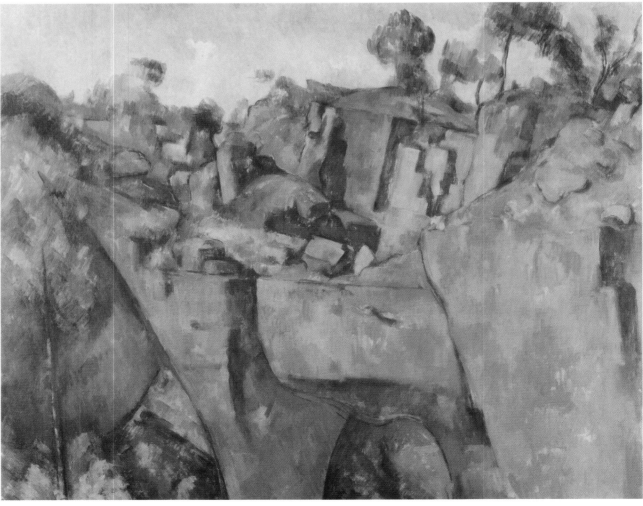

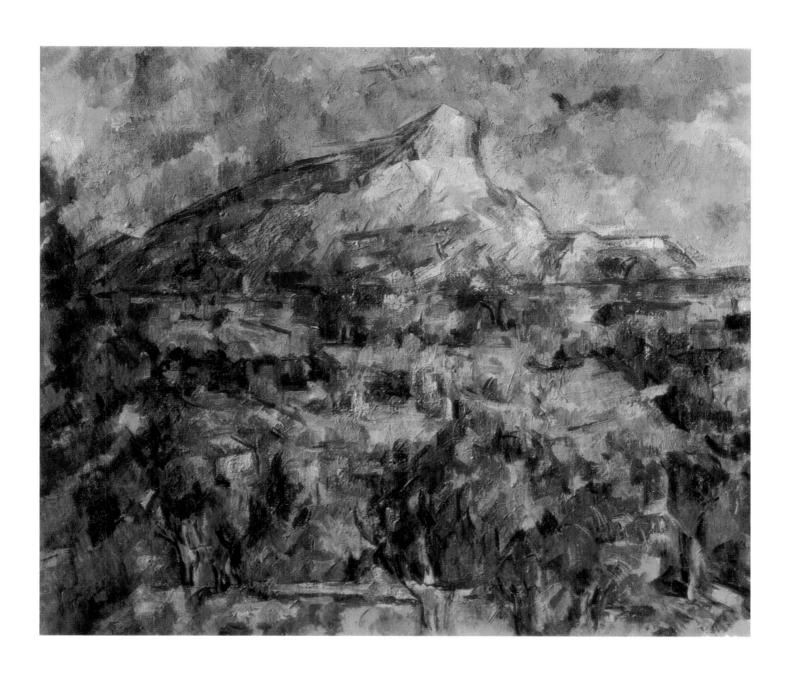

View of the Château Noir, c. 1894–1895.
Oil on canvas, 73.5 x 92.5 cm.
Oskar Reinhart Collection, Winterthur.

Quarry at Bibémus, 1898–1900.
Oil on canvas, 65 x 81 cm.
Folkwang Museum, Essen.

Landscape at Aix (*Mont Sainte-Victoire*),
1905.
Pushkin Museum of Fine Arts, Moscow.

143

25. Landscape at Aix
(Mont Sainte-Victoire)

1905.
Oil on canvas. 60 x 73 cm.
Pushkin Museum of Fine Arts, Moscow.
Inv. No. 3339.

According to Maurice Raynal (M. Raynal, *Paul Cézanne*, Geneva, 1954, p.119), Cézanne drew or painted the Sainte-Victoire mountain approximately fifty times. This *Landscape at Aix* is executed in bright luminous colors, with the brushstrokes regular in shape and almost square. The valley and the trees are thickly painted; the mountain and sky are light and translucent in comparison. The picture is dominated by the vibrant blue tones for which Cézanne showed a preference at the end of his life. He explains his predilection for them in his letter to Émile Bernard sent from Aix on April 15, 1904: "The parallel lines at the horizon give the extension, that is a section of nature or, if you prefer, of the spectacle which the *Pater Omnipotens Aeterne Deus* spreads before our eyes. The perpendicular lines at the horizon give the depth. Now nature appears to us more in depth than in surface, hence the necessity of introducing into our vibrations of light, represented by reds and yellows, enough blue tones to make the atmosphere perceptible."

This landscape is generally dated 1905 (Venturi, Dorival, Barskaya). For its beauty and the perfection of its colors and composition it can justly be considered one of Cézanne's best paintings of the Sainte-Victoire. It appears in the *Portrait of Cézanne* painted by Maurice Denis in Aix in 1905, in which Cézanne is depicted with his son and the artist Xavier Roussel; this made Venturi ascribe the landscape to 1905. On the back, on the subframe of the canvas, was a label with the words "Exposition 1905," and underneath, on the right, "Vollard, 6 rue Laffitte" had been added in blue pencil, which once more confirms that the picture formerly belonged to Ambroise Vollard. In the catalogue to the exhibition "Cézanne. Les dernières années (1895–1906)," it is dated as 1905 or 1906. Reff believes that the picture was painted between 1902 and 1906. In the inventory of the Museum of Modern Western Art there is the following note: "In 1913, during Matisse's stay with Sergei Shchukin in Moscow, he (that is Matisse) varnished the picture." (The date of Matisse's visit to Moscow is wrong, for in fact he was there in 1911).

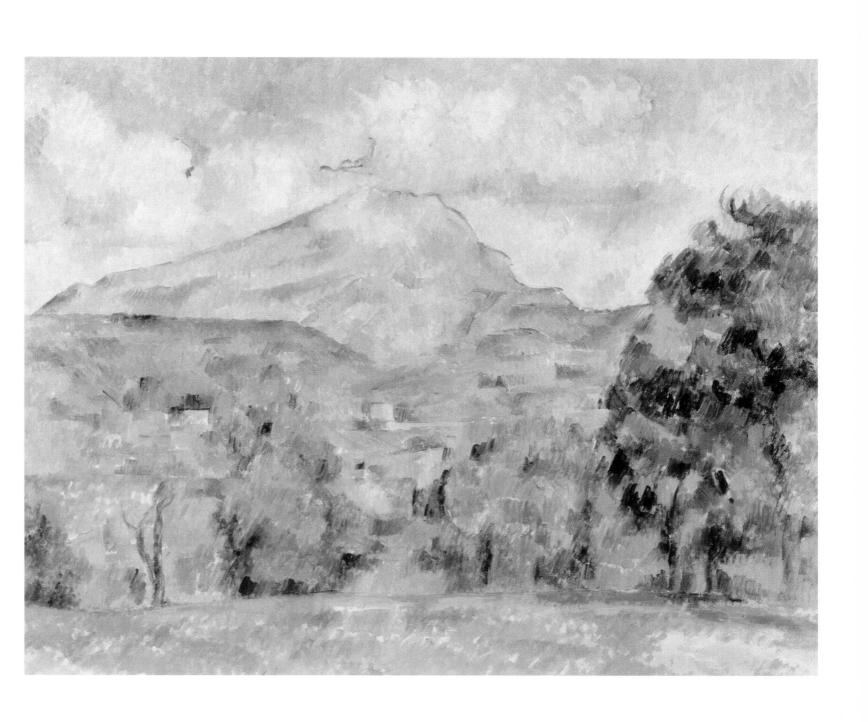

Chronology

1839	Paul Cézanne is born on January 19, in Aix-en-Provence.
1844–1849	Starts school on Rue des Épinaux.
1849–1851	Studies as a half-boarder at the St. Joseph school together with Philippe Solari, the future sculptor, and Henri Gasquet, father of the poet Joachim Gasquet, whom Cézanne later befriended.
1852–1858	Studies at the Collège Bourbon in Aix, first as a full-time boarder and, from 1858, as an extramural student. Friendship with Émile Zola and Baptistin Baille. Receives his baccalaureate on November 12, 1858, and enrolls at the municipal school of drawing at the Aix Museum, studying under Joseph Gibert. Receives a second prize for his drawing. In 1858, Zola leaves for Paris.
1859	Studies law at Aix University and continues to attend the municipal school of drawing from November 1859 to August 1860. Sets up a studio at the Jas de Bouffan. Zola visits Aix during the vacation.
1860	Continues to read law and study at the school from November 1860 to spring 1861. Presumably paints the *Four Seasons* murals at the Jas de Bouffan.
1861	Remains in Aix until April 21 and then leaves for Paris where he settles on Rue Coquilière and later on Rue des Feuillantines. Works at the Académie Suisse, meets Armand Guillaumin and Camille Pissarro, and paints a portrait of Zola, destroying it unfinished. In the evenings, he draws at the Villevielle studio and paints from nature in Marcoussis. Returns to Aix in September and starts work in his father's bank. From November 1861 to August 1862 attends the municipal school of drawing in Aix.
1862	Leaves the bank in January and devotes himself entirely to painting. Friendship with Numa Coste. In November he goes a second time to Paris and settles in the Luxembourg district.
1863	Lives in Paris in the Luxembourg district and works at the Académie Suisse together with Antoine Guillemet, Guillaumin, and Francisco Oller. He probably exhibits at the Salon des Refusés, though his works are not mentioned in its catalogue. Tries to enter the École des Beaux-Arts but fails (however, there is no documentary evidence of the fact). He and Zola visit the Salon and the Salon des Refusés.
1864	Lives in the Luxembourg district, paints a female portrait, possibly of Zola's wife (dated, V. 22). Sends one of his works to the Salon, but the Jury rejects it. Copies a painting by Eugène Delacroix at the Louvre. Returns in the summer to Aix. Friendship with Édouard Marion and Heinrich Morstatt.
1865	Lives in Paris, 22, Rue Beautreillis, with Oller, working at the Académie Suisse. The Salon rejects his pictures. Paints *Still Life with Bread, Jug, Glass, and Egg* (dated, V. 59). In the fall, returns to Aix and remains there until the end of the year, meeting Marion, Morstatt, and Anthony Valabrègue.
1866	Spends January in Aix, where Guillemet pays him a visit. In February returns to Paris and lives on Rue Beautreillis. Shows his still lifes to Édouard Manet. The Jury of the Salon rejects his portrait of Valabrègue (V. 126). He works on a sketch for a large painting, *Marion and Valabrègue out Walking.*

Cézanne writes a letter of protest to Count Nieuwerkerke, superintendent of the Beaux-Arts, with the demand that the Salon des Refusés be reopened. Zola's articles published in the newspaper *L'Événement* in defence of avant-garde artists are issued in a separate pamphlet with a dedication to Cézanne. Spends the summer with Zola, Valabrègue, Baille, Jean-Baptiste Chaillant, and Solari on the banks of the Seine at Bonnecourt. Spends August and September in Aix.

1867	From January to June lives in Paris. His paintings *Punch and Rum* and *Intoxication* are rejected by the Salon. Zola defends him in the press (*Figaro*, April 12, 1867). He spends the summer in Aix. A picture by Cézanne is exhibited in the window of an art dealer in Marseilles. Works on a version of *Girl at the Piano* (*Overture to "Tannhäuser"*) and on portraits (according to recent data, he began work on this painting in 1866). In the fall he returns to Paris, paints *The Rape* (dated, V. 101), and presents it to Zola.
1868	Remains in Paris until mid-May. Rejected by the Jury of the Salon. Late May, travels to Aix and stays there until the end of the year. Friendship with Paul Alexis and collaboration with Marion.
1869	Spends almost the entire year in Paris, meeting Hortense Fiquet (b. 1850), who works at a bookbinder's and also as a model. Once again rejected by the Salon.
1870	Spends the first half of the year in Paris, Rue Notre-Dame-des-Champs. Paints *Idyll* (dated, V. 104). After the declaration of the Franco-Prussian war, he works in Aix and later goes to L'Estaque, accompanied by Hortense Fiquet. Zola comes to stay with him for a time. After the proclamation of the Third Republic, his father is elected a member of the Municipal Council and Cézanne a member of the fine arts commission of the Aix school. However, he does not participate in the commission's activities.
1871	Spends the first half of the year at L'Estaque. In the fall he returns to Paris with Hortense and lives on Rue Notre-Dame-des-Champs in the same house as Solari. In December he moves to Rue Jussieu (opposite the wine market). This year or the next he paints his landscape *The Bercy Embankment* (V. 56). For some time, Achille Emperaire stays with him.
1872	45 Rue Jussieu, Paris. Birth of Paul, his son, by Hortense Fiquet. Cézanne moves with his family to Pontoise where he works with Pissarro and copies one of his landscapes (V. 153). Later he moves to Auvers-sur-Oise.
1873	Stays in Auvers, working in the house of Dr. Gachet. Often meets Pissarro, who lives in Pontoise. Paints several landscapes (dated, V. 138 and 139), *The House of the Hanged Man at Auvers* and *A Modern Olympia* (both in the Musée d'Orsay, Paris). Pissarro introduces him to Julien Tanguy, the art dealer.
1874	Lives in Auvers at the beginning of the year then moves to Paris (120, Rue de Vaugirard). Takes part in the first Impressionist exhibition (Société anonyme des artistes peintres, sculpteurs et graveurs), held from April 15 to May 15. He exhibits *The House of the Hanged Man* (V. 133), *A*

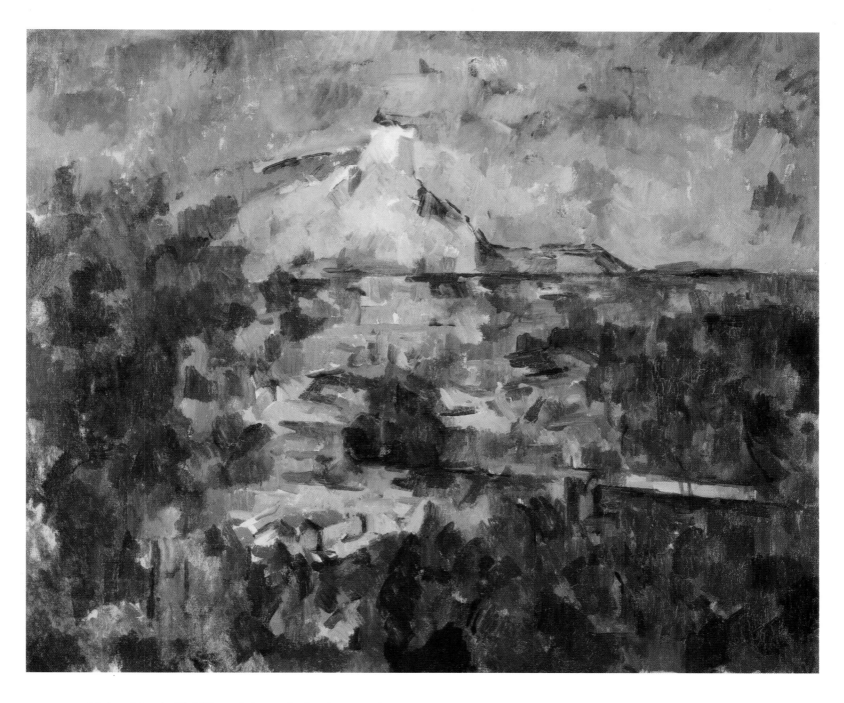

Modern Olympia (V. 225), and the study *Landscape at Auvers*. Spends the summer in Aix and in the fall returns to Paris.

1875 15, Quai d'Anjou, Paris. He is a neighbor of Guillaumin, with whom he sometimes works. Victor Chocquet buys one of Cézanne's paintings from Tanguy. Auguste Renoir introduces Cézanne to Chocquet, and Cézanne paints the latter's portrait (V. 283). The Jury of the Salon continues to reject his paintings.

1876 Paris. April and May spent in Aix; June and July in L'Estaque. His paintings are rejected by the Jury of the Salon. He refuses to send his works to the second Impressionist exhibition and in August returns to Paris.

1877 67, Rue de l'Ouest, Paris. Works with Pissarro in Pontoise and Auvers, and also in Chantilly, Fontainebleau, and Issy. Renoir introduces Cézanne to Georges Rivière, and the latter publishes a detailed article about him in the magazine *L'Impressionnisme*, devoted to the third Impressionist exhibition, in which Cézanne takes part (Cat. Nos. 17 to 32).

Mont Sainte-Victoire, View from Lauves,
1904–1906.
Oil on canvas, 60 x 72 cm.
Kuntmuseum, Basel.

Following Pages:
Mont Sainte-Victoire, View from Lauves,
1905.
Oil on canvas, 60 x 73 cm.
Pushkin Museum of Fine Arts, Moscow.

Mont Sainte-Victoire, View from Bibémus,
c. 1897.
Oil on canvas, 65 x 80 cm.
Museum of Art, Baltimore.

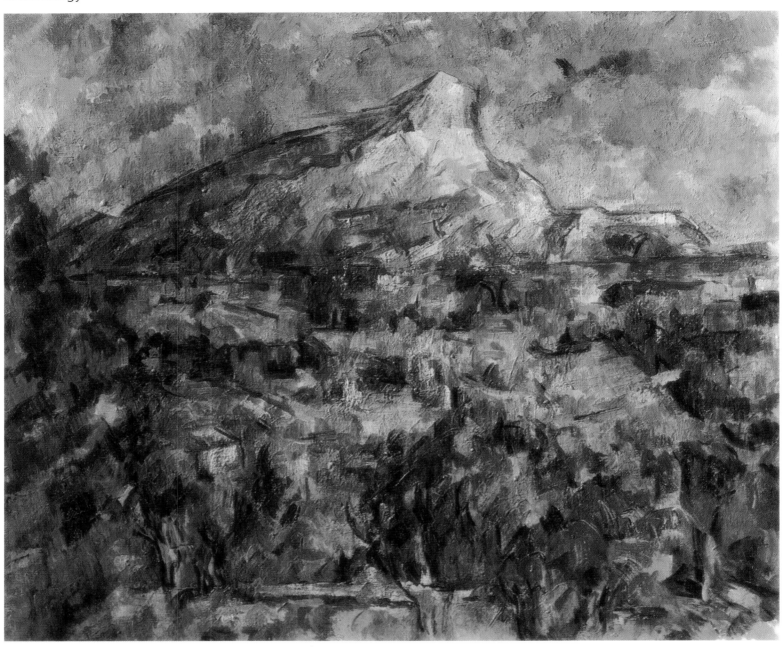

1878 Lives in Aix, L'Estaque and Marseilles, together with Hortense and his son. Plans to participate in an Impressionist exhibition, but it does not take place. Rejected by the Jury of the Salon.

1879 Spends January and February in L'Estaque, travels to Paris in March, and works in Melun in the summer and fall. In July he stays with Zola at Medan and then lives in Paris until the end of the year. Despite Guillemet's intermediacy, the Jury of the Salon rejects his works.

1880 Spends January and February in Melun, and March and December in Paris, 32, Rue de l'Ouest. In August he stays with Zola in Medan, meeting Joris Karl Huysmans. Renoir paints a pastel portrait of Cézanne (Ittelson Collection, New York), and Cézanne copies it (V. 372). Possibly Cézanne submits another painting for the Salon, but is rejected.

1881 Spends January to April in Paris, 32, Rue de l'Ouest. From May to October he lives in Pontoise (but keeps his apartment in Paris) where he works with Pissarro and meets Paul Gauguin. In June his sister Rose marries Maxime Conil and he travels to Paris for a time. At the end of October and the beginning of November he spends a week in Medan with Zola, then return to Aix.

1882 In January and February he works with Renoir at L'Estaque. From March to September, lives in Paris; admitted to the Salon as a "pupil of Guillemet." In spring he works in Hattenville, Normandy, the birthplace of Chocquet's wife. In September he goes to Medan where he spends five weeks with Zola. In October he returns to Aix.

1883 Continues to live in Aix and L'Estaque, where he meets Adolphe Monticelli. At the end of December he visits Claude Monet and Renoir, on their return from Genoa. He evidently submits another painting for the Salon and is again rejected. On May 4, he goes to the funeral of Édouard Manet.

1884 Works in Aix and L'Estaque. The portrait he submits for the Salon is rejected by the Jury, and from then onwards Cézanne apparently sends no more of his works to the Salon. Paul Signac buys one of his landscapes from Tanguy.

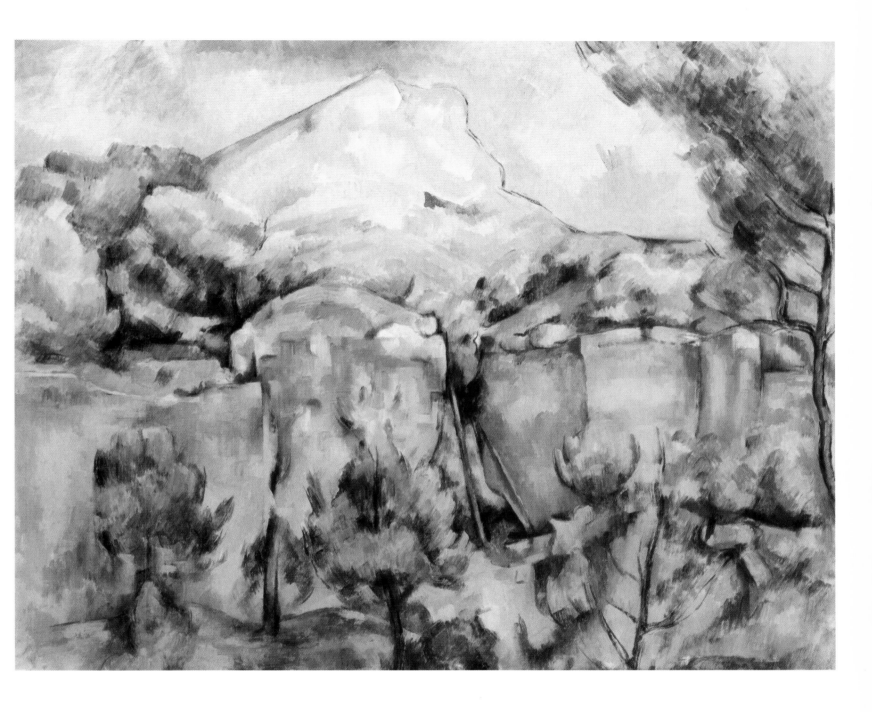

1885	Until summer he works in Aix and L'Estaque; in June and July he lives with Renoir's family at La Roche-Guyon painting landscapes (*La Roche-Guyon*, V. 441, Northampton, Smith College, Museum of Art). He spends most of July in Vernon and at the end of the month goes to Medan. Before returning to the South in August, he stays at Hattenville. In August and September he paints landscapes at Gardanne and evidently produces two portraits of his friend Jules Peyron (V. 1607 and 531), who worked in Gardanne.
1886	Most of the year is spent with his wife and son at Gardanne. In February he stays for some time in Paris. In March, Zola's *L'Œuvre* is published. Break with Zola. On April 28, Cézanne marries Hortense Fiquet. In the summer he lives in Paris and in Hattenville. On October 23, his father dies, leaving him a legacy. The artist exhibits at Eugène Murer's. Renoir stays in Montbriand at the home of Maxime Conil, Cézanne's - brother-in-law.
1887	Spends most of the year in Aix. Exhibits in Brussels with "Les XX."
1888	In January Renoir stays with him in Aix and they work together. Cézanne returns to Paris (15, Quai d'Anjou, with a studio on Rue du Val-de-Grâce). Paints *Pierrot and Harlequin* (*Mardi Gras*) (Pushkin Museum of Fine Arts, Moscow), for which his son Paul and Paul's friend Louis Guillaume posed as models. Works in the vicinity of Paris: Chantilly, Créteil, and Éragny (at Pissarro's). Huysmans publishes an article about Cézanne in *La Cravache*.
1889	Spends a large part of the year in Paris at Quai d'Anjou. Exhibits *The House of the Hanged Man at Auvers* at the World Exposition of 1889–1890. In June he works in Hattenville, painting a portrait of Chocquet (V. 562). Lives for a time in Aix and works with Renoir in Montbriand (at Conil's). After a misunderstanding with Renoir, he returns alone to Paris.
1890	Lives in Paris, at first on the Quai d'Anjou and later on Avenue d'Orléans. In January he exhibits three paintings at

the seventh exhibition of "Les XX" in Brussels, among them is *The House of the Hanged Man at Auvers*. He spends the summer with his wife and child in Switzerland (Neuchâtel, Berne, Fribourg, Geneva, Vevey, and Lausanne), and then the fall in Aix, working at the Jas de Bouffan. Cézanne contracts diabetes. Émile Bernard publishes an article on him in the series *Les Hommes d'Aujourd'hui*.

1891 From the beginning of the year until spring he is in Aix; later in Paris and Fontainebleau.

1892 Lives in Aix and in Paris at 2, Rue Lyon-Saint-Paul; he paints at the Forest of Fontainebleau (Alfors). Ambroise Vollard sees Cézanne's works at Tanguy's for the first time.

1893 Lives in Aix and in Paris and paints in the Forest of Fontainebleau.

1894 In spring he paints at Fontainebleau (Alfors) and probably spends the summer in Aix. Works on an *Apotheosis of Delacroix* in Paris. In the fall he visits Monet at Giverny where he meets Joseph Clemenceau, Auguste Rodin, Octave Mirbeau, Gustave Geffroy, and Mary Cassat. Geffroy writes an article about him. The Tanguy collection is sold off, as is the collection of Théodore Duret.

1895 From January to June, he lives in Paris on Rue Bonaparte; a portrait of Geffroy. From July he is in Aix. Cézanne's first personal exhibition is organized by Vollard on Rue Laffitte (150 works). Geffroy writes an article about the exhibition. Two of Cézanne's landscapes are bequeathed by Gustave Caillebotte to the Musée de Luxembourg.

1896 Spends the spring in Aix, meeting Joachim Gasquet, Jean Royére, Édmond Jaloux, and Louis Aurenche. Vollard visits Cézanne in Aix. Cézanne spends June in Vichy. At the end of June and the beginning of July he is in Aix; later in July and August in Talloires on Lake Annecy (Haut Savoie).

1897 Spends January in Paris, has influenza. His son moves him from Montmartre to 73, Rue Saint-Lazare. Works in May in Mennecy, not far from Corbeil (Seine-et-Oise), and lives in the Hôtel de la Belle Étoile. Stays in Aix from June 1. In August and September, he often works in Tholonnet (Château Noir, Carrière Bibemus). October 25, death of Cézanne's mother. One of his landscapes is acquired by the National Gallery in Berlin as a gift from a Berlin patron of the arts. The acquisition is evidently organized by the director, Hugo von Tschudi.

1898 Lives in Aix and in Paris, Rue Ballu. Works in Montgeroult (near Pontoise), Marines, and Marlotte. Cézanne's second exhibition arranged by Vollard is held from May 9 to June 10. A catalogue is published in the form of a leaflet.

1899 Spends a large part of the year in Paris. Works in Montgeroult and meets the young artist Louis Le Bail. In the fall he paints a portrait of Vollard and then goes to Aix, sells the Jas de Bouffan, and moves to Rue Boulégon. The Italian collector Fabbri pays him a visit. In December he has another exhibition organized by Vollard. Cézanne sends work to the Salon des Indépendants. Sale of the Chocquet and Doria collections (Monet buys the painting *Melting Snow at L'Estaque*).

1900 Lives in Aix. His *Vase of Fruit, Glass, and Apples* (V. 341), *Pool at the Jas de Bouffan* (V. 167), and a landscape are displayed at the exhibition "A Century of French Art," held at the World Exposition in Paris. Exhibits at the Salon des Indépendants. Maurice Denis paints *Hommage à Cézanne*. Sale of the Blot (five works by Cézanne) and Tavernier collections.

1901 Lives in Aix. Denis exhibits *Hommage à Cézanne* at the Salon of the Société des Artistes Français. Cézanne sends several paintings to the Exposition de la Libre Esthétique in Brussels and to the Salon des Indépendants. He builds a studio on Chemin des Lauves, not far from Aix. The poet Leo Larguier and the artist Charles Camoin, who are doing their military service in Aix, make Cézanne's acquaintenace and often visit him. Sale of the Feydeau collection.

1902 Lives in Aix, finishing the construction of his Lauves studio. Exhibits in the Salon des Indépendants. In the fall he visits the Larguier family in Sevennes. Death of Zola on September 29. Cézanne exhibits two works at the Société des Amis des Arts in Aix. Sale of the Jules Strauss collection (two works by Cézanne).

1903 Lives in Aix. His paintings are shown at the Impressionist exhibition of the Vienna Secession, among them *Mardi Gras* and *Road at Pontoise* (both in the Pushkin Museum of Fine Arts, Moscow). Sale of Zola's collection.

1904 Lives in Aix. For three months he goes to Paris and paints at Fontainebleau. Works on the still life *Three Skulls* (V. 759) and *Les Grandes Baigneuses* (V. 719). Paintings on display at the Impressionist exhibition sponsored by the Société de la Libre Esthétique in Brussels. A large retrospective exhibition at the Salon d'Automne. Among the pictures displayed are *Mont Sainte-Victoire*, *The Aqueduct*, *Mardi Gras* (Pushkin Museum of Fine Arts, Moscow), and *The Smoker* (Hermitage, St. Petersburg). A large individual exhibition at the Cassirer Gallery, Berlin. Émile Bernard visits Cézanne and writes a major article about him in the magazine *L'Occident* (July). Claude Roger-Marx gives a prominent place to Cézanne in an article about the Salon d'Automne in the *Gazette des Beaux-Arts*. Hermann-Paul travels to Aix and paints Cézanne's portrait. Joachim Gasquet, Leo Larguier, Charles Camoin (who evidently travels to Aix with Francis Jourdain), and Gaston Bernheim de Viller also visit Cézanne.

1905 Lives in Aix. Exhibits at the Salon d'Automne and the Salon des Indépendants and takes part in an exhibition at the Grafton Gallery in London, organized by Paul Durand-Ruel. Émile Bernard visits Cézanne a second time. Maurice Denis and Xavier Roussel also visit him. Charles Morice publishes a questionnaire in the *Mercure de France*, in which one of the questions is "What do you think of Cézanne?"

1906 Lives in Aix. In spring he is visited by Karl-Ernst Osthaus, who buys two paintings and presents them to the Folkwang Museum in Essen. Another donation to the Berlin National Gallery of two of Cézanne's still lifes (evidently again with the assistance of Tschudi). *The Château Noir* is exhibited at the Société des Amis des Arts in Aix as the work of one of Pissarro's pupils. Camoin visits Cézanne. On October 6, the Salon d'Automne opens, at which ten of Cézanne's works are shown. On October 22, the death of the artist.

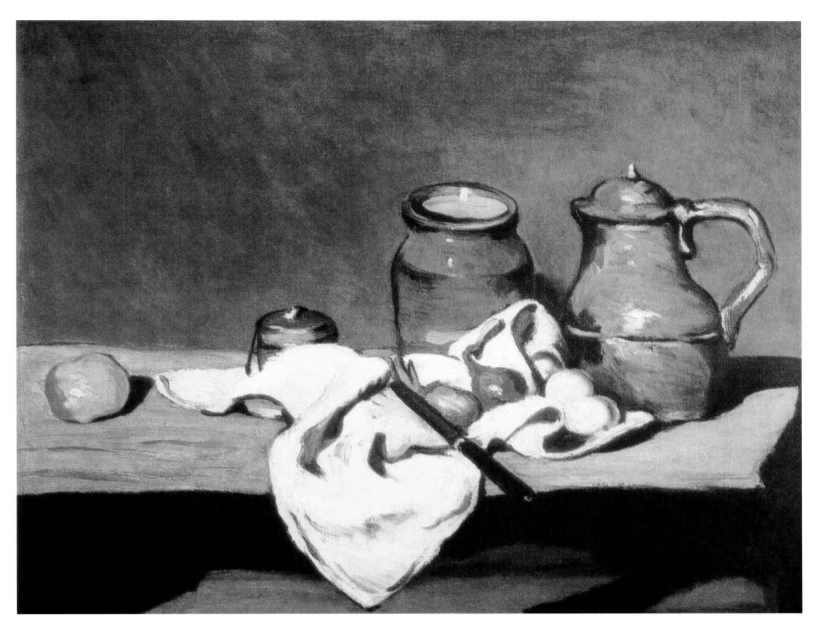

Green Pot and Tin Kettle, c. 1869.
Oil on canvas, 64.5 x 81 cm.
Musée d'Orsay, Paris.

Pitcher and Fruits, 1893–1894.
Oil on canvas, 43.2 x 62.8 cm.
Berggruen Collection, Paris.

Following Pages:
The Stove in the Studio, 1865–1868.
Oil on canvas, 42 x 30 cm.
Private Collection, London.

The Black Scipion, c. 1867.
Oil on canvas, 107 x 83 cm.
Museu de Arte, Sao Paulo.

Bibliography

BABADJAN 1919:
V. Babadjan, *Cézanne. Life, Work. Selected Excerpts from Letters,* St. Petersburg -Odessa, 1919 (in Russian).

BADT 1956:
K. Badt, *Die Kunst Cézannes,* Munich, 1956.

BARNES, MAZIA 1938:
A. Barnes, V. de Mazia, *The Art of Cézanne,* New York, 1938.

BARR 1951:
A. Barr, *Matisse, His Art and His Public,* New York, 1951.

BARSKAYA 1975:

BARSKAYA AND IZERGINA 1975:
French Painting from the Hermitage, Leningrad. Mid-19th to Early 20th Century (Introduction by A. Izergina. Selection and notes on the plates by A. Barskaya), St. Petersburg, 1975.

BELL 1952:
C. Bell, *The French Impressionists,* London-New York, 1952.

BRION-GUERRY 1966:
L. Brion-Guerry, *Cézanne et l'expression de l'espace,* Paris, 1966.

BURGER 1913:
F. Burger, *Cézanne und Hodler,* Munich, 1913 (2nd ed., 1920).

CAHIERS D'ART 1950:
"Art moderne française dans les collections des musées étrangers. Le Musée d'Art Moderne Occidental à Moscou," *Cahiers d'Art,* 1950.

CATALOGUE SHCHUKIN 1913:
Catalogue of Paintings in the Sergei Shchukin Collection, Moscow, 1913 (in Russian).

CHAPPUIS 1957:
A. Chappuis, *Dessins de Cézanne,* Lausanne, 1957.

CHAPPUIS 1973:
A. Chappuis, *The Drawings of Paul Cézanne. A Catalogue Raisonné by Adrien Chappuis,* London, 1973.

DORIVAL 1948:
B. Dorival, *Cézanne,* Paris-New York, 1948.

ETTINGER 1926:
P. Ettinger, "Die modernen Franzosen in den Kunstsammlungen Moskaus," *Der Cicerone,* 1926.

FAURE 1936:
E. Faure, *Cézanne,* Paris, 1936.

FIEST 1963:
P. Fiest, *Cézanne,* Leipig, 1963.

FRENCH 19TH CENTURY MASTERS:
The Hermitage, Leningrad. French 19th Century Masters (Introduction by A. Izergina. Notes by A. Barskaya, V. Berezina, A. Izergina), Prague, 1968.

GENTHON 1958:
I. Genthon, *Cézanne,* Budapest, 1958.

GOWING 1954:
L. Gowing, *An Exhibition of Paintings by Cézanne at the Royal Scottish Academy,* Edinburgh-London, 1954.

HERMITAGE 1958:
The Hermitage. The Department of Western European Art, Catalogue of Paintings, vol. 1, Moscow-St. Petersburg, 1958 (in Russian).

HERMITAGE 1976:
The Hermitage. Western European Painting. Catalogue, vol. 1, St. Petersburg, 1976 (in Russian).

HUYGHE 1962:
R. Huyghe, *Cézanne,* New York, 1962.

KLINGSOR 1924:
T. Klingsor, *Cézanne,* Paris, 1924.

LORAN 1946:
E. Loran, *Cézanne's Composition. Analysis of his Form with Diagrams and Photographs of his motifs,* Berkeley-Los Angeles, 1946.

MACK 1936:
G. Mack, *La vie de Paul Cézanne,* Paris, 1936.

MAKOVSKY 1912:
S. Makovsky, "French Painters in the Ivan Morozov Collection," *Apollon,* 1912, Nos. 3–4 (in Russian).

MEIER-GRAEFE 1910:
J. Meier-Graefe, *Cézanne und seine Ahnen,* Munich, 1910.

MEIER-GRAEFE 1913:
J. Meier-Graefe, *Paul Cézanne,* Munich, 1913.

MEIER-GRAEFE 1922:
J. Meier-Graefe, *Cézanne und sein Kreis,* Munich, 1922.

MURATOV 1923:
P. Muratov, *Cézanne,* Berlin, 1923.

MUSEUM OF MODERN WESTERN ART 1928:
The Museum of Modern Western Art. Illustrated Catalogue, Moscow, 1928 (in Russian).

NOVOTNY 1937:
F. Novotny, *Cézanne,* Vienna-New York, 1937.

NÜRENBERG, 1923:
A. Nürenberg, *Paul Cézanne,* Moscow, 1923 (in Russian).

OPERA COMPLETA DI CÉZANNE:
L'Opera completa di Cézanne (Presentazione di A. Gatto. Apparati critici S. Orienti), Milan, 1970.

PAUL CÉZANNE. CORRESPONDANCE:
Paul Cézanne. Correspondance recueillie par John Rewald, Paris, 1937 (2nd ed., 1978).

PAUL CÉZANNE. CORRESPONDANCE:
Paul Cézanne, Correspondence, Reminiscences of Contemporaries (Selection, introduction, notes, and chronology by N. Yavorskaya. Translated by E. Klasson and L. Lipman), Moscow, 1972 (in Russian).

Bibliography

PERTSOV 1921:
P. Pertsov, *The Shchukin Collection of French Painting*, Moscow, 1912 (in Russian).

PFISTER 1927:
K. Pfister, *Cézanne. Gestalt, Werke, Mythos*, Potsdam, 1927.

PROKOFYEV 1962:
V. Prokofyev, *French Painting in the Museums of the USSR*, Moscow, 1962 (in Russian).

PUSHKIN MUSEUM 1957:
The Pushkin Museum of Fine Arts. Catalogue of the Picture Gallery. Paintings, Sculptures, Moscow, 1957 (in Russian).

PUSHKIN MUSEUM 1961:
The Pushkin Museum of Fine Arts. Catalogue of the Picture Gallery. Paintings, Sculptures, Moscow, 1961 (in Russian).

RÉAU 1929:
L. Réau, *L'Art français dans les musées russes. Catalogue*, Paris, 1929.

REWALD AND MARSHUTZ 1935:
J. Rewald and L. Marshutz, "Cézanne au Château Noir," *L'Amour de l'Art*, 1935.

REWALD 1939:
J. Rewald, *Cézanne. Son vie, son œuvre, son amitié pour Zola*, Paris, 1939.

RUSAKOVA 1970:
R. Rusakova, *Paul Cézanne*, Moscow, 1970.

STERLING 1957:
C. Sterling, *Musée de l'Ermitage. La peinture française de Poussin à nos jours*, Paris, 1957.

TERNOVETZ 1925:
B. Ternovetz, "Le Musée d'Art Moderne Occidental de Moscou (Anciennes collections S. Stchoukine et I. Morosoff)," *L'Amour de l'Art*, 1925, No. 12.

TERNOVETZ 1977:
B. Ternovetz, Letters. Diaries. Articles (Selection, introduction, texts to sections, and comments by L. Alioshin and N. Yavorskaya), Moscow, 1977 (in Russian).

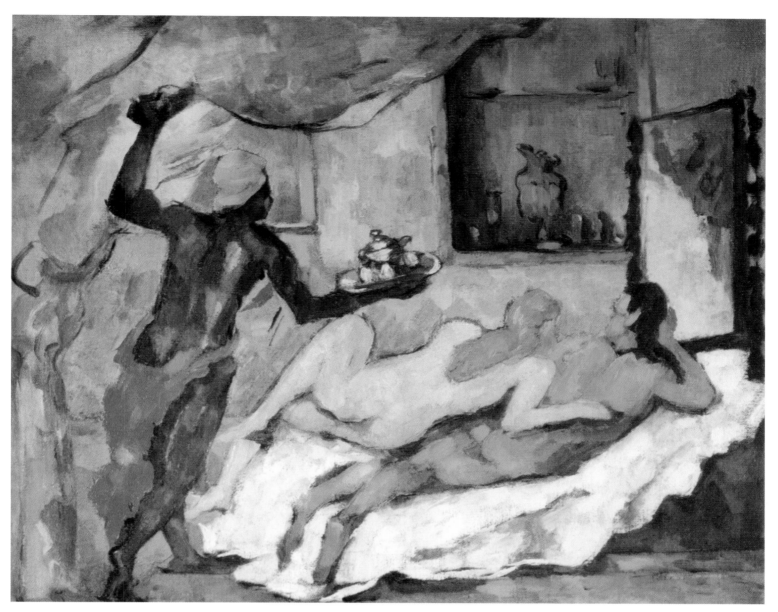

TUGENDHOLD 1914:
Ya. Tugendhold, "The S. Shchukin Collection of French Paintings,"
Apollon, 1914, No. 1–2 (in Russian).

TUGENDHOLD 1923:
Ya. Tugendhold, *The First Museum of Modern Western Painting. The
S. Shchukin Collection*, Moscow-St. Petersburg, 1923 (in Russian).

VENTURI:
L. Venturi, *Paul Cézanne, son art, son œuvre*, Paris, 1936.

VOLLARD:
A. Vollard, *Paul Cézanne*, Paris, 1914 (reprints: 1919, 1924, 1938).

VOLLARD 1934:
A. Vollard, *Paul Cézanne*, St. Petersburg, 1934 (in Russian).

YAVORSKAYA 1926:
N. Yavorskaya, *Paul Cézanne*, Moscow, 1926 (in Russian).

YAVORSKAYA 1935:
N. Yavorskaya, *Cézanne*, Moscow, 1935 (in Russian). All of Cézanne's paintings
from the Pushkin Museum of Fine Arts presented in this book have been
reproduced in *French Painting from the Pushkin Museum of Fine Arts, Moscow: 17th to
20th Century* (St. Petersburg, 1980) by E. Georgievskaya and A. Kuznetsova.

Afternoon in Naples (Rum Punch),
1877–1879.
Oil on canvas, 37 x 45 cm.
Australian National Gallery, Canberra.

Following Pages:
Portrait of Vallier, 1906.
Oil on canvas, 66 x 54 cm.
Private Collection, Switzerland.

Index of works reproduced

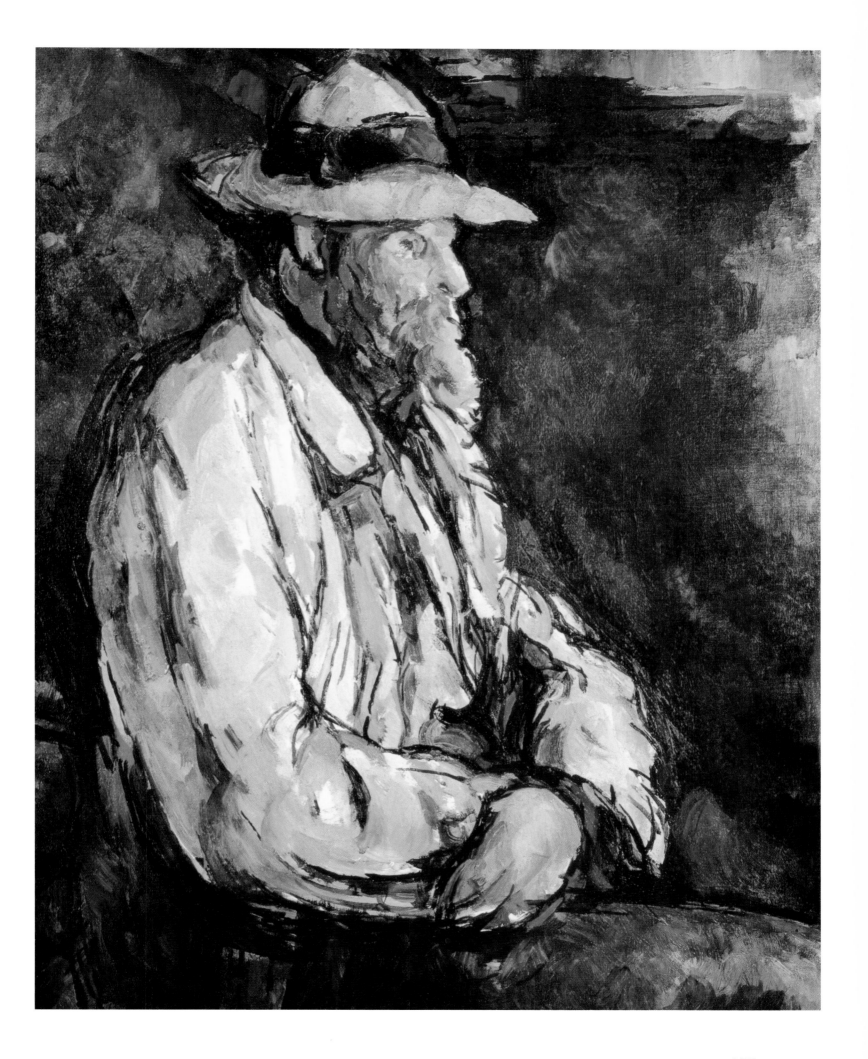

Landscape in Provence, c. 1880,
Watercolor, 34.6 x 49.9 cm,
Kunsthaus Zurich, Zurich.

P. CEZANNE